EUGÈNE DELACROIX

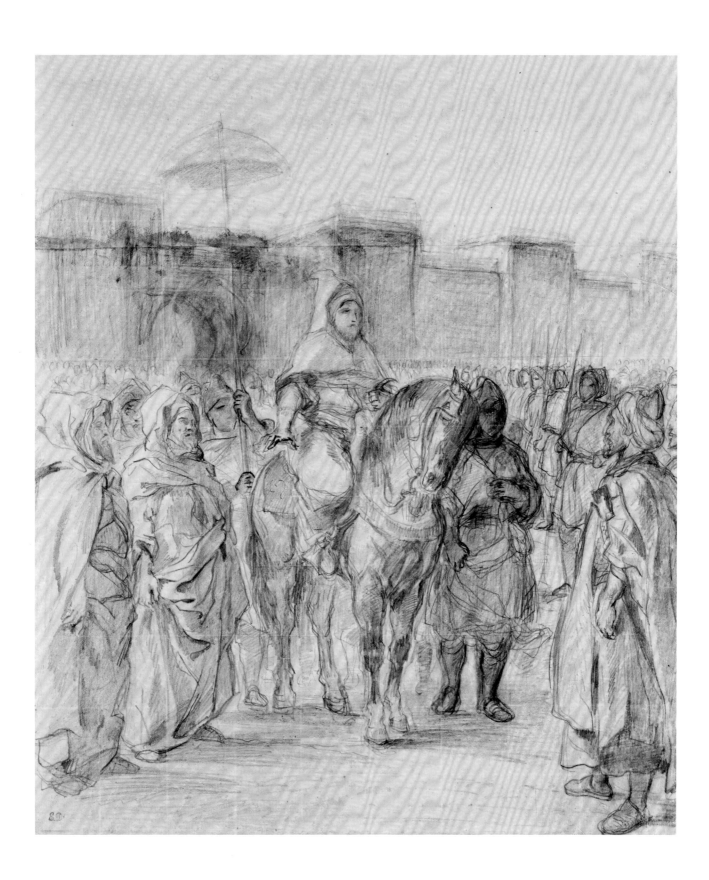

EUGÈNE DELACROIX
(1798–1863)

Paintings, Drawings, and Prints
from North American Collections

The Metropolitan Museum of Art
1991

Distributed by Harry N. Abrams, Inc., New York

This publication is issued in conjunction with the exhibition *Eugène Delacroix (1798–1863): Paintings, Drawings, and Prints from North American Collections,* held at The Metropolitan Museum of Art, New York, from April 10, 1991, through June 16, 1991.

On the cover / jacket: *The Abduction of Rebecca,* No. 5

Frontispiece: *The Sultan of Morocco and His Entourage,* No. 44

Published by
The Metropolitan Museum of Art, New York

John P. O'Neill, Editor in Chief
Teresa Egan, Managing Editor
Georgette Byk Felix, Editor
Matthew Pimm, Production
Steffie Kaplan, Designer

LIBRARY OF CONGRESS CATALOGING-IN-PUBLICATION DATA

Delacroix, Eugène, 1798–1863.
 Eugène Delacroix (1798–1863) : paintings, drawings, and prints
from North American collections.
 p. cm.
 Exhibition catalog.
 ISBN 0-87099-608-8.—ISBN 0-87099-609-6 (pbk.)—ISBN 0-8109-6403-1 (Abrams)
 1. Delacroix, Eugène, 1798–1863—Exhibitions. I. Metropolitan
Museum of Art (New York, N.Y.) II. Title.
N6853.D338A4 1991
760′.092—dc20 91-31
 CIP

Type set by U.S. Lithograph, typographers, New York

Printed by Mercantile Printing Company, Worcester, Massachusetts

Bound by Acme Bookbinding Company, Inc., Charlestown, Massachusetts

CONTENTS

FOREWORD

The artistic achievements of Eugène Delacroix have been appreciated by American collectors of French paintings for a very long time indeed. He needs, so to speak, no introduction. Six of the fourteen paintings in this selection of works from North American collections have been in the United States for more than a hundred years. That this interest continues unabated is evidenced by the acquisition in 1986 of *The Bride of Abydos* by the Kimbell Art Museum, Fort Worth, and in 1989 of *The Natchez* by the Metropolitan Museum.

Appreciation of Delacroix as a draughtsman grew in the course of the twentieth century. Among the drawings on exhibition from the Metropolitan Museum, the earliest acquisition dates from 1916; in the case of loans from the Fogg Art Museum, the earliest acquisitions are dated 1934. More recently, collectors have actively pursued the artist's drawings, and we are happy to present forty-two fine sheets from private collections. Very few of these drawings have previously been exhibited in New York.

All the etchings and lithographs included in this exhibition belong to the Metropolitan Museum, which has as fine a collection of Delacroix's prints as any in America. Our first acquisition in this field dates back to 1917, while the most recent is the brilliant *Turk Mounting a Horse*, purchased in 1990.

For this publication, Lee Johnson, author of the exemplary catalogue raisonné of Delacroix's paintings, has written *The Art of Delacroix*, a lively account of the artist's work as it is represented in the North American collections that he knows so well. Dr. Johnson has also contributed a biographical essay, *Portrait of Delacroix*.

This exhibition has been organized by Jacob Bean, Drue Heinz Curator of Drawings, Helen B. Mules, Associate Curator, and William M. Griswold, Assistant Curator. They wish to express their gratitude to Colta Ives, Curator in Charge of the Department of Prints and Photographs; Everett Fahy, John Pope-Hennessy Chairman, European Paintings; Gary Tinterow, Engelhard Associate Curator; as well as to Calvin Brown and Henrietta Susser of the Department of Drawings.

Philippe de Montebello
Director

Lenders to the Exhibition

The Art Institute of Chicago
Fogg Art Museum, Harvard University
Kimbell Art Museum, Fort Worth, Texas
The Metropolitan Museum of Art, New York
National Gallery of Art, Washington, D.C.
National Gallery of Canada, Ottawa
Philadelphia Museum of Art
The Pierpont Morgan Library, New York
Walters Art Gallery, Baltimore, Maryland

Eric G. Carlson
Karen B. Cohen
Roberta Olson and Alexander Johnson
Jack A. Josephson
Mr. and Mrs. Eugene Victor Thaw
Private collection

EUGÈNE DELACROIX

THE ART OF DELACROIX

by Lee Johnson

Reporting on the reaction of the crowds at Delacroix's studio sale in February 1864, six months after the master's death, Théophile Silvestre wrote that what really astonished everyone was the inexhaustible abundance of his art, the variety of his motifs, and the unflagging energy he put into rendering in every form the subjects that had struck him. It was easy to see, he continued, that there was a man who produced ceaselessly to unburden his mind and his heart, and who condemned his hand to a perpetual skirmish. It came as a surprise to many that an artist who had been so consistently criticized throughout his career for incompetence as a draughtsman and laxity in composition was revealed by the many hundreds of graphic works, the fifty-five sketchbooks (no. 72), and scores of oil sketches (nos. 8, 11) at his sale to have been a draughtsman of extraordinary versatility and one who went to infinite pains to elaborate the compositions of his paintings through preliminary studies of many kinds, from the inchoate scribbles of an idea in germ, to more articulate designs, to detailed drawings of pose and gesture (often from the life—see no. 41) or accessories, and fully realized composition drawings squared for transfer to canvas (no. 44) or *modelli* in oils (no. 8).

If the evidence of such profusion and industry was a revelation to the general public, it was not, needless to say, new to those who had worked with Delacroix. Gustave Lassalle-Bordes, his chief assistant on two of his largest decorative schemes, for the Deputies' and Peers' libraries, tells us that in middle age Delacroix continued to draw sketches every day from engravings, seizing their salient features, and showed him some of his extremely detailed anatomical studies (nos. 54–56) that he might emulate him. He advised Lassalle-Bordes to practise in the same manner because, when it came to painting, one needed to depict without difficulty what one saw in the mind's eye, and a quickness of hand, which could not be acquired without these exercises, was essential. He went on to draw an analogy with Paganini, who, he said, owed his astonishing virtuosity on the violin to his habit of practising scales for an hour every day.

The creative profusion, the amazing range, the variety of subject, of sentiment, of media that so impressed at Delacroix's sale are of course part of what we understand today by romanticism, a term that Delacroix distrusted but which has been inextricably connected with his name since the early 1820s. In a famous avowal to Silvestre he conceded: "If by my romanticism one understands the free manifestation of my personal impressions, my aversion to the models copied in the schools, and my loathing for academic formulas, I must confess that not only am I romantic, but I was so at the age of fifteen; I already preferred Prud'hon and Gros to

Guérin and Girodet." And his friend Paul Huet, the landscape painter, recalls that he defined romanticism as "a reaction against the school, a call for liberty in art, a return to a broader tradition: we wanted to do justice to all the great periods, even to David!" Hence the vast range of Delacroix's interests and the sometimes bewildering assortment of styles found in his copies from the art of all periods, from ancient Egypt to his own day (nos. 57–63). He was, however, trained by Pierre-Narcisse Guérin and in the École des Beaux-Arts, and it was as a student that he drew the first of those accurate anatomical studies referred to by Lassalle-Bordes, and formed the habit of sketching from prints. Then too that he must have painted most of the lot of seventeen academy figures that passed in his sale (no. 1). By the lights of the École, he did not shine however: in the very month, April 1822, that he exhibited his first Salon painting, *The Barque of Dante* (see no. 20), which established his reputation as a powerful new talent and was considered by some to the end of his life to be his greatest picture, he was ranked fifty-ninth out of sixty-one in the competition for places in the life class; in May, thirty-first out of fifty-three in that for drawing after plaster casts. By then, he must have pondered on the wisdom of some comments in Quatremère de Quincy's *Considérations sur la destination des ouvrages de l'art,* a book on his reading list when a student. For instance: "The imitation of bodies must be degenerate when it is no longer required that bodies should be the image of the soul"; or "The knowledge acquired in schools is useful, but its errors should not be circulated out of them . . . : everyone should walk at his own pace and soar with his own wings." He had also surely absorbed the lessons of Charles Bell's *Essays on the Anatomy of Expression,* noted in his list as the best book on anatomy for artists, where it is said: "The study of the action of the figure admits of a natural division; first, of motion and exertion simply; and second, of the effects of sentiment and passion. The knowledge of the former is necessary in order to paint the figure with correctness. . . . The second belongs more to the province of genius." Here, indeed, is the essence of what was to become Delacroix's lifelong attitude to working from the model. While insisting on the discipline of drawing from the live model, for himself and his collaborators, he was nevertheless reluctant to work too closely from models when actually painting a composition of his own lest the temptation to copy nature too closely inhibit his imagination, his ability to infuse "sentiment and passion" into his figures. Such a procedure often led to distortions for dramatic effect, to departures from the canons of "correct" academic drawing. As Gauguin was to put it, with a touch of his own lack of measure: "in Delacroix the arms and shoulders always turn in a senseless and impossible manner by rational standards, yet always express the reality of passion." Delacroix himself held that "every exaggeration must be in keeping with nature and the idea." In other words, it must never be used for its own sake, which would result in affectation, but as a means of stressing a natural characteristic and the spiritual content of a work of art—the speed of a horse, for instance, and the frenzy of its rider (no. 22; see also no. 52 for evidence that Delacroix was equally capable of treating horses in other modes).

In a sense it can be said that Delacroix, though still in training, had nailed his colors to the mast with *The Barque of Dante,* which he exhibited against the advice

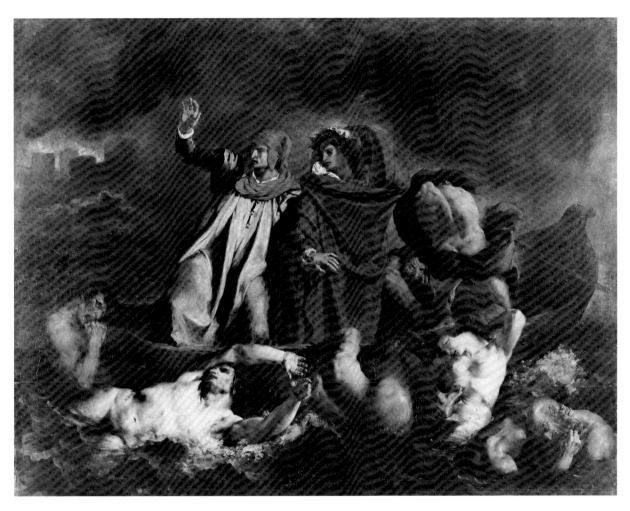

The Barque of Dante. Paris, Musée du Louvre

of his master Guérin. For if it is relatively academic with its array of separately studied figures, all but one posed by the model Suisse, it departs radically from the academic norm in its boldness of handling, its choice of Michelangelesque poses, muscular exaggerations, and *terribilità*. His bodies were the "image of the soul," albeit of damned souls for the most part, but not the less powerful for that. Some of this ability to put a very personal, affective stamp on a figure studied from a model can be seen in a drawing of roughly the same period, *Winged Genius* (no. 18), with its lugubrious, brooding quality. The picture also contained at least one passage painted in the fire of inspiration that is often thought of as characteristic of romanticism: Delacroix informs us that the "best head," that of the man with his arm over the far side of the boat, was done with extreme rapidity and dash while a friend read aloud a passage from Dante in Italian with an energy that "electrified" him.

But it was with his second major painting, the *Scenes from the Chios Massacres,* shown at the Salon of 1824, that critics first applied the term *romantique* to his

13

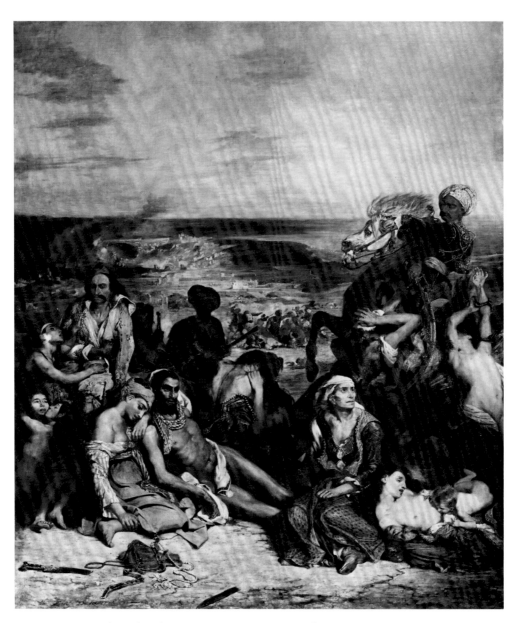

Scenes from the Chios Massacres. Paris, Musée du Louvre

work, to distinguish it from neoclassicism. Delacroix also dated the moment when he became "an object of antipathy and a sort of bugbear for the École" from the appearance of that picture, and wondered in retrospect how he had managed to swim against such a current. The characteristics of his style, which were then, as later, widely judged to part from the French classical ideal, to offend French taste which, as one critic insisted, was "noble and pure," were lack of unity; bold handling at the expense of "correct" drawing and high finish; the sacrifice of "ideal" beauty and restraint for the sake of an expressiveness that was found repugnant

It is one of the paradoxes of Delacroix's art that although he was a sceptic in religious matters and certainly not a practising Catholic, he was undoubtedly the greatest, and one of the most prolific, of all French painters of religious pictures in his century. While distrustful of ecclesiastical dogma and the clergy, he had a profound respect for the teachings of Jesus and was a most sensitive interpreter of Christian subjects. The sound of church music also exalted him, he tells us, when he was painting *The Lamentation* on a wall in Saint-Denis-du-Saint-Sacrement in 1843–1844 (no. 43) and gave rise to some of his best sessions—in much the same way as he had been inspired by listening to Dante recited while he was painting his first Salon exhibit. Likewise, while working at Saint-Sulpice he reported that the music and chants inspired him and that he accomplished twice as much on the days when Mass was sung. He deeply resented the curé's refusal to allow him to violate the Sabbath by painting "to the glory of the Lord," as he put it, on Sundays when the music was at its best (for further evidence of Delacroix's love of church music see no. 71). If music could impel Delacroix to infuse spirituality into paint, his pictures, conversely, could be music to the eyes of some critics, prompting analogies between his brushwork and aural symphony. Théophile Thoré, for example, was moved by the *Christ on the Cross* of 1846 (no. 6), with its tragic grandeur and poetic harmony, to liken Delacroix to Beethoven. From a pictorial point of view, this picture is strongly influenced by Rubens and probably, in the lunar lighting of Christ, by Prud'hon's last painting of the same subject (1822), yet it has a very personal, expressionist stamp in its poignant blend of corporal agony and spiritual redemption, where the correspondences in touch and lighting between Christ and the sky suggest the very transmutation of flesh into spirit. When the subject is treated in the fragile and friable medium of pastel, this impression of the concrete translating into the ethereal is perhaps even more marked (no. 15).

Delacroix's crowning achievement as a religious painter was the pair of murals facing one another in the chapel of the Holy Angels in Saint-Sulpice, which occupied him for much of the last decade of his life and were completed a little more than two years before his death: *Heliodorus Driven from the Temple*, which in its choice of subject seems intrepidly to invite comparison with Raphael, in its glittering array of treasures to vie with the *Sardanapalus* (nos. 48, 49); and *Jacob Wrestling with the Angel* (nos. 8, 46, 47), which owes much to Titian's altarpiece *The Death of St. Peter Martyr* and reflects in its towering oaks Delacroix's tireless observation of nature, as seen in his many drawings of trees and his notes on how to master the complexity of their foliage in painting. These murals also display Delacroix's most advanced color technique, based on the combination of a meticulous rendering of exchanges of colored reflections as they occur in nature and arbitrary color accents introduced for purely decorative effect.

Delacroix also painted a fair number of small religious pictures in his last years, including the *Christ Healing the Blind Men at Jericho* (no. 13), a newly found work in which he reinterprets a theme treated by Poussin in a painting from which he had drawn a detail in the 1820s. Though evidently unfinished, it is one of those sketches which Delacroix may well have felt that a higher degree of finish would have spoilt, it having been a constant preoccupation of his throughout his life that he might

and ugly; and color that was either too brilliant or morbidly realistic. A friendly critic, noting that Delacroix was "accused" of being Romantic, protested that it seemed to him the term was applied, in literature and now in painting, to those who left the beaten track to reach their goal along previously unknown paths that they discovered through their daring and, if so, was it not a term of approval rather than of opprobrium.

Today it is hard to see why Delacroix's huge canvas evoking recent atrocities committed by the Turks on the island of Chios during the Greek War of Independence should have been perceived as a dangerous threat to established values, because, for all its boldness of handling and chromatic daring, it can now be seen to follow, without a crucial rift, in the tradition of Gros's Middle Eastern scene of pestilence, *The Plague at Jaffa,* and beyond that "even" to David's *Sabines* and *Horatii*

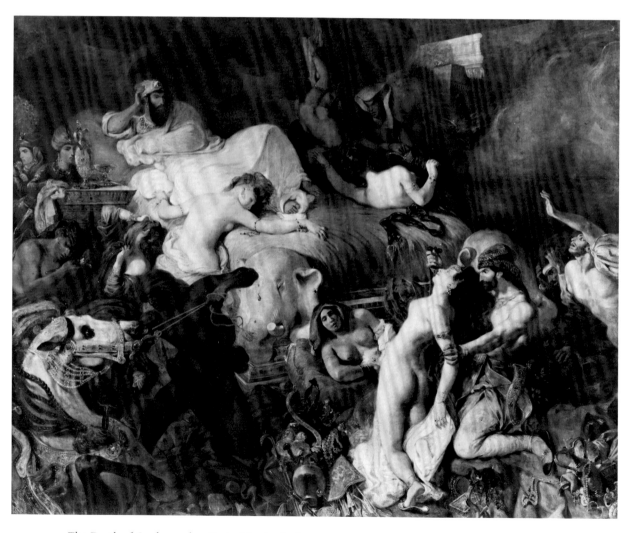

The Death of Sardanapalus. Paris, Musée du Louvre

15

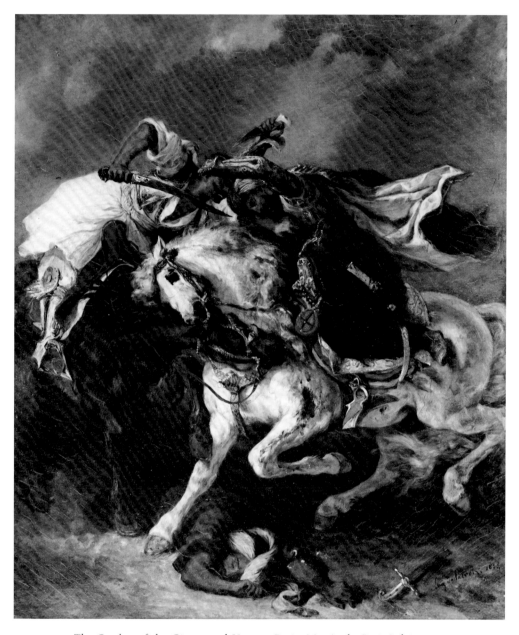

The Combat of the Giaour and Hassan. Paris, Musée du Petit Palais

destroy the vitality of his paintings by not stopping when he had achieved the effect he desired. He was wary of being imperfect through striving to be too perfect, as he judged some academically inclined artists to be.

Another small picture on a religious theme from the same collection, the *Lélia Mourns over Sténio's Body* (no. 7), is rare both in drawing its religious content from a contemporary novel and in being an example of the only subject for an oil

painting that Delacroix is known to have taken from any of the numerous works of fiction by his close friend George Sand, an early champion of women's liberation (he made her a gift of a closely related pastel and a later version in oils).

It is not at all surprising, indeed it seems almost inevitable, that while still working on the *Massacres of Chios* and *The Agony in the Garden* in May 1824, Delacroix was reading Byron and planning to compose subjects inspired by his poetry. The quintessential Romantic poet, Byron had died the month before at Missolonghi, where he had gone to support the Greek cause against the Turks. Ostracized in his own country, he had won phenomenal popularity throughout Europe with his oriental tales full of exotic local color, rich imagery, and stormy passions. Not least, he was loved for his tireless opposition to tyranny and his defense of the oppressed. All Europe mourned his passing. While his death no doubt provided the immediate stimulus for Delacroix's interest in illustrating scenes from his work, he was to become, with Shakespeare (nos. 79, 94–100) and Walter Scott (no. 5), the author most often represented in his œuvre. "To fire your imagination without fail," he wrote in May 1824, "remember certain passages from Byron; they are right for me. The end of the *Bride of Abydos*... That is sublime and his alone. I feel those things as they can be rendered in painting. The *Death of Hassan*, in the *Giaour*."

The Giaour, a Fragment of a Turkish Tale (1813) appears to have been the first poem of Byron's to be treated by Delacroix—in pen and ink (no. 22), in watercolor, with lithographic crayon, and in oils (no. 2). The earliest painting of a scene from the poem is also among the first pictures by Delacroix acquired by an American collector: the famous *Combat of the Giaour and Hassan,* which was bought by Mr. Potter Palmer of Chicago toward the end of the nineteenth century (no. 2). The Christian Giaour is about to kill the Turk Hassan to avenge the death of the slave Leila, who had fled Hassan's harem to become the Giaour's mistress and on being recaptured had suffered for her infidelity the prescribed Islamic punishment of being cast into the sea. In the drawing of an earlier scene from the poem (no. 22), the Giaour's frantic pursuit of Leila's abductors is conveyed with an impetuous, febrile touch matched, in paint, only in the second version of the *Combat* of 1835 (Paris, Musée du Petit Palais). The painting was shown at an exhibition for Greek relief in Paris in 1826—a fitting tribute to the poet who had inspired it and done so much to champion the Greek cause.

The most recent painting of a Byronic subject to be acquired by an American museum was also the last and most perfectly realized of four versions of the end of *The Bride of Abydos* (no. 12), which stirred Delacroix's imagination in 1824, but did not find full expression in a painting before the 1840s. Here Zuleika has stolen away from the harem tower with Selim to avoid an arranged marriage with an aging bey. With her father, Giaffir, and his men in hot pursuit, Selim reveals that he is the leader of a band of pirates that is within hailing distance offshore. But Giaffir shoots Selim dead before they can come to his rescue, and Zuleika dies of grief. While Delacroix makes no attempt literally to transpose Byron's variegated descriptions of costume and locale onto canvas, in the subtlety of its hues his picture offers an exquisite visual parallel to the colorful imagery of the poem, expressed in

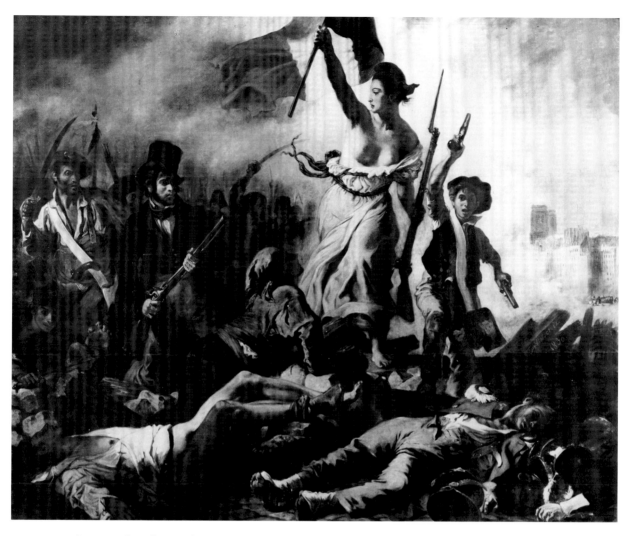

Liberty Leading the People. Paris, Musée du Louvre

such lines as Selim's plea to Zuleika: "Be thou the rainbow to the storms of life";
and Byron's evocation of the land

> Where the tints of the earth, and the hues of the sky,
> In colour though varied, in beauty may vie,
> And the purple of ocean is deepest in die.

Baudelaire, followed by Silvestre, felt that the lines and colors in the paintings of
Delacroix could be appreciated independently of the subject, so that if you saw
them at a distance too great to make out what they represented, you could sense
the character of the subject and a closer analysis would add nothing to the pleasure

of that first impression. Without being too prosaic, it may be wondered if this is quite true and genuinely felt. The sensation conveyed by a patch of red on a canvas seen from afar could change dramatically on closer inspection, depending on whether it proved, for example, to represent a pool of blood or a cheery flag flying in the port of Dieppe (no. 71); as could that of a sinuous contour if it delineated a boa constrictor or the Mississippi. Nevertheless, long before the poet penned his appreciation, Delacroix had probably taken cognizance of the following passage in Jonathan Richardson's *The Theory of Painting,* another work on his early reading list: "Every picture should be so contrived, as that at a distance, when one cannot discern what figures there are, or what they are doing . . . the whole together should be sweet and delightful, lovely shapes and colours, without a name." And he expressed his own view on the function of color in these words: "Color is nothing unless it is appropriate to the subject and increases the effect of the picture through the power of the imagination."

Upon the advent of the July Monarchy in 1830, Delacroix commemorated the three-day revolution that brought the new king, Louis-Philippe, to the throne, with his *Liberty Leading the People* (nos. 24, 25), the only major picture inspired by a contemporary event in France that he ever painted. In composition and coloring it has more in common with *The Barque of Dante* than with any of the intervening Salon paintings; in theme, it joins the *Massacres of Chios* as a cry against oppression, this time in Delacroix's own country.

If the new regime was to offer Delacroix spectacular opportunities to paint vast decorative cycles in key government buildings, it also afforded him, almost fortuitously, an experience that had the most important ramifications for his art: he was invited to join Count Charles de Mornay, special envoy of the King, as a traveling companion on a diplomatic mission to the Sultan of Morocco, and from January 1832 spent five months in North Africa, interrupted by a brief excursion to Spain in May (no. 65). There he was overwhelmed by the sort of exotica that he had always been drawn to by temperament but had so far experienced only vicariously, through such media as paintings of Napoleon's Middle Eastern campaign by Gros and Girodet, prints, oriental miniatures, costumes and accessories seen in Paris, travelers' accounts, and the poetry of Byron.

The sights he saw and excitedly recorded in numberless sketches and notes provided him with subjects of paintings for the rest of his life and with motifs that he sometimes introduced into pictures that were not depictions of Moroccan scenes but where Moorish characters or architecture did not seem out of place—in lion hunts, for example, or some biblical scenes (see the city ramparts in no. 13). The most immediate effect on his art of this multifarious assault on his vision was, not surprisingly, an increase in documentary realism. But he also discovered in North Africa what he regarded as a living antiquity. He likened some Arabs to senators of ancient Rome in their nobility and dignity of bearing, and contrasted them with the artificiality of David's Romans. Thus we find in his most ambitious paintings to come out of the North African journey, *Women of Algiers in Their Apartment* of 1834 and *The Sultan of Morocco and His Entourage* of 1845, which re-creates the

ceremonial reception of Count de Mornay by the Sultan at Meknes, not only a Romantic fascination with the exotic and a concern for documentary accuracy but a classical grandeur and sobriety in the supple monumentality of the figures and their ordered setting—in short, a classicism congruent with his understanding of the term as a "skillful breadth of form combined with a feeling of life" or, elsewhere, as an amalgam of "all those qualities which enhance the impression by creating a final simplicity."

Among the earliest finished works to result from the North African experience was the set of eighteen watercolors that Delacroix offered to Count de Mornay as a souvenir of their journey together. Some of these portray native people of various stations whom they had come in contact with, others record views of town and country or picturesque spectacles, such as an Arab fantasia and a group of negroes dancing to the rhythm of a tambourine in the streets of Tangier. Long dispersed, and some still untraced, there are now no fewer than six in American collections,

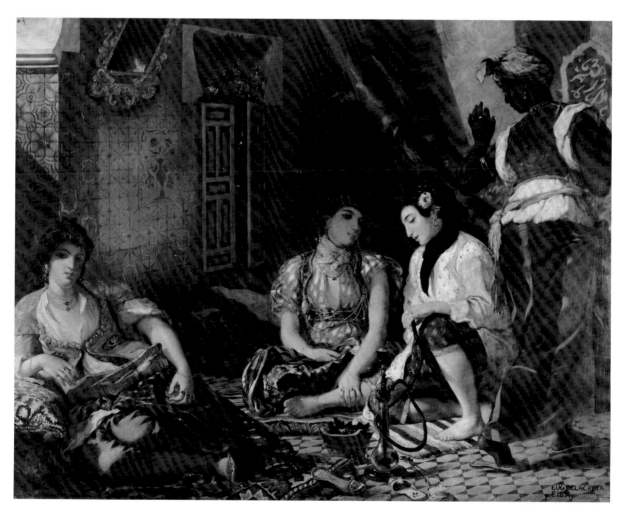

Women of Algiers in Their Apartment. Paris, Musée du Louvre

23

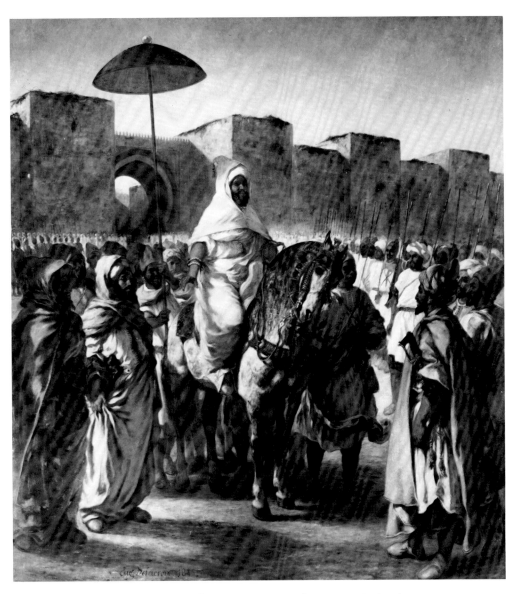

The Sultan of Morocco and His Entourage. Toulouse, Musée des Augustins

including two very beautiful examples that belong to the Metropolitan Museum: the portrait of the wife of the Jewish interpreter for the French delegation, Abraham Benchimol, and one of their daughters (no. 27), and the so-called *Conversation mauresque* (no. 26). Although it is clearly of immense importance to Delacroix to present a faithful image of Moroccan costume, jewelry, and physiognomy, these watercolors are imbued with a poetic sentiment and a humanity that far transcend a mere ethnographic record. Yet Delacroix was to confide in his *Journal* in 1853: "I did not begin to do anything worthwhile from my North African journey until I had so far forgotten the small details as to recall only the striking and poetic aspects. Up to then, I was pursued by the love of exactitude which the majority

take for truth." If, on contemplating the Mornay watercolors and the *Women of Algiers,* the first major painting of a North African subject, we can hardly agree with this self-deprecatory appraisal, we can, by examining his largest late painting on a Moroccan theme, the *Arabs Skirmishing in the Mountains* (no. 14), at least see what he meant. Here, in contrast to many of the earlier North African pictures, is an Arab fantasy drawn from the artist's imagination. It is nonetheless founded in recollections of the journey. There is no reason to believe that Delacroix actually witnessed a combat of this sort, but early sources (though not Delacroix himself) called it *The Collection of Arab Taxes,* and it seems likely that he developed the idea from a conversation with Sidi Ettayeb Biaz, the Sultan's minister in charge of nego-tiations with the French and Chief (*Amin*) of Customs (far left in no. 44), who explained to him en route to Meknes that as a matter of policy bridges were not built, so as to make it easier to apprehend robbers, rebels, and tax evaders. Thus, apparently recalling this "striking aspect" of Moroccan law enforcement (all the more memorable in that he had had to ford the rivers), Delacroix conjures up an image of the sort of battle that might have been fought between the Sultan's forces and a band of miscreants, peoples it with figures wearing costumes and carrying arms of which he had acquired direct knowledge, and sets them within a land-scape that seems to be a magical setting dreamt up from disparate and distant memories, perhaps not all of Morocco, despite the cacti, but intermingled with reminiscences of French landscape. The dress and accessories, though authentic, lack the documentary precision of the earlier works, and there is little interest now in defining the facial features of the Arabs, many of whom are turned away from the viewer. Costumes and figures tell more as color accents and shapes within a grand atmospheric tapestry, those in the middle distance combining with the vege-tation to form a ragout of color and touch.

This picture, among Delacroix's last, was also the last of a particularly distin-guished group of his Moroccan paintings to be acquired by one of the first and most discerning American collectors of his work, James J. Hill, of Saint Paul, Minnesota, who died in 1916, within three years of purchasing it. In 1892 he had secured one of Delacroix's finest marine prospects, the *View of Tangier from the Seashore* of 1858; by 1895, the famous *Fanatics of Tangier* shown at the Salon of 1838. Both these masterpieces passed from his descendants to the Minneapolis Institute of Arts, in 1949 and 1973 respectively. A smaller, less well known North African scene, the *View of Tangier with Two Seated Arabs* of 1852–1853, which is a variant of the watercolor in this exhibition (no. 30), remains in the possession of the family and had previously belonged to another notable, even earlier collector of Delacroix who did not, however, concentrate so exclusively on Moroccan scenes. On his death in February 1880, the collection of Adolphe E. Borie of Philadelphia, a former Secretary of the Navy, boasted not only this picture but a Goethe-inspired *Weislingen Captured* of 1853, acquired by the City Art Museum, Saint Louis, in 1954; the *Lion Hunt* of 1858, bought by the Boston Museum of Fine Arts in 1895; and the exquisite *"Circassian" Holding a Horse by Its Bridle,* which entered the Wadsworth Atheneum in Hartford in 1906.

In quality these collections were matched, in range surpassed, by that formed by

William T. Walters of Baltimore (1820–1894) and his son Henry, who died in 1931, bequeathing the celebrated gallery that bears their name to the city. Two religious pictures bought by the father, the first in 1886, the second a year later, are in the present exhibition, the *Christ on the Cross* (no. 6) and *Christ and His Disciples Crossing the Sea of Galilee* (no. 10). In 1883 William Walters also bought a superb secular painting derived from scenes Delacroix had witnessed in Morocco, the *Collision of Arab Horsemen* of 1843. At the turn of the century, his son rounded out the collection to embrace most of the categories favored by Delacroix, by adding an oil sketch for the early *Battle of Poitiers* and the *Marfisa,* inspired by Ariosto's *Orlando Furioso.*

Also early into the field were Mr. Potter Palmer of Chicago and his French wife, Berthe Honoré, who, as we have seen, had acquired *The Combat of the Giaour and Hassan* before 1900 (no. 2). Like James Hill, they were attracted by exotic themes, but by ones less perceptibly linked to actual experience and involving imagined combat not only between men but between men and felines. Thus the trio of pictures that they bought in the last decade of the century included an *Arab Horseman Attacked by a Lion* of 1849/1851 and the more complex *Lion Hunt* of 1861, Delacroix's last and perhaps most beautiful treatment of this theme. Both these were bought in 1892, both bequeathed to The Art Institute of Chicago by Mrs. Potter Palmer, who died in 1918. *The Combat of the Giaour and Hassan,* having passed to her descendants, did not enter the permanent collection of the Institute before 1962, having been on loan there since 1930.

The Metropolitan Museum was among the first of the American galleries to acquire a painting by Delacroix, having purchased in 1903 *The Abduction of Rebecca* (no. 5) with funds bequeathed by Catharine Lorillard Wolfe in 1887, together with over 100 nineteenth-century French paintings, for the preservation and increase of her collection, which did not include any works by Delacroix. This picture had been in the United States since 1888, when it was purchased by David C. Lyall of Brooklyn, New York. The Metropolitan Museum was to gain a further Delacroix in 1929, the *Christ and His Disciples Crossing the Sea of Galilee* (no. 9), through the bequest of Mr. and Mrs. H. O. Havemeyer's important collection of nineteenth-century pictures.

As the present century advanced there was a marked increase in the appreciation of Delacroix's drawings by American collectors. Notable among these were Grenville Winthrop, who in 1943 bequeathed about a dozen works on paper to the Fogg Museum of Art with interdiction to lend, including the watercolor of negroes dancing from the Mornay album mentioned above; Philip Hofer, who donated two of the drawings in this exhibition to the same museum (nos. 47, 49) and left others to the Houghton Library at Harvard; and John S. Thacher, who bequeathed two works shown here to the Morgan Library in 1985 (nos. 70, 71). Another connoisseur whose collection was mostly formed between the two world wars was Henry P. McIlhenny, of Philadelphia, who, though not primarily a collector of drawings, stands out for the individuality and sureness of his taste in Delacroix, as well as in other French masters of the nineteenth century. As a young man, barely out of Harvard, he had the flair to buy the replica of *The Death of Sardanapalus* (no. 4),

and toward the end of his life acquired the splendid and unusual drawing *Winged Genius* (no. 18), which, fatefully, may be the *Angel of Death*. He died in 1986, leaving his collection to the Philadelphia Museum of Art.

Among living American collectors of Delacroix drawings, Eugene Victor Thaw is well known through previous exhibitions of his collection and is represented here by three fine drawings. Karen B. Cohen is today, as far as I know, the most active private collector of Delacroix drawings in any country and has already assembled over a period of only fifteen years the largest single body of works in the United States. Since her collection has received little publicity, a generous proportion of her holdings is shown here: their quality and range may be left to speak for themselves. In conjunction with her taste for drawings, Mrs. Cohen has shown a special appreciation for Delacroix's oil sketches, which sets her apart from earlier American collectors of his paintings, who generally preferred finished pictures.

A major aspect of Delacroix's painting that can be viewed only in France is his murals, since they are by their nature fixed in place—in three State buildings and two churches in Paris. But a fair proportion of the drawings for them have found their way into North American collections, and a goodly selection of these are shown in this exhibition (nos. 31–35, 37, 38, 41, 43, 46–49), together with the very fine oil sketch-cum-drawing for the *Jacob Wrestling with the Angel* in Saint-Sulpice (no. 8).

Nearly 750 drawings listed as studies for his five extant decorative projects (a large cycle in the Salon de la Paix of the Town Hall in Paris, painted in 1852–1854, was destroyed by fire in 1871) passed in Delacroix's posthumous sale in 1864. Of these there are just over 100 in the Louvre and, at a rough guess, perhaps half as many dispersed in the United States, with others regularly coming up for auction on both sides of the Atlantic. More than a third of the total number in the sale (256; 23 now in the Louvre) were related to Delacroix's first monumental commission for the Salon du Roi in the Palais Bourbon, so called because it is the anteroom to the Chamber of Deputies where the King sat enthroned at the opening of Parliament. With no previous experience in decorative painting on this scale, Delacroix was fortunate to receive the commission in 1833. It was thanks to Adolphe Thiers, who had been an early supporter of his and was now in a position as Minister of Trade and Public Works to bestow State patronage. His choice was triumphantly vindicated, as the completed work revealed hitherto unsuspected talents in Delacroix and led to further important commissions, including in 1838 that for the Deputies' Library in the same building.

The decorations in the Salon du Roi comprise three zones, each of which is represented in the exhibition (nos. 31–35): a flat ceiling with four coffers containing personifications of the "life-forces" of the State: *Justice, Agriculture, Industry,* and *War;* a frieze the full length of each wall, depicting activities related to the figure immediately above it; eight piers painted with colossal tinted grisaille figures personifying the rivers of France and the seas on her shores. The Metropolitan Museum's study for the *Justice* coffer (no. 31) is typical of other early drawings for the scheme in showing a far more belligerent and hyperactive figure than was chosen for the final design (whether the end result reflects a natural evolution or official

intervention is not altogether clear). Thus the painted *Justice* holds a slim protective wand over mother and child instead of a weighty sword, and her leashed lion, symbol of authority, is replaced by a frail old man seated within her ambit. The other drawing in the Metropolitan Museum (no. 32) is for part of the section devoted to the making of arms, on the far right of the *War* frieze, opposite *Justice*. It explores the two figures before their poses have been fully adapted to the cramped, irregular space between archivolt and cornice. The lower figure reclines with the easeful languor of a Michelangelo *ignudo,* whereas in the painting it lies less comfortably on the curve of the arch. For other sections of the friezes Delacroix looked to Raphael's frescoes in the Chigi Chapel and Villa Farnesina for solutions to placing figures gracefully in constraining spandrels.

Another sheet of figure studies (no. 33) has at the bottom right an early idea for the *War* coffer, abandoned in the final scheme, and experiments with reclining figures curved to fit over the arches of the friezes, perhaps the *Industry* or *War* frieze, though these poses too were not retained in the same form on the walls. The two figures at the top right of the second sheet of multiple studies (no. 34) also appear to be related to initial ideas for the *War* coffer.

The studies for a pier (no. 35) show Delacroix searching for a way to decorate the eight broad surfaces in the lowest zone of the scheme without distracting the eye overmuch from the upper zones. Here he is apparently influenced by the feigned, shell-headed niches containing full-length figures of Philosophers on the piers in the Sala Dorata in the Library of St. Mark's, Venice, which was decorated by sixteenth-century Venetian masters and referred to in a note by Delacroix on one of his studies for the Salon du Roi. In the event, he opted for a less ornate setting and made one figure over life-size occupy most of the area of each pier.

In the context of this show, the best indication of the forceful plasticity of many of the figures in the Salon du Roi can perhaps be had by examining the father in the Metropolitan Museum's recent acquisition *The Natchez* (no. 3), a painting conceived and started in the early 1820s, but, as recent inspection in the conservation studio of the Museum has shown, probably executed for the most part shortly before the Salon of 1835, when the decorations in the Salon du Roi were in full swing. The scene is taken from the epilogue of Chateaubriand's novel *Atala* of 1801, which relates the tale of an American Indian whose wife gives birth while they are fleeing up the Mississippi to escape the massacre of his tribe by the French. This is Delacroix's only painting inspired by the proto-Romantic Chateaubriand, who may also however have played some part in stimulating his early interest in Dante's *Inferno,* the subject of his first Salon picture ("Do you wish to be stirred," he had written in 1802, "do you wish to know the poetry of tortures and the hymns of flesh and blood, then descend into Dante's *Inferno*"). *The Natchez* reflects a similar concern with the theme of the oppression of innocent, exotic people to that found in the contemporary *Massacres of Chios,* with the difference that in this case it is the "noble savage" rather than the heirs of ancient Greek civilization who suffers persecution. Another point of similarity is the poignant motif of mother and doomed baby—in *The Natchez* soon to die because its mother's milk is spoilt, in the *Massacres* clutching its dead mother's breast. In terms of

style, Thoré saw in *The Natchez* new signs of a change of manner, characterized by tighter handling and more concentrated effects, and these are some of the qualities perceived by critics in the Salon du Roi.

In 1838 Delacroix received the commission for the larger scheme in the Depu-

The Deputies' Library. Paris, Palais Bourbon, looking north

ties' Library which he did not complete until 1847. This consisted of a row of five cupolas, each devoted to one or two branches of knowledge, as classified in libraries, and containing four pendentives illustrating the appropriate themes. At either end of the room were two half-domes representing the dawn and twilight of ancient civilization: *Orpheus Civilizes the Greeks, Attila and His Hordes Overrun Italy and the Arts*. This cycle is represented in the exhibition by an advanced study for *The Tribute Money* in the *Theology* cupola (no. 37), a pendentive painting of Rubensian inspiration that was being painted by Louis de Planet under Delacroix's supervision in May and June 1843. The drawing is of special interest in that it includes prominently in the foreground a figure of a nude boy which was omitted from the final design, perhaps because Delacroix felt it would have overcharged one of the more crowded pendentives and distracted attention from St. Peter. Or could he have encountered official disapproval of this display of nudity in the sanctuary of France's legislators?

Concurrently with the decorations in the library of the Palais Bourbon, from 1841 to 1846, Delacroix was painting a large cupola and half-dome in the library of the upper chamber, the Peers' Library in the Palais du Luxembourg. There is also one drawing for this scheme in the exhibition (no. 41), which illustrates a different aspect of Delacroix's preparation of monumental projects from that of the compositional study for *The Tribute Money*. Here, ever mindful that nature must be the anchor of his art, he sketches studies, apparently from the same live model, for three figures widely separated in the final scheme: Hannibal, who is heavily draped in the painting, Socrates, and Cato—all major figures in the cupola, where *Dante and the Spirits of the Great* is depicted in a circular composition whose theme is derived from Dante's *Inferno*. Thus, at the height of his powers, in middle age, Delacroix is seen to follow the same discipline of making preliminary drawings from the life as in his first Salon picture, *The Barque of Dante*, also inspired by Dante's *Inferno*, and also, incidentally, hanging in the Palais du Luxembourg in the 1840s.

As soon as Delacroix received academic recognition by being elected to the Institut on his seventh application, in January 1857, he began to compile a didactic Dictionary of the Fine Arts, which he never finished. He did not venture a definition of his own under the heading *"Romantisme"*; instead, he entered a reference to a passage by Théophile Gautier on the actor Frédérick Lemaître, which he had copied out a few years before. This gives a further indication of what he understood romanticism to be, and in its eulogy of the actor's talent he surely recognized much of what he himself had stood for in painting:

> He ranges over the keyboard of the human soul from one end to the other, an admirable gift, which is rarely found in the same person; he has passion, faith, irony, and scepticism; he knows how to render every emotion beautifully . . .; in the same evening, he can be Romeo and Mephistopheles, Ruy Blas and Robert Macaire, Gennaro and *le Joueur* [a comedy by Regnard, 1696]. The cloak suits him as well as the smock, the purple as well as rags; but, whichever character he represents, he brings it to life,

and can infuse a full, red blood into the feeblest melodrama . . . ; he belongs to that strong and powerful romantic generation whose success he shared and whose spirits he rallied; he is the Shakespearian actor *par excellence,* the most complete incarnation of the modern drama.

Concluding the study quoted in the first lines of this essay, Théophile Silvestre wrote with feeling of Delacroix's last hours and ended by describing him in comparable terms as "a painter of great distinction, who had a sun in his head and storms in his heart; who for forty years played the whole keyboard of human passions, and whose grand, awe-inspiring or gentle brush passed from saints to warriors, from warriors to lovers, from lovers to tigers [nos. 53, 88], and from tigers to flowers [no. 17]."

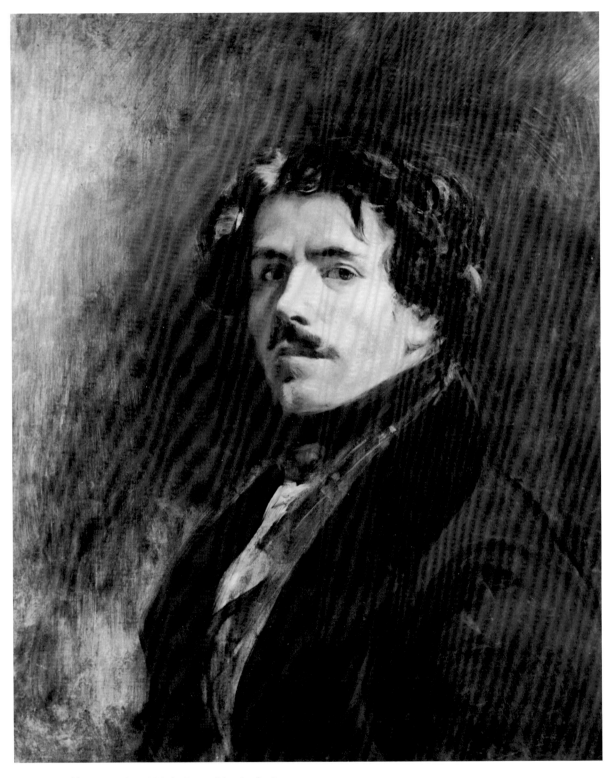

Self-Portrait (ca. 1837). Paris, Musée du Louvre

PORTRAIT OF DELACROIX

by Lee Johnson

"Nous aimons à trouver l'homme à côté ou à la place du héros."
(Delacroix, on portraiture, *Journal,* July 29, 1854)

Eugène Delacroix was quite tall, thin, and rather frail, but he had a good figure, an elegant appearance, and distinguished manners. He had jet-black hair, vivacious eyes, fine teeth, a kind and witty smile; his complexion was pale and bilious, and his face seemed small beneath his thick and silky hair; now and then he would screw up his eyes slightly, like a man about to look at the sun and readying himself to withstand its glare.

He had, as someone [Théophile Silvestre] put it, small, nervous hands that were nimble and sharper than a cat's claws [he wore his nails very long].

He dressed smartly, affecting the habits of a man of the world; it was clear that he did not wish to be confused with those studio heroes who win notoriety by virtue of their eccentric attire. He was reserved in bearing, sparing in gesture, and would throw out a few words to keep a conversation going without any thought of dominating it.

His constitution was delicate, and in the course of his life his poor health, which began with long fevers in 1820 and ended with a fatal disease of the chest in 1863, greatly influenced his frame of mind.

Well-bred and very cultivated, he was sought after in society, which he often avoided, however, for reasons of health and self-preservation.

Age neither whitened his hair nor blunted the power of his intellect; he died in full possession of his talent.

Thus, in some of the opening sentences of his *Eugène Delacroix, sa vie et ses œuvres,* published anonymously in 1865, did Achille Piron, one of his oldest and most trusted friends, present a sketch of Delacroix, taken largely from a manuscript written by Baron Charles Rivet, another lifelong friend. An anonymous article published in *L'Artiste* in 1831 and perhaps written by Achille Ricourt, the founder of that influential new magazine, adds detail and depth to the portrait of the head: "sometimes his features are pensive and introspective, but more often ironical; his upper lip is regularly drawn into a fairly fixed expression of scorn and sadness [Baudelaire, on later acquaintance, saw the lips as compressed by a constant exercise of willpower, conveying an impression of cruelty]; in his look, there is the feverish animation of a man who feels he is carrying within himself something of indisputable and lasting value; and sometimes profound dejection, bitter discouragement."

The same author, who by his own account moved among the most eloquent

figures of his day, also expands on Delacroix's gifts as a conversationalist: "I know no one who speaks in a more lively, sparkling, and supple manner, nor with a wittier agility of mind and quicker, more marvelous skill in making sudden, un-hackneyed comparisons. Free from pedantry or affectation, his conversation springs from a broad range of knowledge, immensely wide reading, and a fund of precise, topical, and spirited reminiscences."

Albert Vandam, also writing anonymously in his two-volume *An Englishman in Paris* (1892), and a friend of Delacroix's from about 1840, confessed to being puzzled by the contradictions in his character, but also by his deceptive stature: "Long as I knew Delacroix, I had never been able to make out whether he was tall or short, and most of his friends were equally puzzled. As we stood around his coffin many were surprised at its length." Delacroix was in fact 1.70 m tall (5′ 7″), as shown by a passport issued in 1831.

Regarding externals, Vandam also draws a colorful contrast between Delacroix, "that man of the world, exceedingly careful of his appearance," and Delacroix at work: "An old jacket buttoned up to the chin, a large muffler round his neck, a cloth cap pulled over his ears, and a pair of thick felt slippers made up his usual garb. For he was nearly always shivering with cold, and had an affection of the throat, besides, which compelled him to be careful. 'But for my wrapping up, I should have been dead at thirty,' he said."

Delacroix certainly meant what he said, for in 1828, when he was thirty, he had written to Soulier, following a recent illness: "By the way, I am not so thin now. It seems that I nearly died." He appears to have suffered from a tubercular infection which periodically manifested itself with more or less severity throughout his adult years in the form of laryngitis or pulmonary congestion. His assistant Lassalle-Bordes records that the timbre of his voice was thin, affected perhaps by the chronic condition of his throat, which cannot have been improved by his habit of smoking. It may, sadly, have been owing to a steady deterioration in the state of his larynx that a friend, on meeting him in 1855 for the first time in twenty-five years, told him that the greatest change he found in him was that he spoke less rapidly and his voice was different. He also suffered regularly from a delicate stomach and dyspepsia, which may have derived as much from his excessively nervous temperament as from any intrinsic physical disorder.

All men of perception who knew Delacroix well and recorded their impressions of him were struck by the remarkable contrast between his polished exterior and the impulsive, savage, passionate spirit lurking beneath it and finding expression in his art, though none phrased it more poetically than Baudelaire: "On eût dit un cratère de volcan artistement caché par des bouquets de fleurs." As the poet rightly judged, it was one of Delacroix's major preoccupations to conceal the "rage in his heart" but also his vulnerability and shyness behind a civilized front; and from the beginning of his career as an artist to be reckoned with he quite consciously set about acquiring this protective coloring, noting for his guidance in 1823, for example: "The mask is everything. Sang-froid, the best defense, only comes when one feels that there is no chance of being taken unawares because everything has been

foreseen. I know that this requires immense determination, but with perseverance one is bound to make great headway." And around 1840 he copied with obvious sympathy this passage from Eugène Sue's *Arthur*: "I congratulated myself on having so far disguised my true character as to give him an absolutely false or singularly vague impression of it. It has always seemed to me odious that casual acquaintances should know me well or penetrate my inner self, and dangerous that my enemies or even my friends should do so."

Through perseverance no doubt, but also perhaps aided by an inbred sense of the proprieties, Delacroix fashioned an exquisite protective mantle of self-control and courtesy. Baudelaire notes that his tone could convey every nuance, "from the most cordial friendliness to the most irreproachable impertinence. He had easily twenty different ways of uttering 'mon cher monsieur,' which to the trained ear denoted an intriguing range of feelings."

But Delacroix's conduct was regulated by a sterner morality than mere social convention. Baudelaire tells us that he liked to formulate brief maxims by which to live, precepts that might appear too elementary to some, but which genius does not despise because it is itself akin to simplicity: "healthy, strong, simple, and stern maxims, which serve as shield and breastplate to one whom the fate of genius has plunged into an unending battle." From the beginning to the end of his career, such maxims are to be found in Delacroix's writings: in 1822, "Do not be tolerant of unscrupulous people"; or in 1854, "Shun wicked men, even when they are agreeable, instructive, or charming"; and "The company of honest people not only reinforces our sense of integrity, but teaches us to attach no value to rewards that are acquired only by straying from the path of rectitude. One learns thus to neglect none of one's essential duties."

The company that Delacroix least liked to frequent was that of the bourgeois. "Among all those men who had a profound, ineradicable contempt for the bourgeois," writes Vandam, "I have only known one who despised him even to a greater extent than [Delacroix]; it was Gustave Flaubert. Though Delacroix's manners were perfect, he could scarcely be polite to the middle classes." For Delacroix "bourgeois" stood not so much for a social class, since he and many of his friends and relatives were members of the higher bourgeoisie, as for a state of mind that was the antithesis of everything he believed in. It was characterized by acquisitiveness, philistinism, utilitarianism, lack of imagination, and of any spiritual ideals or nobility of purpose. He largely blamed the predominance of bourgeois attitudes in his own age for his personal tribulations as an artist, as well as for what he felt was a general decline in cultural standards. Inveighing against this "wholly new barbarism" in 1857, he wrote: "Commercialism and love of pleasure are, to the present way of thinking, the most compelling motives of the human soul. The young are left in complete ignorance of ancient languages, on the grounds that they are useless for earning money. They are taught the sciences not in order to illuminate or correct their judgment, but to help them make calculations that will lead to their making a fortune." Contemporary decadence in the arts he ascribed directly to the rise of the middle classes and their spokesmen, the critics:

Since the height of their perfection in the sixteenth century the arts have shown a steady decline. The cause lies rather in the changes that have occurred in thought and manners than in any scarcity of great artists. . . . The absence of a general standard of taste, the gradual enrichment of the middle classes, the increasingly autocratic sway of sterile criticism, whose special task is to encourage mediocrity and discourage genius, the tendency of men with good brains to study the practical sciences, the growth in material knowledge which inhibits works of the imagination—a combination of all these things has inevitably condemned the arts to be increasingly at the mercy of changing fashions and to lose all nobility.

Though Delacroix was treated well by many critics throughout his career, he detested journalists in general as much as he did the bourgeois. He looked upon them as parasites and despoilers of reputations. Consoling George Sand, who had been victimized by a hack, he wrote prophetically in 1859: "journalists rule our lives and will do so more and more; they hold sway over our honor and our character. They speak only of liberty and light, as they snuff out all glory."

Vandam remarks that although "Delacroix had what a great many Frenchmen lack—a sense of humor—it was considerably tempered by what, for the want of a better term, I may call the bump of reverence. He could not be humorous at the expense of those he admired or respected. His admiration and respect were not necessarily reserved for those with whom he agreed in art or politics, but for everyone who attempted something great or useful, though he failed." A concrete example of this aspect of his character is given by Silvestre, who relates how Delacroix hotly defended his arch-rival Ingres against the flippant comments of Auguste Jal contained in a booklet entitled *Ingres, peintre et martyr.* "I don't like that," he quotes Delacroix as saying. "I strongly disapprove of these insults to a man of M. Ingres's character. It annoys me the way dull hacks permit themselves to attack the beginnings especially of this man, who struggled with such perseverance."

Fortunately, Delacroix also possessed what may be called the bump of irreverence and loved to record incidents, no doubt for later use in conversation, that brought the mighty down a peg or two. If he was outraged by Jal's disrespect, it was with obvious relish that he caught the peculiar look on Ingres's face when Prince Louis-Napoléon complimented him on his beautiful *Capuchins,* a painting in the Prince's own collection that was not in fact by Ingres, but by Granet. In a similar spirit of fun, he noted down an anecdote about his fellow artist Baron Gérard, who, having been snubbed by Napoleon sometime after the Retreat from Russia, quipped: "The Emperor turned his back on me; no doubt he took me for a Cossack."

One of Delacroix's most endearing traits was his sense of loyalty, loyalty to colleagues, to friends, and to family. There are many recorded, and no doubt countless unrecorded, instances of the kindly and practical ways in which he helped his fellow artists of all ranks. A further example of how he stood up for a painter—one as great but not so successful as Ingres—will suffice to illustrate his mettle. He was serving on the committee for awarding honors to artists who had exhibited at the Exposition Universelle in 1855, when names including Corot's

were put to the vote, but Corot failed to obtain a majority and win a medal. "That's impossible, my friend Corot," the landscape painter François Français, another member of the committee, protested, "it's unforgivable!" "Not so loud, Monsieur Français," Delacroix retorted. "Corot received only two votes, that of Dauzats and mine, therefore you did not vote for him." "It's a mistake," cried Français, "they must have mistaken 'Corot' for 'Court' on my ballot paper." Delacroix shrugged his shoulders and turned his back on him.

Although Delacroix had a wide circle of eminent friends and acquaintants in government, in the civil service, in the liberal professions, and in the arts, the enduring friendships that he formed in his youth were with men who almost without exception measured out their lives as minor functionaries: Achille Piron, Jean-Baptiste Pierret, Charles Soulier, Félix Guillemardet. Yet, as his fame grew, he remained devoted to them despite the ever-widening gap between his destiny and theirs; and Léon Riesener, his cousin and a secondary painter who must be counted among them, reports that, loving them as they were, he was extremely indulgent of their failings. Some of them were not always so tolerant of their distinguished friend's qualities: following a dinner party at Pierret's home in 1853, attended by Riesener among others, Delacroix noted with sorrow their ill-concealed envy: "Nowadays I feel isolated among these old friends! . . . There are any number of things they cannot forgive me—first and foremost the greater advantages that fortune has given me."

Among the celebrities of his day, Delacroix enjoyed the company of Alexandre Dumas, with some reservation, and of George Sand, but there was only one contemporary artist for whom he felt unqualified affection and respect, and that was Chopin.

Though an orphan by the age of sixteen and having very few immediate relatives, with whom, moreover, he had almost nothing in common except ties of blood, Delacroix had a very French sense of family. His patient and respectful attention to the constant, often petty demands of his sister, Henriette de Verninac, eighteen years his senior, at a time when he was struggling to establish himself, is as noteworthy as his fond tutelage of her son, Charles, who was only five years younger than he. Also touching is his solicitude for his worthy but perhaps somewhat gross elder brother Charles, a retired general of the Empire (his second brother had fallen at the Battle of Friedland). One by one he was deprived of these members of his family: his sister died in 1827; his nephew, most tragically, of yellow fever in New York in 1834; and his brother in 1845. In his later years, feeling an ever greater sense of solitude, he cherished his ties with more distant relatives, with his cousins on his father's side, the cultivated and eminent lawyer Pierre-Antoine Berryer and Commander Philogène Delacroix, both of whom had country properties that he enjoyed visiting and sketching; and, on his mother's side, Auguste Lamey, a magistrate in Strasbourg.

Delacroix never married and raised a family of his own, fearing the curtailment of his activity as an artist and that he would make an unhappy woman of his wife. His decision to resist marital ties may well have been influenced by the sort of arguments against them that are expounded by Pierre Charron (1541–1603) in *De*

la sagesse. In the chapter on marriage, which is listed by Delacroix among previously unpublished notes that he wrote at the age of thirty in a sketchbook now in the Metropolitan Museum (no. 72), the author discourses on the various objections to matrimony, including that which sees it as a corruption of good and rare minds, entailing diversions which dilute and soften the vigor of the most vital and noble men, witness Samson, Solomon, Mark Antony. Marriage is all very well for those who have more brawn than brain, the argument goes, but for those who are weak in body and mentally strong, is it not a great shame to confine them in wedlock, to bind them to the flesh, as beasts are tethered in their stalls? Utility may be on the side of marriage, but probity, according to this view, is on the other side. Before advancing the arguments in favor of marriage, Charron bolsters the case against it by citing a wise man's opinion that if men could do without women they would be attended by angels. But Delacroix, though disinclined to marry, would not have wished to qualify for that celestial reward, for he adored women and his gallantry is well attested by his contemporaries as well as by his own writings —from the billet-doux composed in tortured English for Elisabeth Salter, the domestic servant living under the same roof as he in 1817: "Oh my lips are arid, since had been cooled so deliciously. . . . My whisker not sting more"; to the less urgent assurance addressed in 1850 to his mistress of many years' standing, the aristocratic Joséphine de Forget: "I send you in my thoughts all the violets I find in the woods." He did not, however, regret the decline of physical passion with advancing years, but looked upon it, rather, as a deliverance, and certainly endorsed a remark of Sophocles that he copied into the *Journal* at the age of fifty-four: asked whether, in his old age, he regretted the pleasures of love, the sage replied: "Love? I was glad to be rid of it, as of a savage and crazed master."

Léon Riesener notes that Delacroix could be very warm-hearted toward members of the working class and treated them as true equals if he found them intelligent and staunch. "What attracted him," Riesener explains, "was natural intelligence and genuine kindness. Intellect was not enough." No better illustration of this quality could be found than his relationship with Jenny Le Guillou, the housekeeper who served him faithfully for some twenty-eight years and nursed him in his final hours. This unlettered Breton peasant was probably the woman to whom he was most attached in his late years and the one he most feared losing.

While Delacroix may have been charmed by the occasional gamekeeper, gardener, coal-man, or chambermaid and been sincerely fraternal in his dealings with them, or in Jenny's case shown himself capable of a deep and abiding affection, he was by no means an admirer of plebeians as a whole, nor a believer in political doctrines that equated progress with their advancement. Despite his *Liberty Leading the People,* which has served later generations as a clarion call to the barricades, he viewed revolution as a destructive rather than a progressive force. "I have never loved the crowd, nor all that the crowd feeds on," he wrote when only twenty. "A hater of the mob, he regarded them as little more than destroyers of images," says Baudelaire, who also observes that when confronted with the "great chimera of modern times," the idea of the perfectibility and indefinite progress of society, he would ask: "Where are your Phidiases? Where your Raphaels?"

Of the French Revolution itself, Delacroix wrote: "The Revolution completed the process of binding us to the yoke of self-interest and physical pleasure. It abolished every kind of belief: in place of that support in a supernatural power that a creature as weak as man naturally seeks, it presented him with abstract words: reason, justice, equality, rights. A band of brigands can as well rule itself on the basis of those words as a society organized according to moral principles. They have nothing in common with goodness, tenderness, charity, or devotion."

It would not be true, however, to say that Delacroix, the son of a *Conventionnel,* was not republican in his sympathies, but he thought a republic was best ruled by a patrician *élite.* "The most celebrated republics were governed by an aristocracy," he wrote in 1854, "provided that a nobleman is intelligent he will understand his country's interests as well as the man in the street, but whereas the latter is a member of no particular body, the nobleman is what he is only by virtue of tradition and an instinct for conservation, which renders his country all the more dear to him because he is placed at its head by the very institutions which he is called upon to defend. Venice, Rome, England, etc., are good examples." Commenting on the British government while on a visit to London in 1825, he declared: "Liberty, here, is not an empty word. Aristocratic pride and class distinctions are carried to a point that I find infinitely shocking; but these have certain good results."

Delacroix did not believe that improving the material welfare of the masses would in any essential way alleviate the irremediable suffering of mankind. He saw resignation, as taught by Jesus Christ and Marcus Aurelius, as the only palliative, the highest wisdom; and art, a personal consolation to him and a civilizing force, as a fragile veil drawn over the "terrible emptiness in the soul of man." His deeply pessimistic view of the human condition is, of course, reflected in his art, but not so pervasively as Baudelaire, in his spleenish way and followed by latter-day votaries of the Romantic agony, would lead us to believe, with his now overfamiliar description of it as a "fearful hymn composed in honor of calamity and irremediable pain." The author of the *Fleurs du mal* underestimates the hymns to life and energy, the lyrical and serene or just tranquilly exotic elements in Delacroix's *œuvre.* Few works from the large body of paintings, drawings, and watercolors inspired by the North African journey, for example, can be said to fall into Baudelaire's dolorous category.

If Delacroix was out of sympathy with the political ideologies of his day, he was also critical of most modern developments in literature and music, though he followed them avidly and with discernment. In keeping with his conviction that he was living in an age of decadence for the arts, he generally preferred artists of the past to his contemporaries: Dante to Hugo, Shakespeare and Racine to Dumas, Molière and Voltaire to Balzac, Mozart, his favorite composer, to Beethoven, Verdi, or Berlioz. Chopin, who with Rossini was the contemporary musician whose work he most enjoyed, says that he knew all Mozart's operas by heart. In literature and drama Delacroix admired clarity, concision, form, truth to nature conveyed in fresh, pithy, and simple terms. He expressed one of his fundamental beliefs in the phrase "A handful of *naïve inspiration* is preferable to everything else." Mere virtuosity in any of the arts displeased him. His principal objections to contemporary

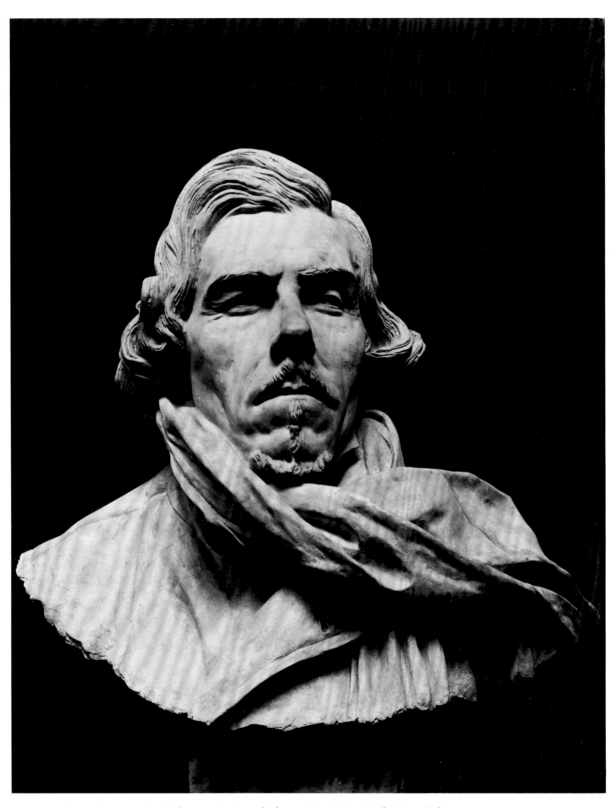

A.-J. Dalou. *Eugène Delacroix*. Patinated plaster. Paris, Musée du Petit Palais

literature were the excessively detailed description of the physical appearance of characters and their surroundings, and the artificial, high-flown expression of human feelings affected by the French Romantics. Yet Delacroix was an *enfant du siècle* and inevitably influenced by much of the literature of his day. He may have found Byron's heroes to be "braggarts" and Walter Scott "long-winded," but he owed many of his subjects to them, and it cannot be said that his treatment of those themes and others was always entirely free from the overblown expression and hyperbolic emotion that he complained of in contemporary men of letters.

Delacroix was an *enfant du siècle,* too, in his belief that he was a persecuted genius. While there can be no doubt that in certain respects his grievance was well founded and in contrast to a popular artist such as Horace Vernet or Paul Delaroche he never made more than a comfortable living from his art, it must be said that from the beginning of his career to the end he received official encouragement and support from State and City. In the 1820s his first two major Salon paintings, *The Barque of Dante* and the *Scenes from the Chios Massacres,* were purchased by the State for the Musée du Luxembourg, and he received commissions for paintings to be placed in a Paris church and in the Conseil d'État, as well as patronage from the Royal Family. From the July Monarchy on, his more important Salon paintings were regularly purchased by the State and he was awarded a series of major commissions for mural paintings to decorate public buildings in Paris, both secular and religious, in addition to commissions for large canvases to hang in the historical galleries at Versailles. As for worldly success, he was made an Officer of the Legion of Honor in 1846, a Commander of the same order in 1855. Under the Second Empire he was appointed to the Municipal Council of Paris by Baron Haussmann and served for ten years, taking his duties very seriously and using his influence, as far as he could, to further the cause of art and artists.

He did not lack, then, a very fair measure of official recognition. Where he did have legitimate cause for complaint was in the persistent mauling he received at the hands of certain critics, but even some of those who were the most rigidly committed to the cause of classicism, such as Delécluze, could occasionally pay him a compliment. He was as deeply resentful of inept and malevolent criticism as he was responsive to informed, heartfelt praise. Silvestre says his face would light up if he was paid a perceptive and sincere compliment on one of his pictures, but he was glacial with flatterers.

Above all, Delacroix had good reason to feel that the academic establishment, fearing the influence of his artistically liberal ideas and the very magnitude of his creative talent, discriminated against him. Seven times between 1837 and 1856 he applied for admission to the Academy of Fine Arts, a section of the Institut. On two occasions, in 1838 and 1851, he received no votes at all. He was elected a member of the Royal Academy in Amsterdam three years before he received the equivalent honor in his own country. When he was finally elected to the French Academy in January 1857, it was too late for him to exert any influence as a teacher at the École des Beaux-Arts, a function reserved for academicians. It was then that, with a view to disseminating his ideas, he began to draft entries for a Dictionary of the Fine Arts, a project which was never completed but is copiously represented in

the *Journal* under a variety of Delacroix's own rubrics. The artists who won the places he had applied for were Schnetz, Langlois, Couder, Cogniet, Alaux, Flandrin. (He withdrew a second application in the single year 1849, following Cogniet's election, and Robert-Fleury was given the seat.) Well might he have felt disgusted at the reports of intrigue to exclude him that reached his ears! The names of the artists who were elected instead of him are scarcely familiar today, even to specialists; none was an artist of the first rank, and surely none could, in the light of Delacroix's achievement, have seemed so to impartial observers of the time. Reflecting on this string of defeats, Delacroix must have found at least one point of communion with his fellow genius Balzac. He was not much taken by Balzac as a person, nor by his novels, from which, however, he copied long passages, recognizing some pearls of wisdom among the dross of realism and the depiction of low life that he deplored. With none can he have felt more empathy than with this extract, taken in 1850 from *La dernière incarnation de Vautrin:* "Power can only prove its strength to itself through the singular abuse of crowning some nonentity with the palms of success, and thus insulting genius, the one force that absolute power cannot touch."

This essay, *Portrait of Delacroix*, is reprinted, except for the addition of the passage on Pierre Charron, some minor amendments, and the deletion of footnotes, from Lee Johnson: *The Paintings of Eugène Delacroix: A Critical Catalogue. 1832–1863 (Movable Pictures and Private Decorations)*, vol. III (Clarendon Press, Oxford, 1986), where full references to all the quotations can be found.

COLORPLATES

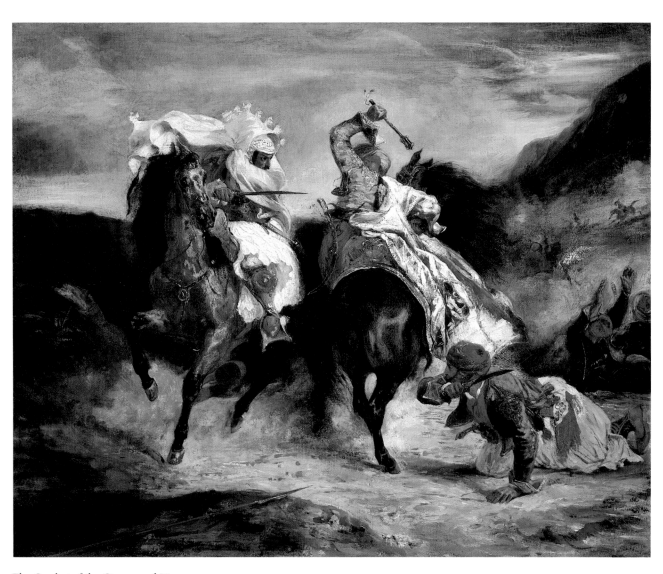

The Combat of the Giaour and Hassan
The Art Institute of Chicago (no. 2)

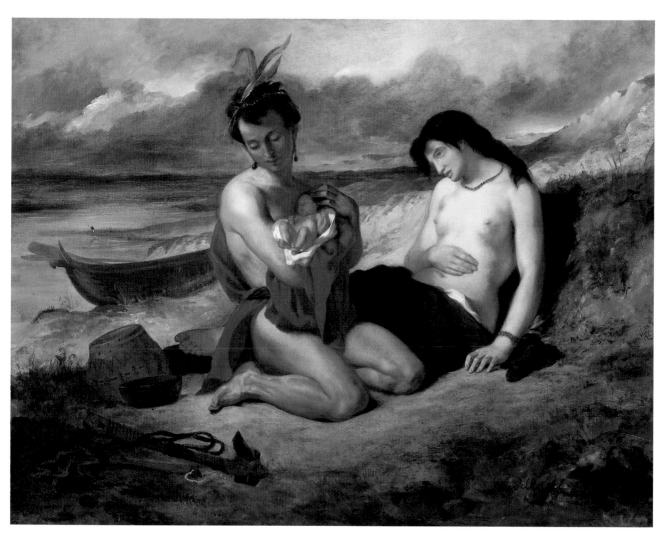

The Natchez
New York, The Metropolitan Museum of Art (no. 3)

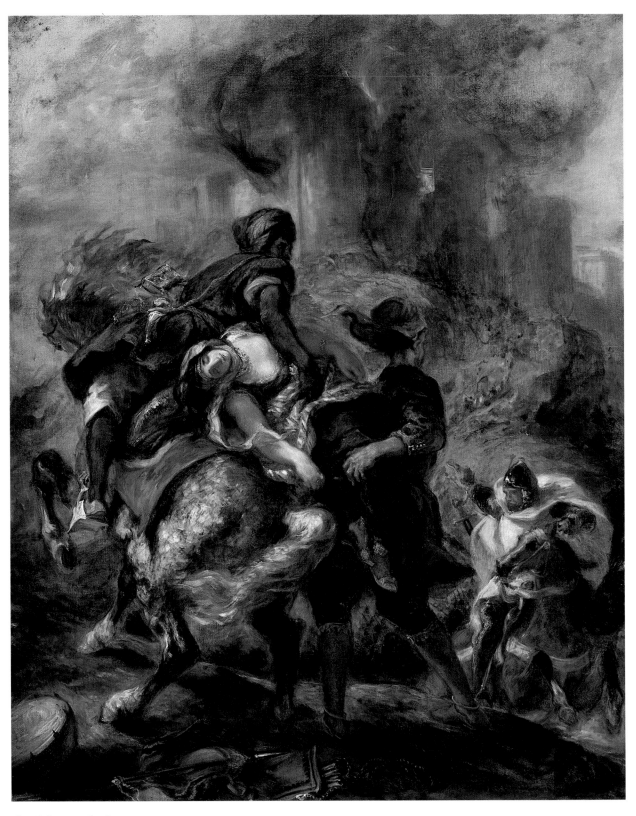

The Abduction of Rebecca
New York, The Metropolitan Museum of Art (no. 5)

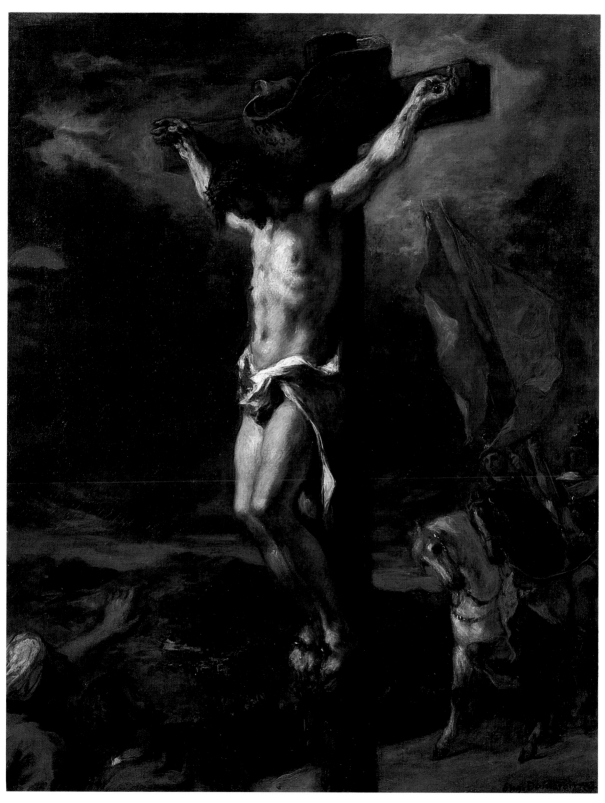

Christ on the Cross
Baltimore, Walters Art Gallery (no. 6)

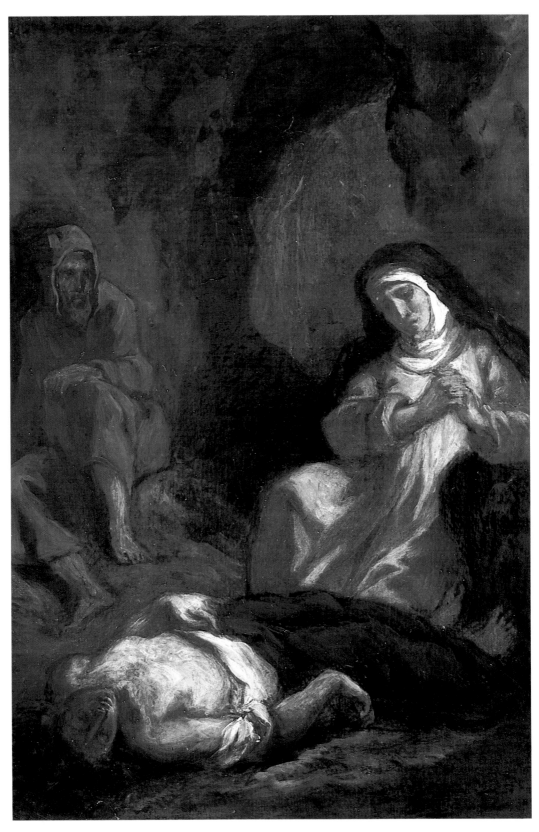

Lélia Mourns over Sténio's Body
Karen B. Cohen (no. 7)

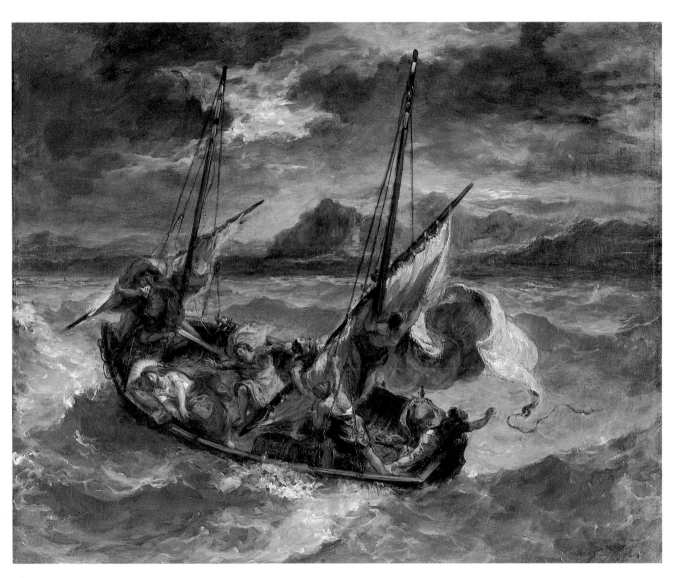

Christ and His Disciples Crossing the Sea of Galilee
Baltimore, Walters Art Gallery (no. 10)

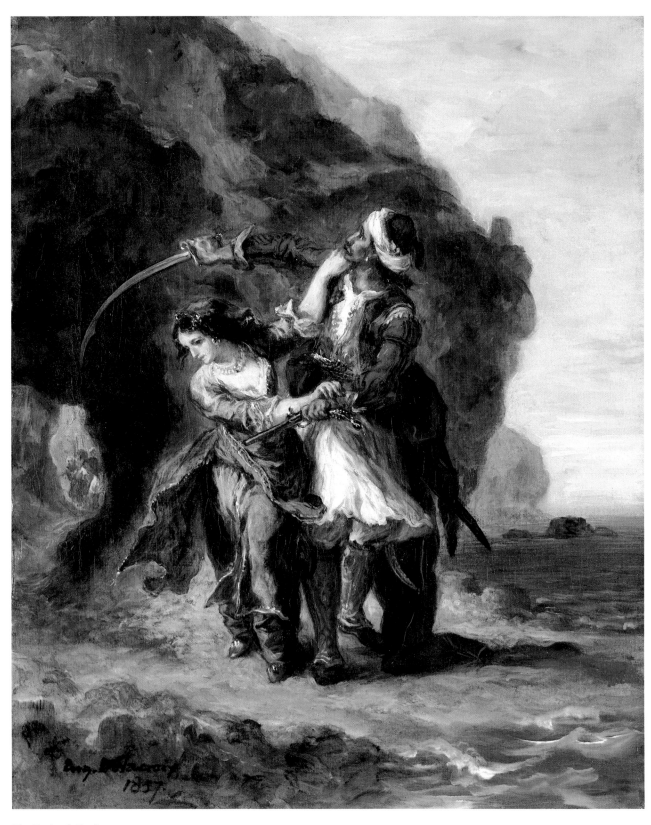

The Bride of Abydos
Fort Worth, Kimbell Art Museum (no. 12)

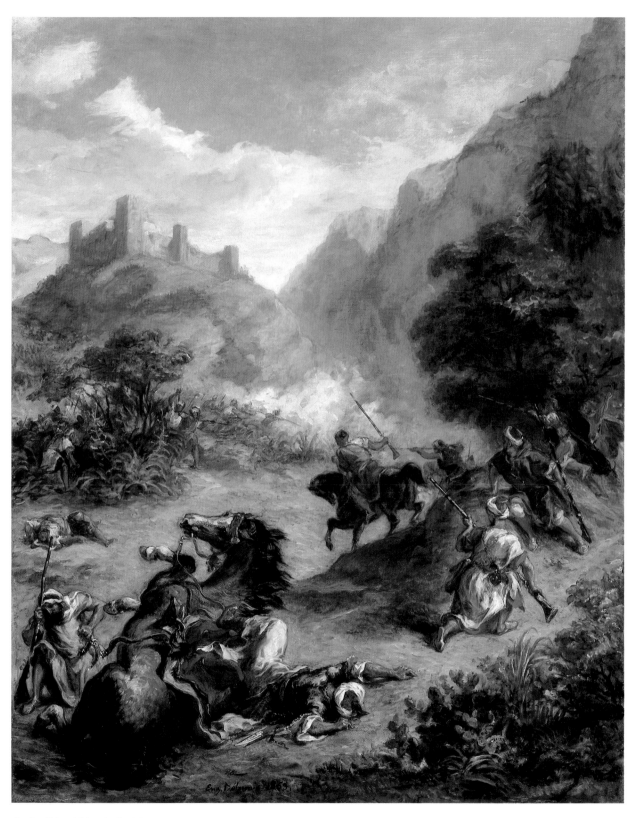

Arabs Skirmishing in the Mountains
Washington, D.C., National Gallery of Art (no. 14)

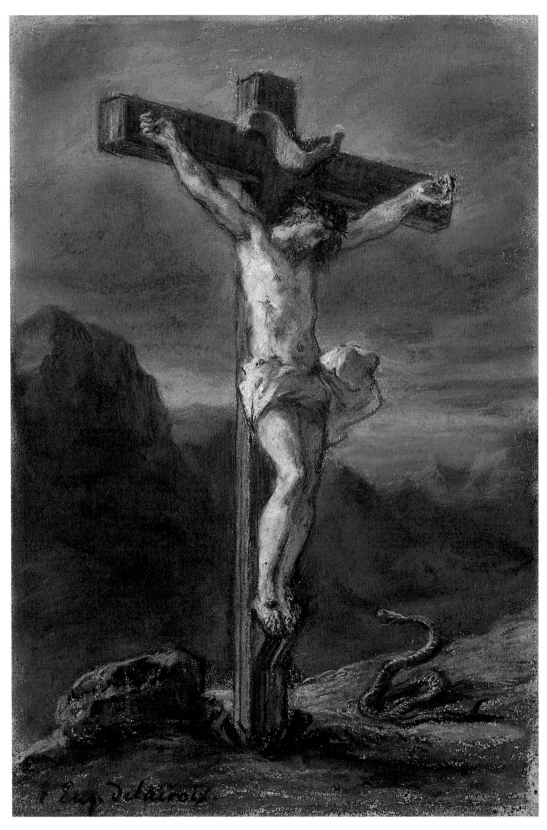

Christ on the Cross
Ottawa, National Gallery of Canada (no. 15)

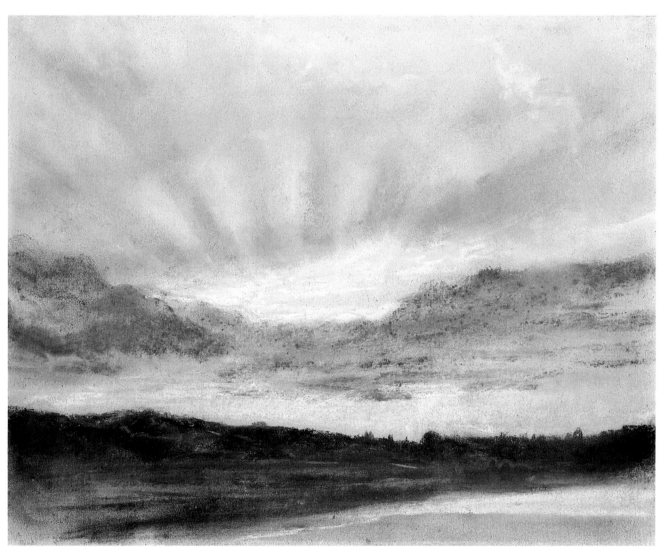

Sunset
Karen B. Cohen (no. 16)

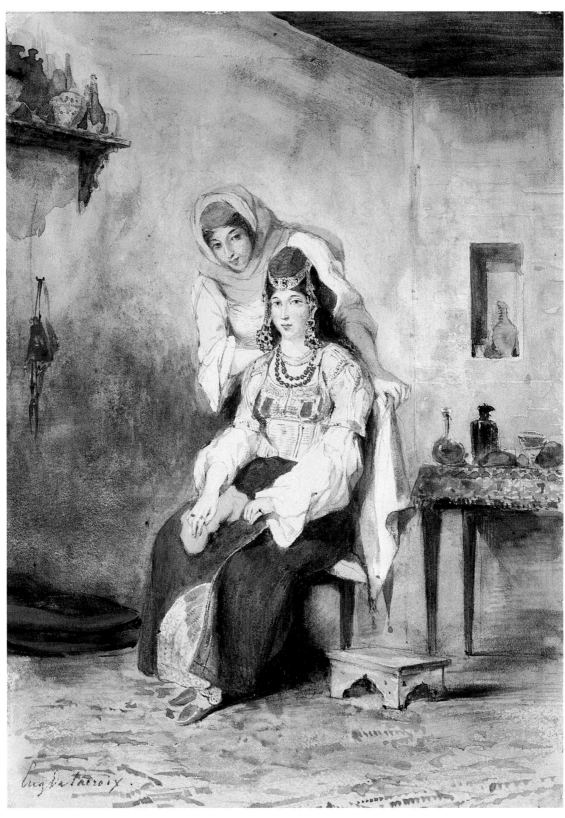

The Wife of Abraham Benchimol and One of Their Daughters
New York, The Metropolitan Museum of Art (no. 27)

54

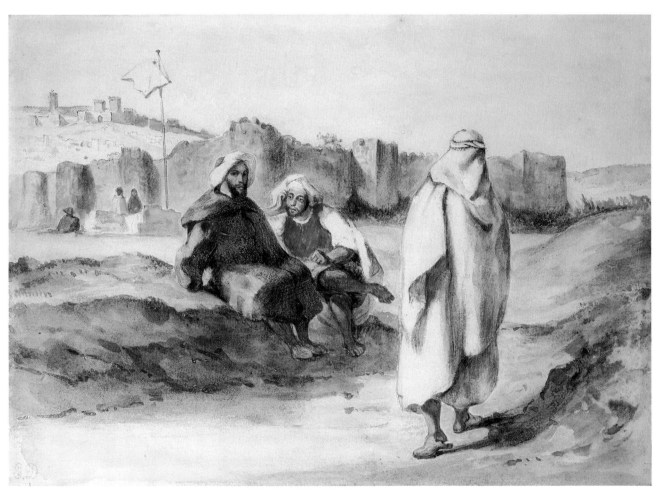

Moroccans Outside the Walls of Tangier
Mr. and Mrs. Eugene Victor Thaw (no. 30)

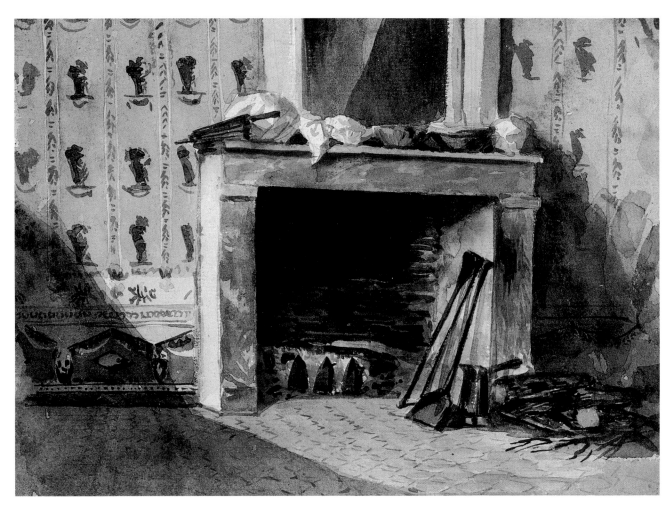

The Fireplace
Philadelphia Museum of Art (no. 64)

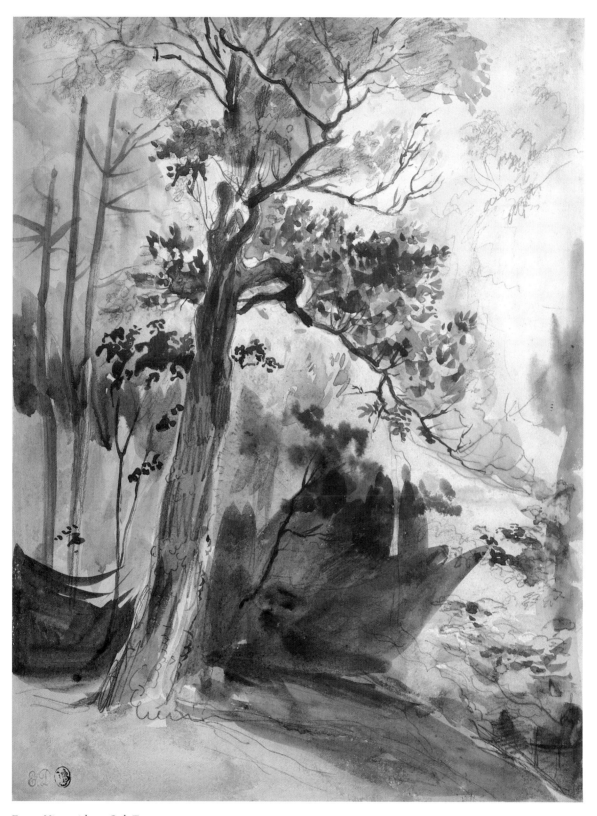

Forest View with an Oak Tree
Mr. and Mrs. Eugene Victor Thaw (no. 68)

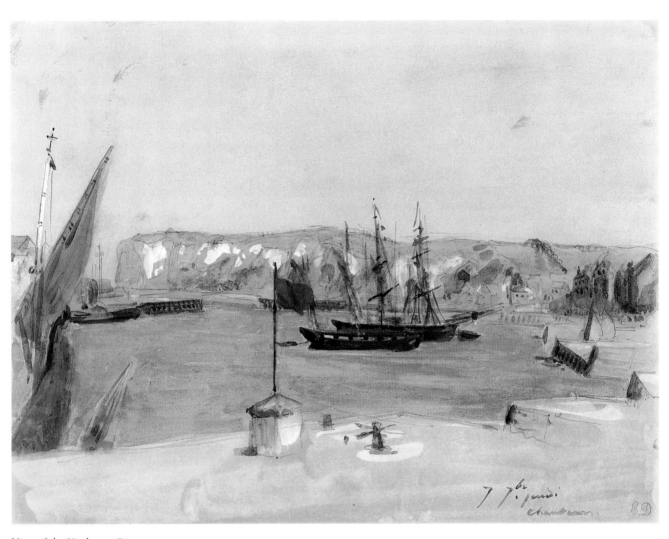

View of the Harbor at Dieppe
New York, The Pierpont Morgan Library (no. 71)

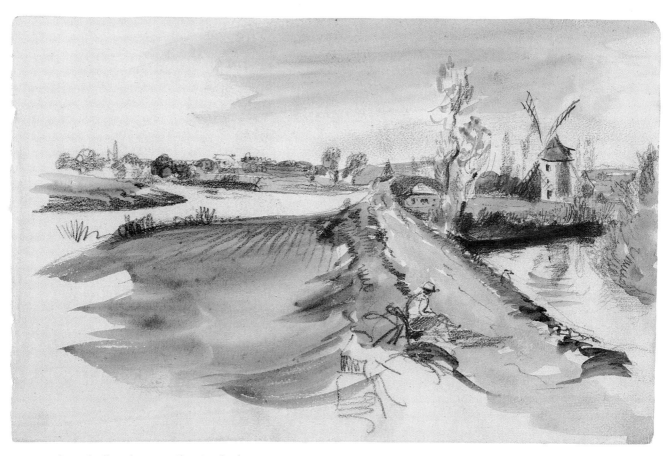

Levee and Windmill on the River Cher, South of Tours
New York, The Metropolitan Museum of Art (no. 72,
Fol. 3 recto)

WORKS EXHIBITED

The brief notices that follow are based, for the paintings, on Lee Johnson's catalogue raisonné. The short entries on the drawings, pastels, and prints have been prepared by Jacob Bean and William Griswold, who acknowledge their debt to Lee Johnson and to Maurice Sérullaz. Jacques Olivier Bouffier, in 1990 a graduate intern from the Institute of Fine Arts, New York University, is responsible for much of the information in nos. 71 and 72. Bibliographical references are limited to the essential publications cited below:

Delteil
 Loys Delteil, *Le peintre-graveur illustré (XIX^e et XX^e siècles). Tome troisième. Ingres et Delacroix,* Paris, 1908.

Escholier
 Raymond Escholier, *Delacroix, peintre, graveur, écrivain,* 3 vols., Paris, 1926–1929.

Johnson
 Lee Johnson, *The Paintings of Eugène Delacroix. A Critical Catalogue,* 6 vols., Oxford, 1981–1989.

Lugt
 Frits Lugt, *Les marques de collections de dessins et d'estampes . . .,* Amsterdam, 1921.

Lugt Supp.
 Frits Lugt, *Les marques de collections de dessins et d'estampes . . . Supplément,* The Hague, 1956.

Paris, 1930
 Exposition Eugène Delacroix. Peintures, aquarelles, pastels, dessins, gravures, documents, Palais du Louvre, Paris, 1930.

Robaut
 Alfred Robaut, *L'œuvre complet d'Eugène Delacroix,* Paris, 1885.

Sérullaz, 1963
 Maurice Sérullaz, *Mémorial de l'exposition Eugène Delacroix organisée au Musée du Louvre à l'occasion du centenaire de la mort de l'artiste,* Paris, 1963.

Sérullaz, 1984
 Maurice Sérullaz, with the collaboration of Arlette Sérullaz, Louis-Antoine Prat, and Claudine Ganeval, *Musée du Louvre. Cabinet des Dessins. Inventaire général des dessins. École française. Dessins d'Eugène Delacroix,* 2 vols., Paris, 1984.

PAINTINGS

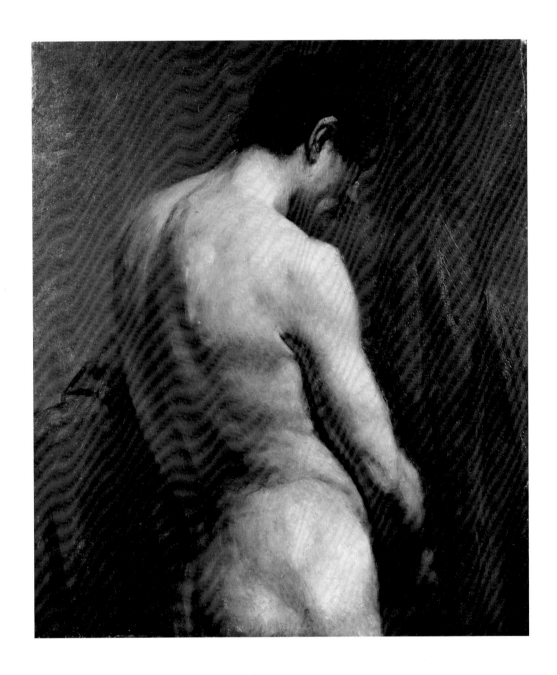

1. MALE ACADEMY FIGURE:
HALF-LENGTH, SIDE VIEW

Oil on paper, laid down on panel
15¾ x 13⅜ in. (40 x 34 cm.)

BIBLIOGRAPHY: Robaut, part of no. 1470; Johnson, no. 1.

Karen B. Cohen

This study after the nude model is given an early date, 1818–1820, by Lee Johnson; it was probably executed by Delacroix in the studio of his master Pierre-Narcisse Guérin.

2. THE COMBAT OF THE GIAOUR AND HASSAN

Oil on canvas
23½ x 28⅞ in. (59.6 x 73.4 cm.)
Signed at lower left, *Eug. Delacroix.*

BIBLIOGRAPHY: Robaut, no. 202; Johnson, no. 114.

The Art Institute of Chicago
Gift of Mrs. Bertha Palmer Thorne, Mrs. Rose Movius
Palmer, Mr. and Mrs. Arthur M. Wood, and Mr. and Mrs.
Gordon Palmer
1962.966

This painting, which dates from 1826, illustrates a scene from Byron's poem *The Giaour, a Fragment of a Turkish Tale,* first published in 1813. The setting is Greece in the late seventeenth century; the hero is a Venetian warrior known only by the name of Giaour, a term of reproach applied by Turks to non-Mussulmans, especially Christians. Leila, a slave who had fled Hassan's harem to become the Giaour's mistress, had been thrown (in the Muslim manner) into the sea for infidelity and is about to be avenged by her lover. With a band of followers, "now array'd in Arnaut garb," he has ambushed Hassan and his escort in a craggy defile. Engaging Hassan in single combat, he kills him.

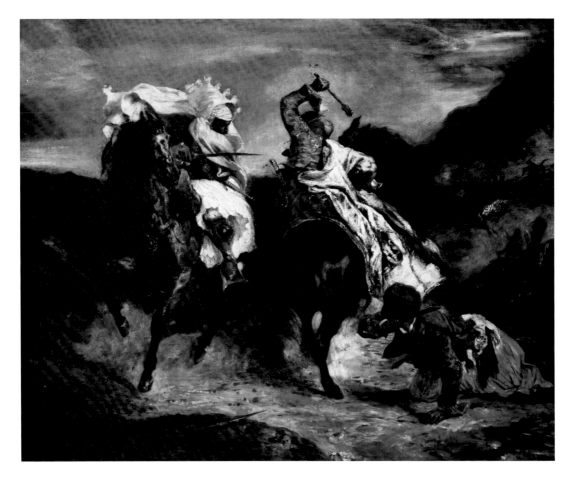

3. THE NATCHEZ

Oil on canvas
35½ x 46 in. (90.2 x 116.8 cm.)
Signed at lower right, *Eug. Delacroix.*

BIBLIOGRAPHY: Robaut, no. 108; Sérullaz, 1963, no. 217;
Johnson, no. 101; Gary Tinterow, *The Metropolitan Museum
of Art Bulletin,* Fall, 1990, pp. 41–42.

The Metropolitan Museum of Art
Purchase, Gifts of George N. and Helen M. Richard and Mr.
and Mrs. Charles S. McVeigh, by exchange, and The Lesley
and Emma Sheafer Collection, Bequest of Emma A. Sheafer,
by exchange, 1989
1989.328

Delacroix had decided on the subject of this painting as early as October 1822, but it was not finished until 1835, and was shown at the Salon of that year.

According to the Salon *livret,* the scene represented is from the Epilogue to Chateaubriand's *Atala:* "Fleeing from the massacre of their tribe, two young savages travel up the Mississippi River. During the voyage, the young woman suffers labor pains. The moment shown is that when the father holds their newborn son in his arms, and both regard him tenderly."

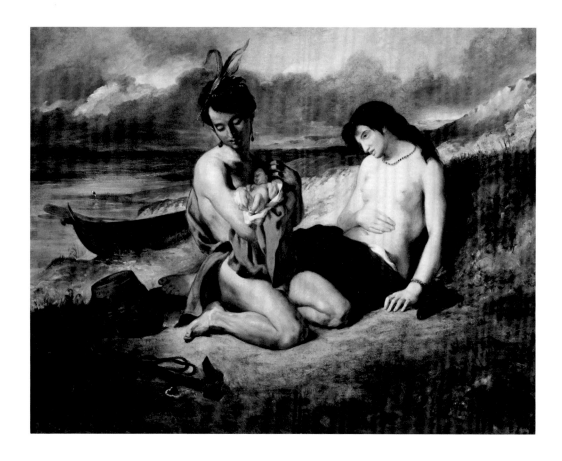

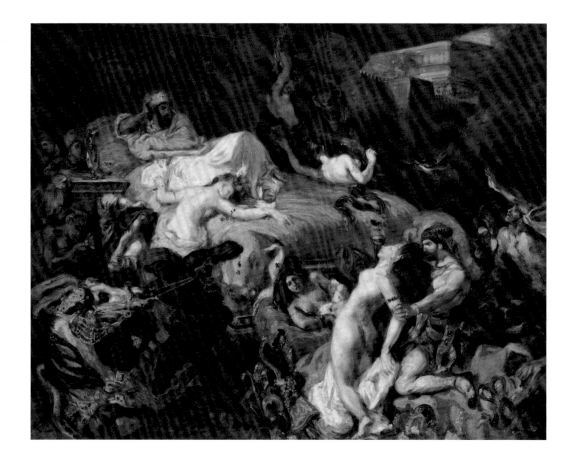

4. THE DEATH OF SARDANAPALUS

Oil on canvas
28¹³⁄₁₆ x 36½ in. (73.2 x 92.7 cm.)

BIBLIOGRAPHY: Robaut, no. 791; Johnson, no. 286.

Philadelphia Museum of Art
The Henry P. McIlhenny Collection in memory of
Frances P. McIlhenny

Sardanapalus, besieged by his rebellious subjects in his palace at Nineveh, lies on a huge bed at the top of a funeral pyre. Rather than fall captive with his retinue, he has ordered all his women and horses to be slaughtered, all his treasures to be heaped on the pile and burnt with him. Byron's play *Sardanapalus,* published in 1821, apparently provided the initial stimulus for the painting, although the play ends with Sardanapalus seated alone on a pyre that is fired by Myrrha, his favorite concubine, as the curtain falls; there is no suggestion of a preliminary massacre.

The Death of Sardanapalus is the subject of the very large painting by Delacroix shown in the Salon of 1827–1828 and now in the Musée du Louvre (Johnson, no. 125). The present picture is a small autograph replica of the Louvre painting. It was probably executed shortly before Delacroix sold the large canvas, in 1846, as a kind of substitute and reminder of the famous early work he was about to relinquish.

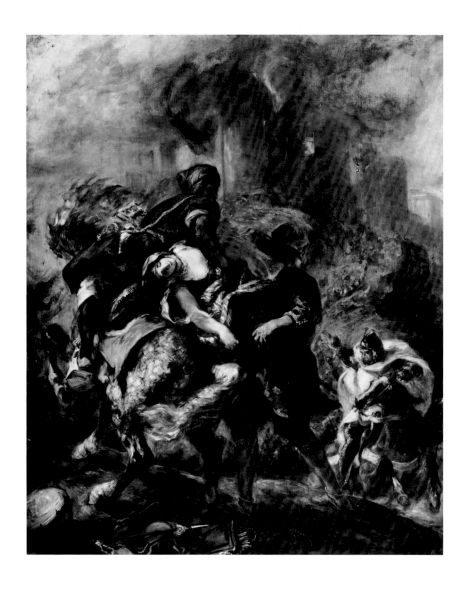

5. THE ABDUCTION OF REBECCA

Oil on canvas
39⅜ x 32¼ in. (100 x 82 cm.)
Signed and dated at lower right, *Eug. Delacroix / 1846.*

BIBLIOGRAPHY: Robaut, no. 974; Johnson, no. 284.

The scene is inspired by chapter 32 of Walter Scott's *Ivanhoe*. Front-de-Boeuf's castle has been sacked by the Black Knight (Richard I) with Locksley's (Robin Hood's) men. Rebecca has been abducted from the castle on the orders of the Templar Bois-Guilbert, who has long lusted after her; she is in the process of being placed on horseback before one of the Templar's Saracen slaves. Bois-Guilbert is on horseback on the right.

6.　CHRIST ON THE CROSS

Oil on canvas
31½ x 25¼ in. (80 x 64.2 cm.)
Signed and dated at lower right, *Eug. Delacroix 1846.*

BIBLIOGRAPHY: Robaut, no. 986; Sérullaz, 1963, no. 360;
Johnson, no. 433.

Walters Art Gallery, Baltimore

Signed and dated 1846, this painting was accepted for the Salon of 1847. It has rightly
been judged to be the finest of the several versions of the subject painted by Delacroix
between 1846 and the end of his life.

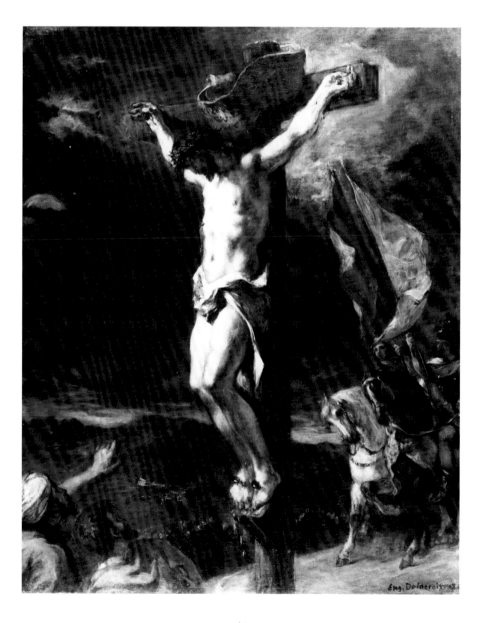

7. LÉLIA MOURNS OVER STÉNIO'S BODY

Oil on canvas
8¹¹⁄₁₆ x 6⅛ in. (22 x 15.5 cm.)

BIBLIOGRAPHY: Robaut, no. 1032; Sérullaz, 1963, no. 393;
Johnson, no. 289.

Karen B. Cohen

The scene is taken from the 1839 edition of George Sand's novel *Lélia* (chapter 64; the heroine does not enter a convent in the first, 1833, edition). Following her disillusionment with the poet Sténio when he makes love to her sister, a courtesan, Lélia enters a Camaldulensian convent and becomes Abbess. After a period of dissipation Sténio meets her in the convent and, being told that she does not love him, drowns himself. Lélia, "la digne fiancée d'un cadavre," declares her love to his corpse, while the monk Magnus looks on. In the first edition, Magnus goes mad and strangles her with his rosary; in the 1839 edition, she dies a natural death.

 This is the smaller of two versions of the subject that Delacroix is recorded as having painted before 1855, the larger of which he sent to George Sand in 1852 (Johnson, no. 310; present whereabouts unknown).

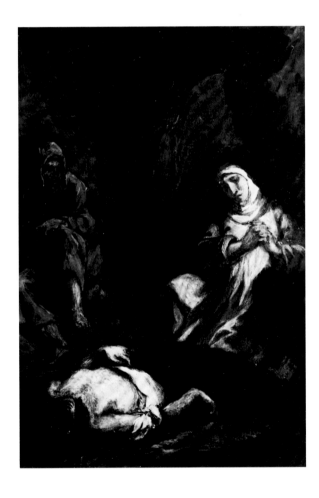

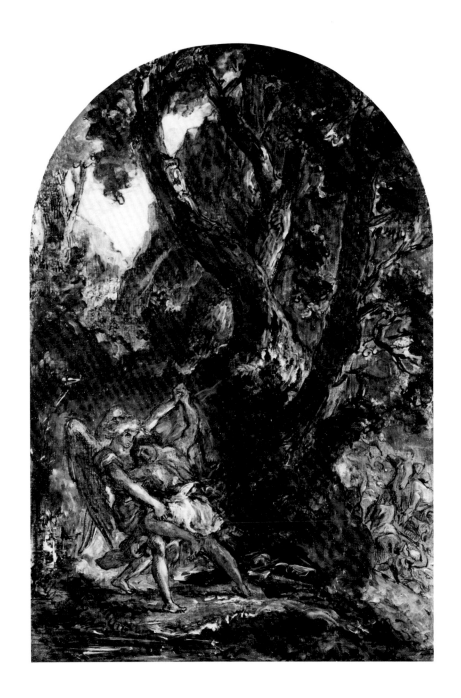

8. JACOB WRESTLING WITH THE ANGEL

Oil paint on paper, laid down on canvas
22¼ x 16 in. (56.5 x 40.6 cm.)

BIBLIOGRAPHY: Johnson, no. 595.

Karen B. Cohen

This oil sketch, datable to 1850, is a study for one of the two large wall paintings in the
chapel of the Holy Angels in the church of Saint-Sulpice, Paris (Johnson, no. 602).

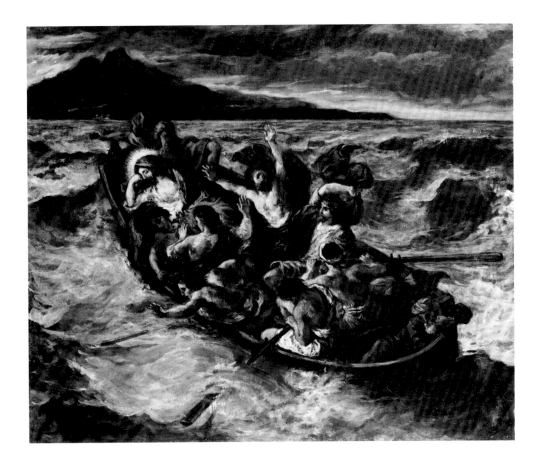

9. CHRIST AND HIS DISCIPLES CROSSING THE SEA OF GALILEE

Oil on canvas
20 x 24 in. (50.8 x 61 cm.)
Signed at lower left, *Eug. Delacroix.*

BIBLIOGRAPHY: Robaut, no. 1215; Johnson, no. 454.

The Metropolitan Museum of Art
Bequest of Mrs. H. O. Havemeyer, 1929
H. O. Havemeyer Collection
29.100.131

The Gospels of Matthew, Mark, and Luke tell in similar texts how in crossing the Sea of Galilee Jesus fell asleep undisturbed by a storm that filled the boat with water. When the frightened Disciples wakened him, He miraculously quieted the elements and rebuked His followers for their lack of faith. The Evangelist Mark specified that Christ slept on a cushion in the stern of the boat, as He does here.

Three other painted versions of the subject share this feature, where Christ sleeps in the stern of a rowboat. These paintings are in the Nelson-Atkins Museum of Art, Kansas City, Missouri (Johnson, no. 451), the Portland Art Museum, Oregon (Johnson, no. 452), and in the collection of Peter Nathan, Zurich (Johnson, no. 453).

10. CHRIST AND HIS DISCIPLES CROSSING THE SEA OF GALILEE

Oil on canvas
23½ x 28⅞ in. (59.8 x 73.3 cm.)
Signed and dated at lower right, *Eug. Delacroix / 1854.*

BIBLIOGRAPHY: Robaut, no. 1214; Sérullaz, 1963, no. 450;
Johnson, no. 456.

Walters Art Gallery, Baltimore

This is the most complex and dramatic of all Delacroix's paintings of this subject. The boat has become a sailing vessel, and Jesus sleeps near the prow. These features characterize another version in the Emil Bührle Foundation, Zurich, that is dated 1853 (Johnson, no. 455).

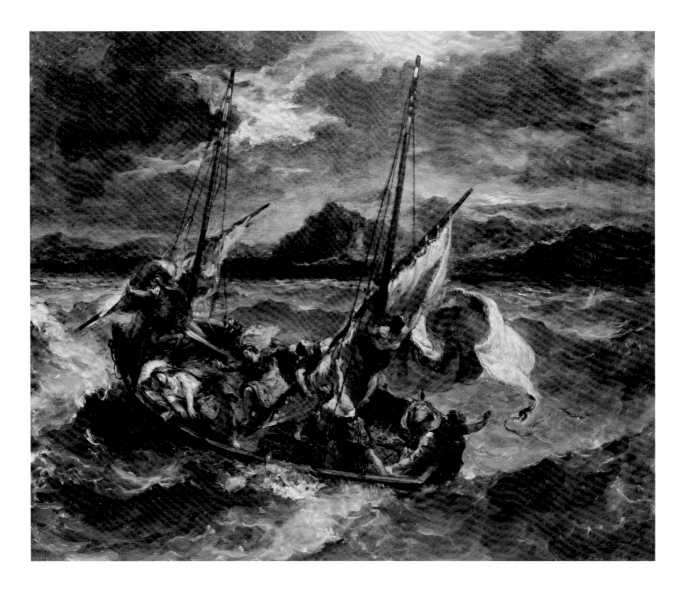

11. HILLY LANDSCAPE

Oil paint on paper, laid down on canvas
7⁷⁄₁₆ x 11⅛ in. (18.9 x 28.3 cm.)

BIBLIOGRAPHY: Johnson, no. 484a.

Karen B. Cohen

Landscape of a similar character to that seen in this rapidly brushed study is to be found
in drawings that Delacroix made near Brive in Corrèze and at Baden-Baden in September
1855; this sketch may date from the same period.

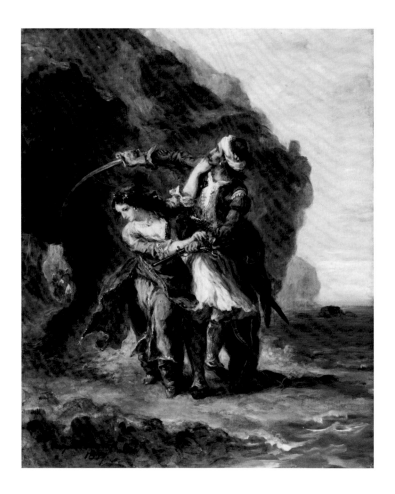

12.　THE BRIDE OF ABYDOS

Oil on canvas
18½ x 14¹⁵⁄₁₆ in. (47 x 38 cm.)
Signed and dated at lower left,
Eug. Delacroix / 1857.

BIBLIOGRAPHY: Johnson, no. 325.

Kimbell Art Museum, Fort Worth

The painting illustrates the climax of Byron's *Bride of Abydos.* Zuleika, daughter of the elderly Pasha Giaffir, who wishes her to marry an aging Bey instead of Selim, with whom she has been brought up and whom she loves, has stolen away from the harem tower with Selim and fled to a grotto by the sea. There, Selim reveals that he is the leader of a band of pirates, who are within hailing distance offshore. As Giaffir and his men, armed and bearing torches, approach in hot pursuit, the hero fires his pistol to summon his comrades, but before they can rescue him he is shot dead by Giaffir and Zuleika dies of grief.

　　This is the last and most perfectly resolved of the four versions of this subject painted by Delacroix. The three earlier paintings are at King's College, Cambridge (Johnson, no. 297), in the Musée des Beaux-Arts, Lyon (Johnson, no. 300), and in the Musée du Louvre, Paris (Johnson, no. 311).

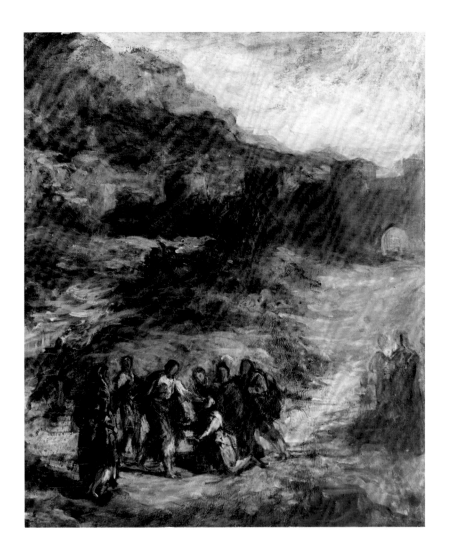

13. CHRIST HEALING THE BLIND MEN AT JERICHO

Oil on canvas
18½ x 15³⁄₁₆ in. (47 x 38.5 cm.)

BIBLIOGRAPHY: Johnson, no. 473a.

Karen B. Cohen

This late work, which illustrates Matthew 21 : 29–34, is a variation on Poussin's *Blind Men of Jericho* in the Louvre, from which Delacroix, in about 1820, had made a drawing of the blind man touched by Christ (Sérullaz, 1984, no. 1745, fol. 48v). While owing much to Poussin's grouping, reversed, Delacroix modifies it by showing the second blind man pressing forward on the right of the main group instead of kneeling in tandem behind the man whose sight is being restored. He also replaces the severely geometrical, Italianate landscape with a freely brushed setting reminiscent of North Africa, into which the figures are more atmospherically integrated through color and brushwork.

14. ARABS SKIRMISHING IN THE MOUNTAINS

Oil on canvas
36⅜ x 29⅜ in. (92.4 x 74.6 cm.)
Signed and dated bottom, left of center,
Eug. Delacroix 1863.

BIBLIOGRAPHY: Robaut, no. 1448; Johnson, no. 419.

National Gallery of Art, Washington, D.C.
Chester Dale Fund, 1966

Robaut entitled this painting *La perception de l'impôt arabe*. Though it may well represent a band resisting tax collectors, Delacroix himself called it simply *Combat d'arabes dans les montagnes*. The artist does not record having witnessed such an incident, but he may have imagined it from a conversation he had on March 12, 1832, with Amin Bias, the Moroccan Minister of Foreign Affairs, while crossing the river Sebou en route to Meknes. Bias told him that in order to make it easier to collect taxes and to arrest robbers and the seditious, the Moroccan government did not build bridges.

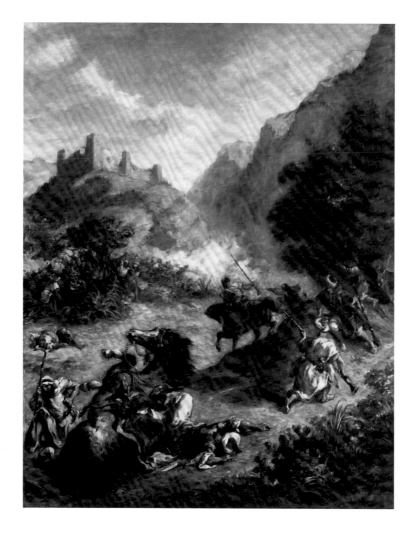

PASTELS AND DRAWINGS

15. CHRIST ON THE CROSS

Pastel, on blue-gray paper
9¾ x 6¹¹⁄₁₆ in. (24.7 x 16.5 cm.)
Signed at lower left, *E Eug. Delacroix.*

BIBLIOGRAPHY: Paris, 1930, no. 752; Mimi Taylor, "Recent
Acquisitions: The National Gallery, Department of Prints
and Drawings," *Artscanada*, 128/129, 1969, pp. 19–20, repr.

National Gallery of Canada, Ottawa

The coiled serpent rearing its head represents Original Sin, over which Christ triumphed
by His death on the Cross.

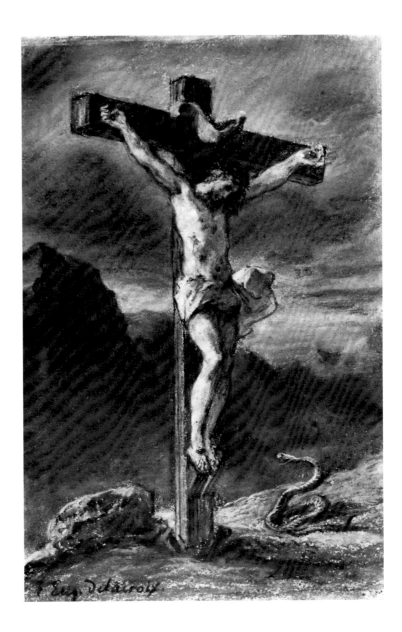

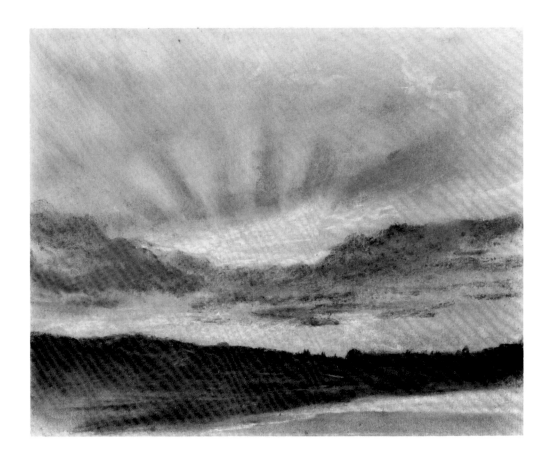

16. SUNSET

Pastel
8³⁄₁₆ x 10¼ in. (20.8 x 26 cm.)

BIBLIOGRAPHY: Paris, 1930, no. 706.

Karen B. Cohen

Delacroix executed a number of pastel studies of skies at sunrise or sunset. These are thought to have been drawn at his country house at Champrosay, south of Paris.

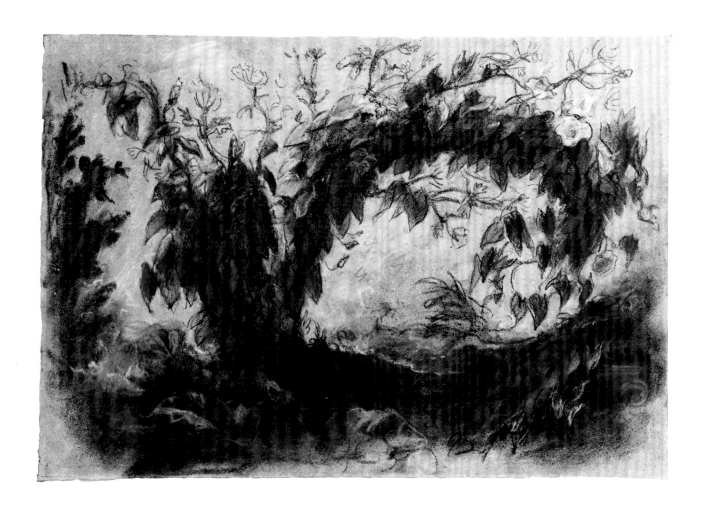

17. ARCH OF MORNING GLORIES

Pastel, on gray paper
12¹/₁₆ x 18 in. (30.6 x 45.7 cm.)

BIBLIOGRAPHY: Robaut, part of no. 1073, repr.; Johnson,
III, pp. 263–264, fig. 57.

The Metropolitan Museum of Art
Bequest of Miss Adelaide Milton de Groot (1876–1967), 1967
67.187.4

This arch of flowers and foliage appears in the painting *A Basket of Flowers Overturned in a Park* (1848–1849), now in The Metropolitan Museum of Art (Johnson, no. 502).

18. NUDE YOUTH REPRESENTED AS A
 WINGED GENIUS

Charcoal and graphite, on beige paper
19⅞ x 16⅞ in. (50.5 x 42.9 cm.)
Mark E.D (Lugt 838)

BIBLIOGRAPHY: Sérullaz, 1984, under no. 260.

Philadelphia Museum of Art
The Henry P. McIlhenny Collection in memory of
Frances P. McIlhenny

This study for a winged genius is tentatively dated by Lee Johnson to 1820–1821. It was probably intended for a never-realized allegorical composition. Other drawings of the same nude figure are in the Musée du Louvre (Sérullaz, 1984, nos. 260, 505, 506).

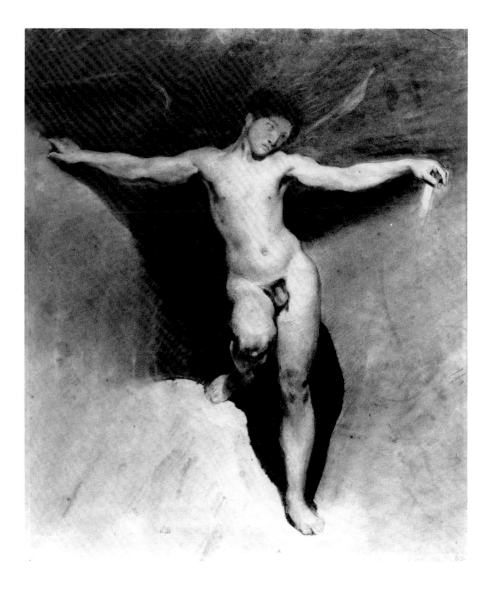

19. SEATED FEMALE NUDE WITH RIGHT
 ARM RAISED
 VERSO. FEMALE NUDE HOLDING A CROSS
 AND A FLAMING HEART

Pen and brown ink (recto);
pen and brown ink, brown wash (verso)
8⅜ x 6⅞ in. (21.3 x 17.5 cm.)
Inscribed in graphite at upper right of verso,
M.^{lle} Caroline/rue des Boucheries/N.° 9.
Mark E.D (Lugt Supp. 838a)

BIBLIOGRAPHY: Johnson, VI, pp. 196–198, figs. 79 (verso),
80 (recto).

Karen B. Cohen

Both these nude figures are studies for the central figure of Religion in *The Triumph of
Religion,* a painting datable to 1821 and now in the cathedral at Ajaccio (Johnson, no. 153).
This picture is often wrongly described as *The Virgin of the Sacred Heart,* but the allegorical
female figure—who in the painting is draped and holds aloft a flaming heart in her right
hand and a large cross at her left side—is clearly not the Blessed Virgin Mary but a
personification of Religion with appropriate attributes. The name and address that appear
on the sheet are probably those of the model Delacroix used for these studies.

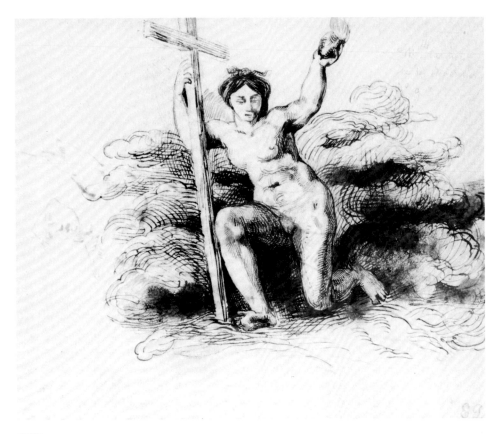

verso

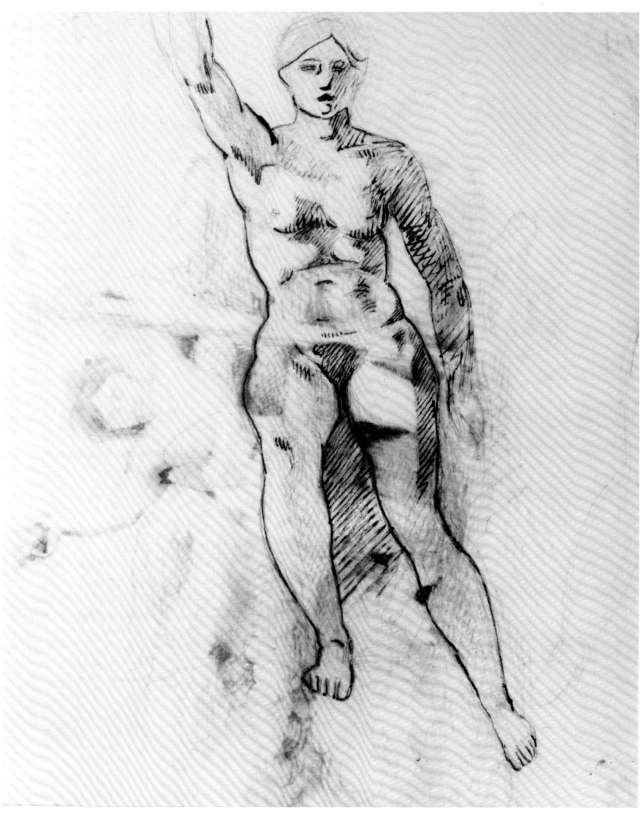

recto

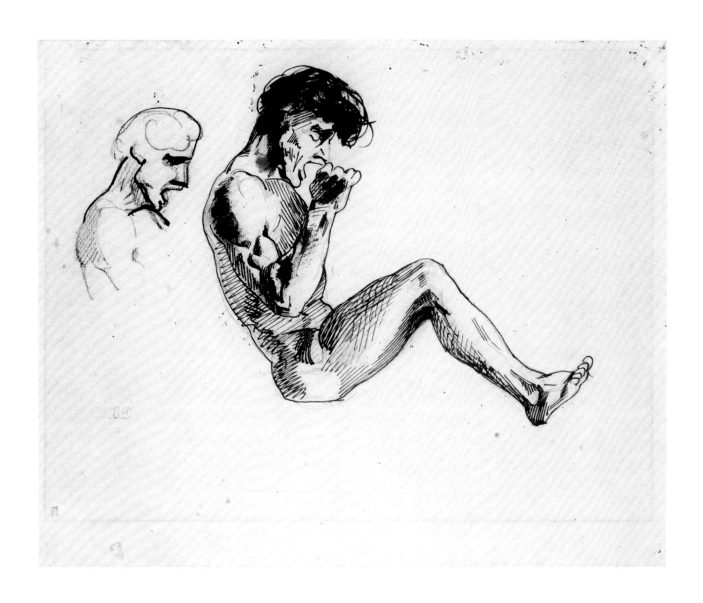

20. STUDIES OF A DAMNED MAN

Pen and brown ink, brown wash,
over graphite and black chalk
10½ x 13¼ in. (26.7 x 33.7 cm.)
Mark E.D (Lugt Supp. 838a)

BIBLIOGRAPHY: Escholier, I, repr. p. 66; Sérullaz, 1963,
no. 31; Sérullaz, 1984, under nos. 31 and 32; Johnson, I, p. 77.

The Metropolitan Museum of Art
Rogers Fund, 1961
61.23

Study for the damned man who desperately bites the boat in *The Barque of Dante* (Johnson, no. 100). This painting, dated 1822, is now in the Musée du Louvre.

21. THE AGONY IN THE GARDEN

Point of brush, brown wash, over graphite
4^{15}/$_{16}$ x 7½ in. (12.5 x 19 cm.)
Mark E.D (Lugt Supp. 838a)

BIBLIOGRAPHY: Robaut, no. 1522; Escholier, I, repr. p. 172;
Johnson, I, p. 167.

Karen B. Cohen

Study for a painting commissioned in 1824 for the church of Saint-Paul-Saint-Louis,
Paris, and shown in the Salon of 1827–1828. The drawing establishes the essentials of the
final composition, except that the Christ is younger, beardless, and in a more vertical
kneeling position than in the painting.

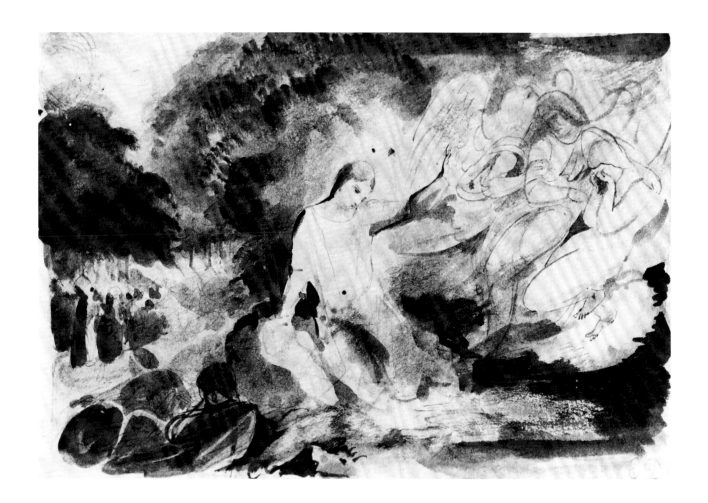

22. THE GIAOUR ON HORSEBACK

Pen and brown ink, brown wash, over graphite
Verso: figure studies in pen and brown ink
and graphite. Notations in graphite beginning
couper / chars / abbatu . . .
7%₁₆ x 11⅞ in. (19.3 x 30.2 cm.)
Mark E.D (Lugt Supp. 838a)

BIBLIOGRAPHY: Robaut, probably part of no. 1529;
Johnson, I, p. 105.

Karen B. Cohen

This early drawing is surely a study for *The Combat of the Giaour and Hassan,* a subject from
Byron that fascinated Delacroix (see no. 2 above).

verso

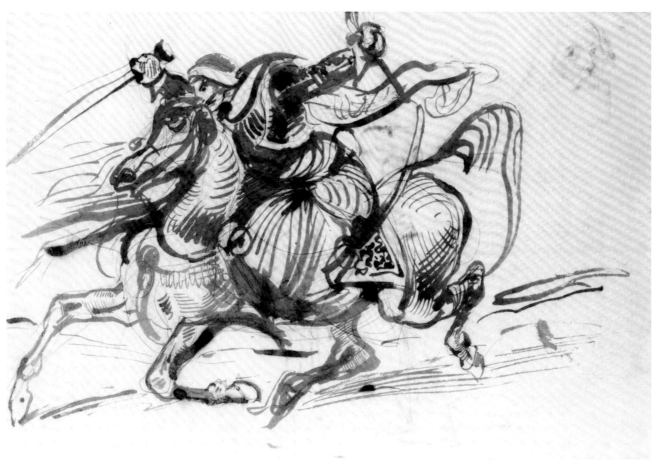

recto

23. MEPHISTOPHELES APPEARS BEFORE FAUST

Pen and brown ink, brown wash
8⅛ x 6½ in. (20.6 x 16.5 cm.)
Signed in pen and brown ink at lower margin,
Eug. delacroix.

BIBLIOGRAPHY: Johnson, VI, pp. 194–195, fig. 77.

Mr. and Mrs. Eugene Victor Thaw

This subject, taken from Goethe's *Faust,* was treated by Delacroix in a painting of 1826–1827, now in The Wallace Collection, London (Johnson, no. 116), and in a lithograph of about the same date (Delteil, no. 62). This drawing differs from these versions, notably in the reversal of the figures; Lee Johnson suggests that it may precede both of them.

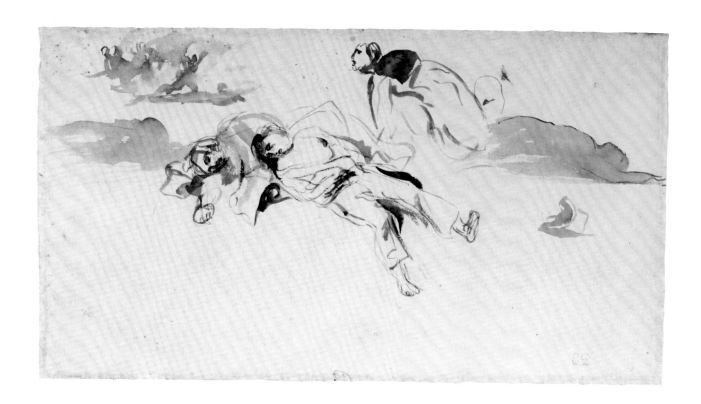

24. FIGURE STUDIES

Pen and brown ink, brown wash
7⁵/₁₆ x 13¹¹/₁₆ in. (18.6 x 34.8 cm.)
Mark E.D (Lugt Supp. 838a)

BIBLIOGRAPHY: Escholier, I, p. 267, repr.

The Metropolitan Museum of Art
Robert Lehman Collection, 1975
1975.1.613

The figures on this sheet—the two dead men at the center of the sheet, the kneeling woman with another cadaver at the right, and the running figures lightly indicated at upper left—are no doubt related to the 1830 painting *Liberty Leading the People,* now in the Musée du Louvre, Paris.

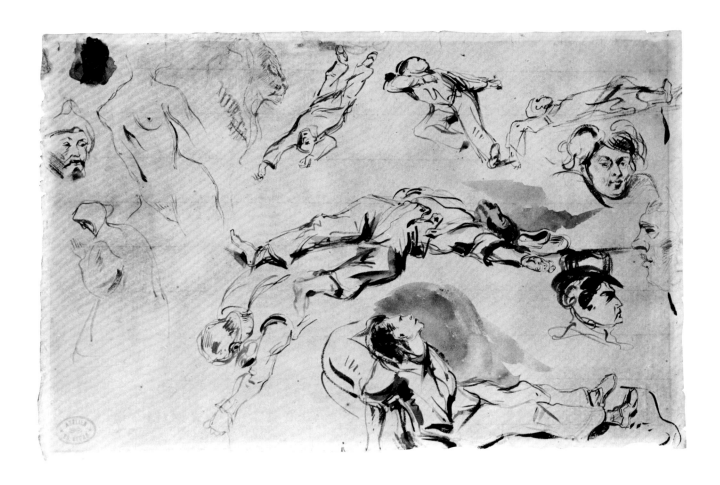

25. FIGURE STUDIES

Pen and brown ink, brown wash
8¹³⁄₁₆ x 13¾ in. (22.4 x 34.9 cm.)
Mark ATELIER ED. DEGAS (Lugt 657)

BIBLIOGRAPHY: Escholier, I, p. 271, repr.;
Sérullaz, 1984, I, p. 115.

Karen B. Cohen

The six dead men studied on this sheet may well be studies for figures that lie in the foreground of *Liberty Leading the People*. The same six figures, arranged in a different way, may be found on a sheet in the Cabinet des Dessins, Musée du Louvre (Sérullaz, 1984, no. 155). The Louvre sheet is one of 477 drawings gathered in six albums entitled *Soirées chez Pierret*, which suggests that they were drawn in the course of evenings spent with Delacroix's close friend Jean-Baptiste Pierret. It has been proposed that some of these drawings may be the work of Charles Soulier or Pierret himself, copying sketches by Delacroix. This hypothesis is given some weight by the fact that other studies on the present sheet—the three heads at the right and the nude female torso, the figure in a cowl, and the turbaned head at the left—are repeated on three other sheets from the *Soirées chez Pierret* (Sérullaz, 1984, nos. 686, 710, 1045).

26. CONVERSATION MAURESQUE

Watercolor, over graphite
5⅜ x 7⁷⁄₁₆ in. (13.7 x 18.8 cm.)
Signed at lower left in pen and brown ink,
Eug delacroix.

BIBLIOGRAPHY: Robaut, no. 497.

The Metropolitan Museum of Art
The Mr. and Mrs. Henry Ittleson, Jr.
Purchase Fund, 1963
1963.215

This and the following work form part of a group of eighteen watercolors, begun in Tangier and perhaps finished in Toulon, that Delacroix offered to Count de Mornay as a souvenir of their journey to Morocco in 1832.

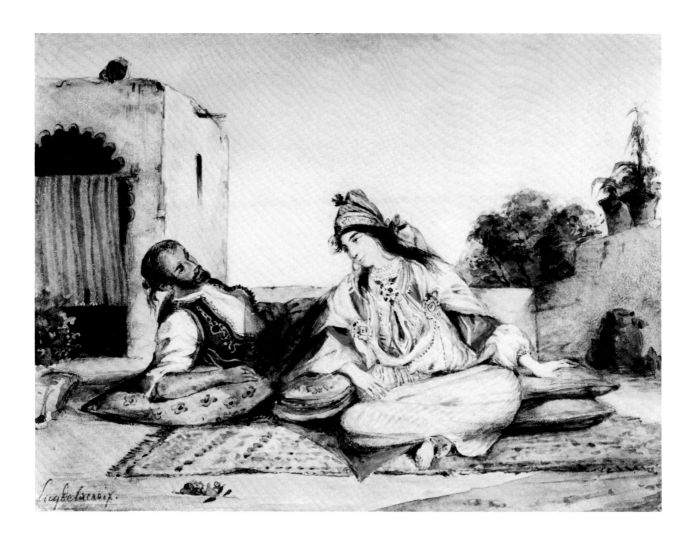

27. THE WIFE OF ABRAHAM BENCHIMOL AND ONE OF THEIR DAUGHTERS

Watercolor, over graphite
8¹³⁄₁₆ x 6⅜ in. (22.3 x 16.2 cm.)
Signed at lower left in pen and brown ink,
Eug Delacroix.

BIBLIOGRAPHY: Robaut, no. 500; Escholier, II, repr.
opposite p. 30; Sérullaz, 1963, no. 162, repr.

The Metropolitan Museum of Art
Bequest of Walter C. Baker, 1971
1972.118.210

Abraham Benchimol was the Jewish interpreter for the French delegation to Morocco headed by Count de Mornay.

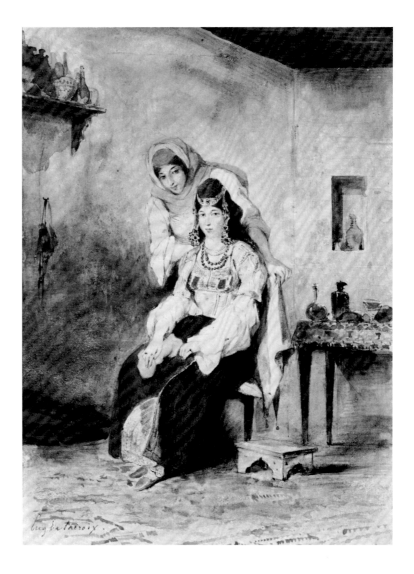

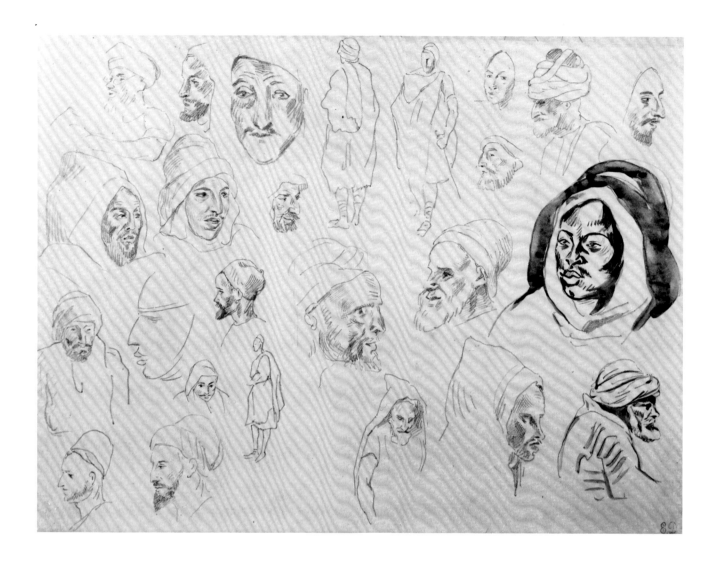

28. STUDIES OF ARAB HEADS AND FIGURES

Graphite and brown wash
10¾ x 14⁹⁄₁₆ in. (27.3 x 37 cm.)
Mark E.D (Lugt Supp. 838a)

Karen B. Cohen

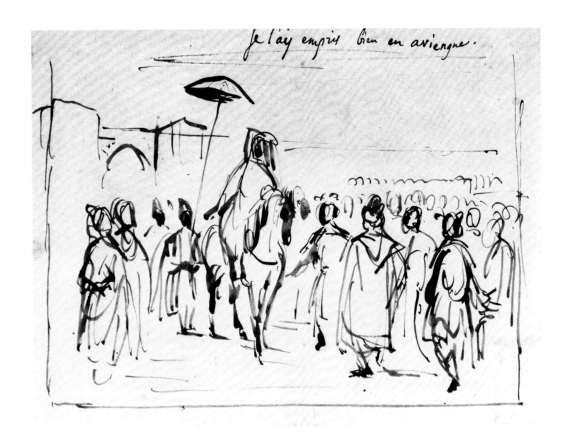

29. THE SULTAN OF MOROCCO RECEIVES COUNT DE MORNAY

Pen and brown ink, brown wash
7¹¹/₁₆ x 9¹³/₁₆ in. (19.5 x 25 cm.)
Inscribed at upper right in pen and brown ink,
Je l'ay empris bien en aviengne.
Mark E.D (Lugt Supp. 838a)

BIBLIOGRAPHY: Robaut, nos. 928–936 (first vignette);
Paris, 1930, no. 438; Élie Lambert, *Histoire d'un tableau.*
L'Abd er Rahman Sultan du Maroc de Delacroix, Paris, 1953,
p. 44, no. 22, pl. XVII; Johnson, III, p. 180.

Karen B. Cohen

This free study is related to a never-executed painting of the reception of Count de Mornay at Meknes on March 22, 1832. The project seems to have been carried no further than an oil sketch of the same horizontal format, now in the Musée des Beaux-Arts, Dijon, which can be dated to 1832–1833, immediately after Delacroix's return from Morocco (Johnson, no. 369).

The inscription at the upper margin has no connection with the subject represented; Élie Lambert suggested that it is a line of Old French transcribed from some text that Delacroix was reading at the time he made this sketch.

30. MOROCCANS OUTSIDE THE WALLS OF TANGIER

Watercolor, over graphite
7⁵⁄₁₆ x 10⅜ in. (18.6 x 26.4 cm.)
Mark E.D (Lugt Supp. 838a)

BIBLIOGRAPHY: Robaut, no. 433, repr. in reverse;
Johnson, III, pp. 196–197, fig. 45.

Mr. and Mrs. Eugene Victor Thaw

This watercolor probably dates from 1836 or 1837, a few years after Delacroix's return from North Africa. He repeated the same composition in a painting of 1852–1853, replacing the standing Arab with his back to the spectator with a frontal view of a young woman in Arab costume. A headstone has been added at the left and a cactus at the right (private collection, U.S.A.; Johnson, no. 390).

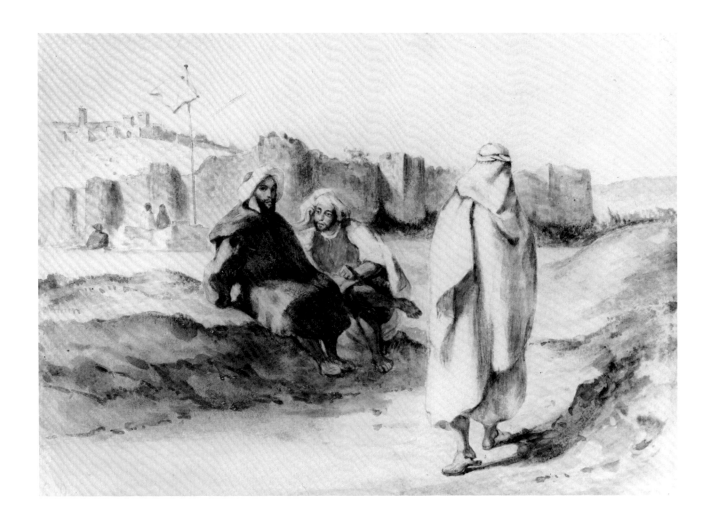

31. ALLEGORICAL FIGURE OF JUSTICE

Graphite. Verso: Faint graphite sketches for the
Justice composition and of architectural details
8⁹⁄₁₆ x 13½ in. (21.8 x 34.3 cm.)
Inscribed in graphite in the artist's hand at upper
margin of verso, *page* [crossed out] *nᵒ 123 et 124
d'Herculanum sous l'édifice du fond./de la fig...../
dans toute la tête touchant en haut/la force.*
Mark E.D on verso (Lugt Supp. 838a)

BIBLIOGRAPHY: Maurice Sérullaz, "Delacroix Drawings for
the Decoration of the Salon du Roi," *Master Drawings*, I, 4,
1963, p. 42, pl. 30; Johnson, V, pp. 13, 26.

The Metropolitan Museum of Art
Rogers Fund, 1916
16.37.4

Study for the *Justice* coffer in the ceiling of the Salon du Roi, Palais Bourbon, Paris. Delacroix's
decorations in this anteroom to the Chamber of Deputies date from 1833–1837 (Johnson,
nos. 505–526).

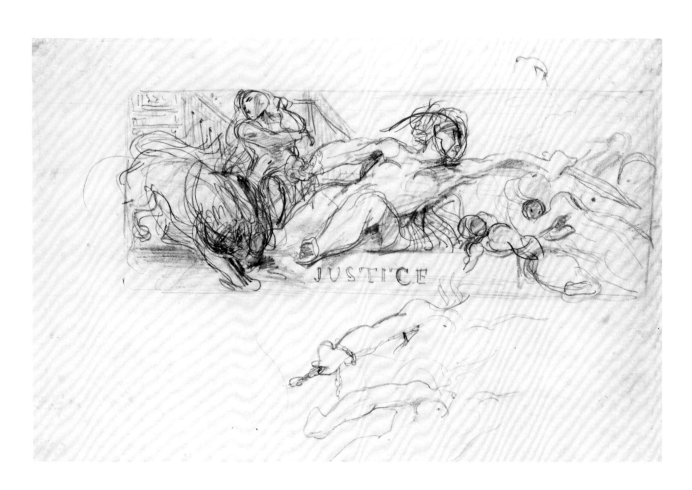

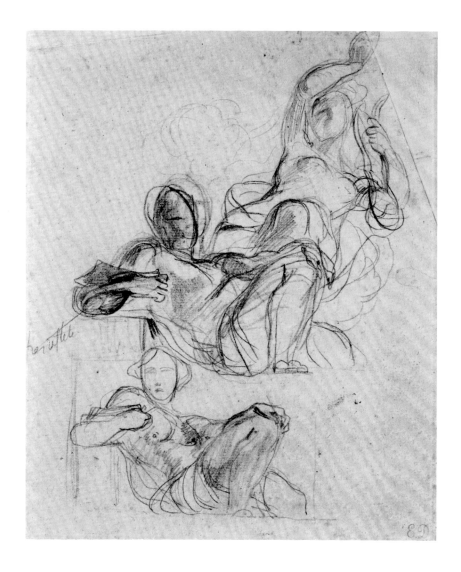

32. THREE RECLINING FEMALE FIGURES

Graphite
9 1/16 x 7 3/8 in. (23 x 18.7 cm.). Lined
Inscribed in graphite in the artist's hand
at left margin, *très reflété*.
Mark E.D (Lugt Supp. 838a)

BIBLIOGRAPHY: Maurice Sérullaz, "Delacroix Drawings for
the Decoration of the Salon du Roi," *Master Drawings*, I, 4,
1963, p. 43, pl. 35; Johnson, V, p. 23.

The Metropolitan Museum of Art
Bequest of Alexandrine Sinsheimer, 1958
59.23.27

Studies for female figures that appear in the extreme right section of the *War* frieze in the
Salon du Roi, Palais Bourbon.

33. FIGURE STUDIES

Pen and brown ink, over graphite
10¹⁵⁄₁₆ x 15⅝ in. (27.8 x 39.6 cm.)
Mark E.D (Lugt Supp. 838a)

Karen B. Cohen

The figures on this sheet were probably studies for the *War* coffer and the *Industry* or *War* friezes in the Salon du Roi of the Palais Bourbon.

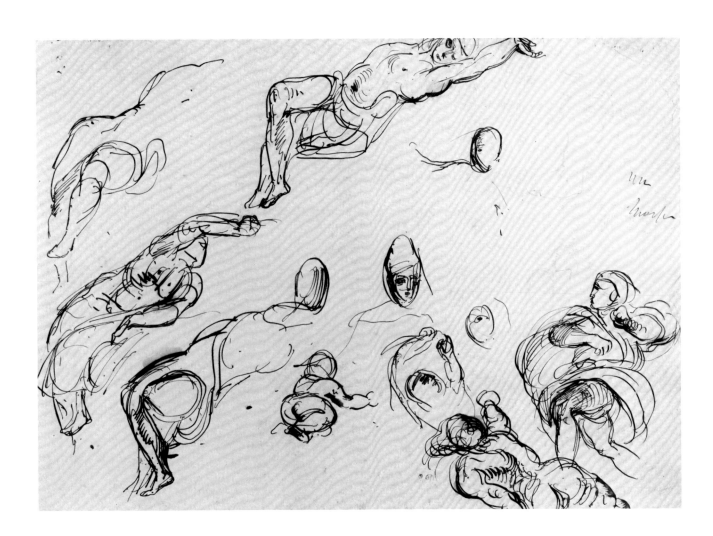

34. FIGURE STUDIES

Pen and black ink
7⅞ x 11⅝ in. (20 x 29.5 cm.)
Mark E.D (Lugt Supp. 838a)

Karen B. Cohen

These studies may be related to the design of the *War* coffer in the Salon du Roi of the
Palais Bourbon.

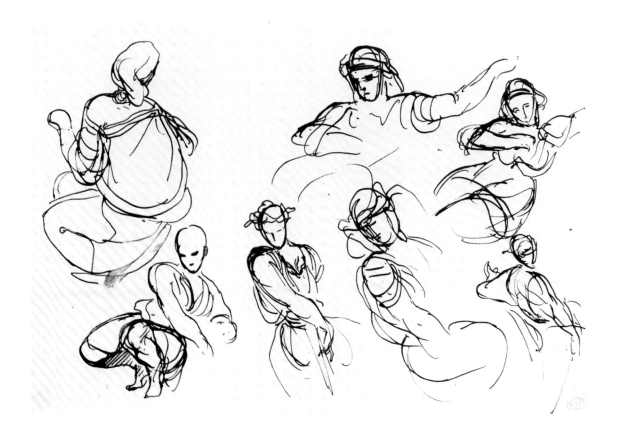

35. STUDIES FOR A PIER

Graphite, pen and brown ink, brown wash
8½ x 5¾ in. (21.6 x 14.6 cm.)
Mark E.D (Lugt Supp. 838a)

BIBLIOGRAPHY: Johnson, v, p. 27, fig. 14.

Eric G. Carlson

This design for a pier with a feigned niche and statue is a rejected scheme for the orna-
mentation of the lower zone of the Salon du Roi, Palais Bourbon.

36. FRÉDÉRIC VILLOT

Graphite, black chalk, stumped
13⅛ x 9⅜ in. (33.3 x 23.8 cm.)
Mark E.D (Lugt Supp. 838a)

BIBLIOGRAPHY: Agnes Mongan and Paul J. Sachs,
Drawings in the Fogg Museum of Art, Cambridge, Mass.,
1940, I, no. 682, III, fig. 357; Lee Johnson, *Delacroix,*
exhibition catalogue, Edinburgh and London, 1964,
p. 26, under no. 28.

Fogg Art Museum, Harvard University, Cambridge, Mass.
Gift of Meta and Paul J. Sachs

Frédéric Villot (1809–1875), for many years one of Delacroix's most intimate friends, was a painter and engraver. A man of considerable learning, he was appointed curator of paintings of the Musée du Louvre in 1848. Delacroix painted a portrait of the young Villot in 1832 (Prague, National Gallery; Johnson, no. 217). This drawing, showing Villot as a man of twenty-eight or twenty-nine years, is associated by Lee Johnson with an unfinished and now-lost portrait dated to 1838 in an early source.

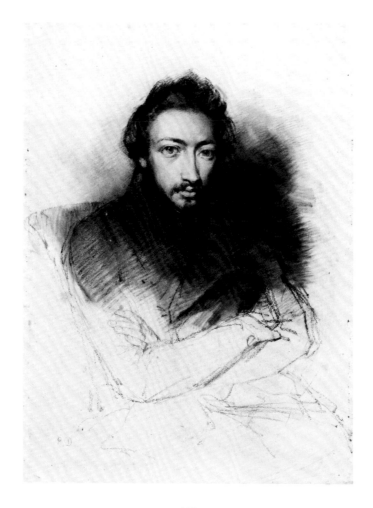

37. THE TRIBUTE MONEY

Graphite
8⁷/₁₆ x 11 in. (21.5 x 28 cm.)
Mark E.D (Lugt Supp. 838a)

BIBLIOGRAPHY: Robaut, no. 864;
Johnson, V, p. 53.

Karen B. Cohen

This is a preliminary design for one of the four pendentives under the *Theology* cupola in the Deputies' Library of the Palais Bourbon, a decorative commission carried out by Delacroix and his assistants from 1838 to 1847 (Johnson, nos. 527–561). The subject comes from the Gospel according to St. Matthew (17 : 24–27); as Jesus has predicted, St. Peter finds a shekel for the payment of the temple tax in the mouth of a fish.

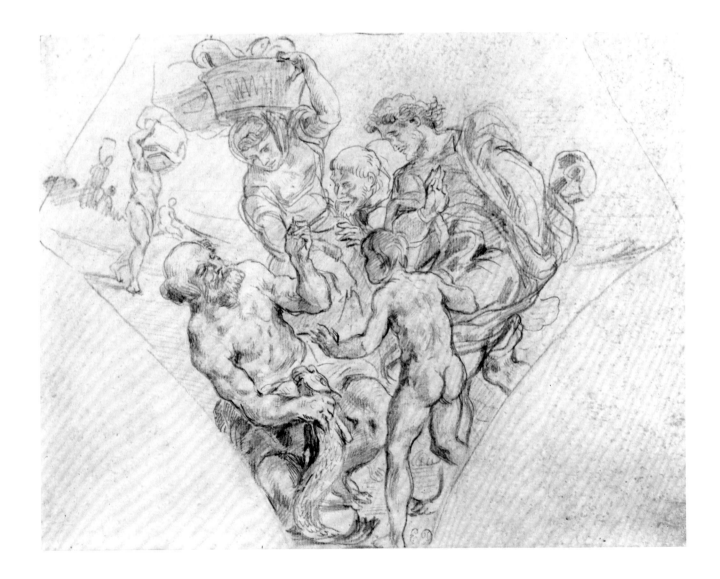

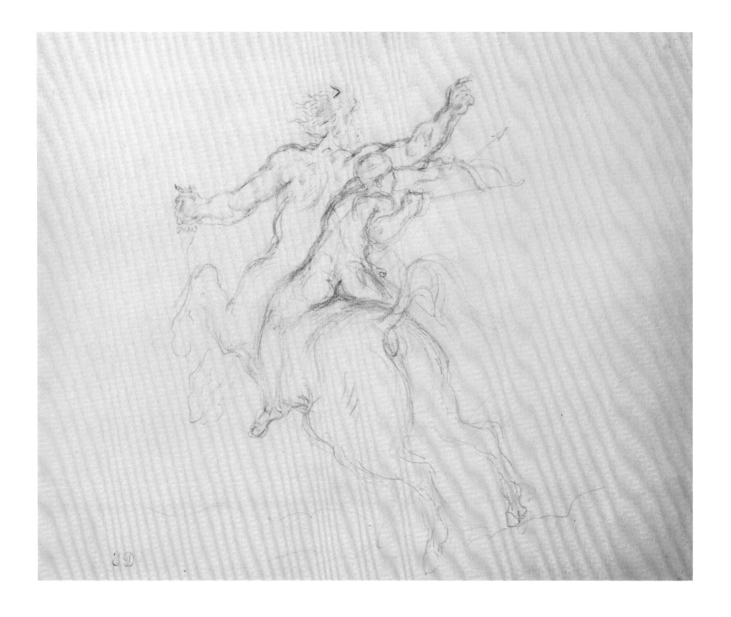

38. THE EDUCATION OF ACHILLES

Black chalk
11¾ x 9¼ in. (29.8 x 23.5 cm.)
Mark E.D (Lugt Supp. 838a)

Karen B. Cohen

Achilles is instructed in the art of hunting by the centaur Chiron. This group was first used for a pendentive in the *Poetry* cupola in the Deputies' Library of the Palais Bourbon, then in a painting of rectangular format dated 1862 (private collection; Johnson, no. 341). Delacroix presented to his friend George Sand a free pastel replica of the 1862 picture; this is now in the Getty Museum, Malibu (Lee Johnson, *The J. Paul Getty Museum Journal,* XVI, 1988, pp. 25–32, fig. 6).

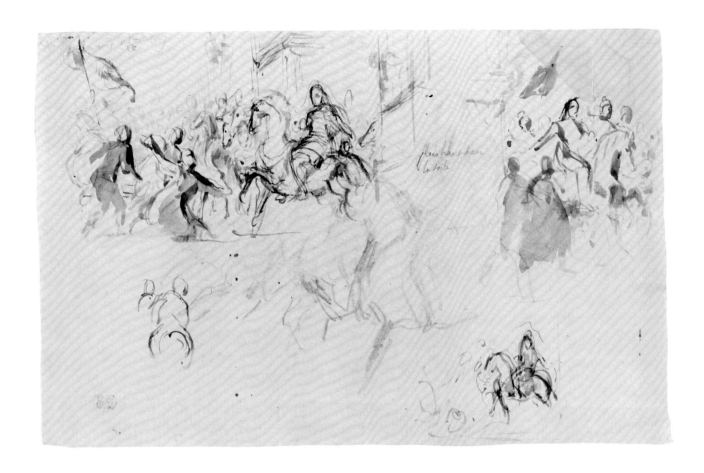

39. STUDIES FOR THE JUSTICE OF TRAJAN

Brush, brown wash, over graphite
7⅝ x 12⅛ in. (19.4 x 30.8 cm.)
Inscribed in graphite at upper left corner, *14 . . .*
chevaux . . .; in graphite right of center, *plus haut*
dans / la toile; in graphite on verso, *La Justice de Trajan.*
Mark E.D (Lugt Supp. 838a)

BIBLIOGRAPHY: Robaut, part of no. 1695; Johnson, III,
p. 93.

Jack A. Josephson

These are preparatory sketches for *The Justice of Trajan,* dated 1840 and now in the Musée
des Beaux-Arts at Rouen (Johnson, no. 271). The painting is vertical in format, and the
Emperor Trajan advances from the right. His horse rears up as his progress is impeded by
a kneeling widow; she demands vengeance for the death of her child, who has been run
down by an unrestrained horse belonging to Trajan's son.

40. A GROUP OF FIVE SINGERS

Brush, black and brown wash, over graphite
6⅞ x 9³⁄₁₆ in. (17.5 x 23.4 cm.)
Mark E.D (Lugt Supp. 838a)

BIBLIOGRAPHY: Robaut, no. 1701.

Karen B. Cohen

Robaut gave the title *Choeur à cinq parties* to this summary representation of an evening musical party. The faces of the singers are strongly lit from below, presumably by a single lamp. A mysterious and dramatic chiaroscuro is achieved by the contrast between the reserves of the paper and the broadly applied dark wash.

41. FIGURE STUDIES

Graphite
10 x 13¹⁵⁄₁₆ in. (25.4 x 35.5 cm.)
Mark E.D (Lugt Supp. 838a)

BIBLIOGRAPHY: Robaut, probably part of no. 952;
Johnson, V, pp. 105–107, fig. 41.

Karen B. Cohen

Lee Johnson points out that these studies, perhaps all taken from the same semi-nude model, are preparatory for three figures that are widely separated in the cupola of the Peers' Library, Palais du Luxembourg, Paris. This painting, datable to 1841–1845, represents *Dante and the Spirits of the Great* (Johnson, no. 569). The nude figure at the left is a study for Hannibal, who is heavily clothed in the painting. The two studies at the center of the sheet are for Socrates and those on the right for Cato Uticensis.

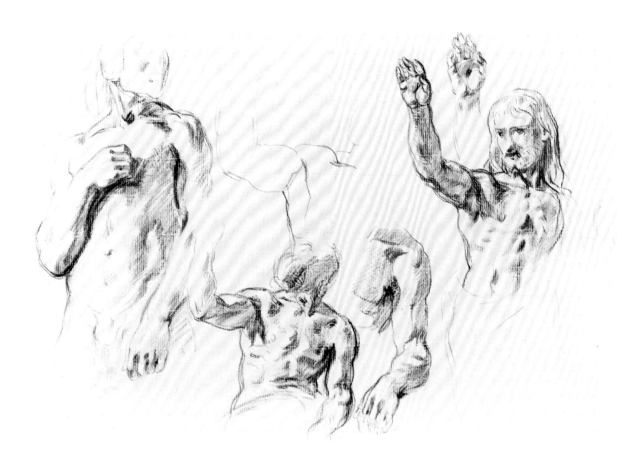

42. MATHURIN RÉGNIER

Watercolor and gouache, over traces of graphite
The image, 10½ x 7¼ in. (26.5 x 18.3 cm.);
the whole sheet, 12⅛ x 8¹³⁄₁₆ in. (30.9 x 22.4 cm.)
Signed in brush and gray wash, *Eug delacroix.*

BIBLIOGRAPHY: Robaut, no. 719.

The Metropolitan Museum of Art
Rogers Fund, 1969
69.180

This imaginary portrait of the satirical poet Mathurin Régnier (1573–1613) was one of four illustrations supplied by Delacroix for the second edition of *Le Plutarque français, vies des hommes et des femmes illustres de la France depuis le cinquième siècle jusqu'à nos jours . . . ,* published in four volumes in Paris between 1844 and 1847. The steel engraving by A. A. Wacquez after this drawing appears in volume III (1846), opposite page 251. For this same edition Delacroix also supplied portraits of Calvin, Froissart, and Rabelais.

43. STUDIES FOR THE LAMENTATION

Graphite
9¾ x 14¼ in. (24.8 x 36.2 cm.)
Inscribed in graphite at lower center,
plus levée que dans le dessin.
Mark E.D (Lugt Supp. 838a)

BIBLIOGRAPHY: Johnson, v, p. 83.

Karen B. Cohen

Studies for the head of the Virgin and for the two holy women who kneel on either side of
the dead Christ in *The Lamentation*, a mural painting signed and dated 1844 in Saint-
Denis-du-Saint-Sacrement, Paris (Johnson, no. 564). In the painting all the figures are
reversed from the direction indicated in this and all the other surviving preparatory draw-
ings and oil sketches for this work.

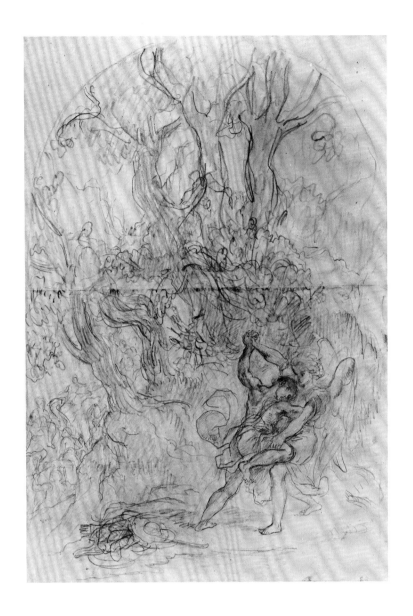

47. JACOB WRESTLING WITH THE ANGEL

Graphite, over traces of orange crayon
22¼ x 15⅛ in. (56.6 x 38.3 cm.)
Mark E.D (Lugt Supp. 838a)

BIBLIOGRAPHY: Escholier, III, repr. p. 101; Agnes Mongan
and Paul J. Sachs, *Drawings in the Fogg Museum of Art,*
Cambridge, Mass., 1940, I, no. 686, III, fig. 360; Sérullaz,
1963, no. 517; Johnson, V, p. 192.

Fogg Art Museum, Harvard University, Cambridge, Mass.
Gift of Philip Hofer

In this preparatory drawing, Jacob and the angel appear in reverse on the right, and not on
the left as they do in the painting in Saint-Sulpice.

114

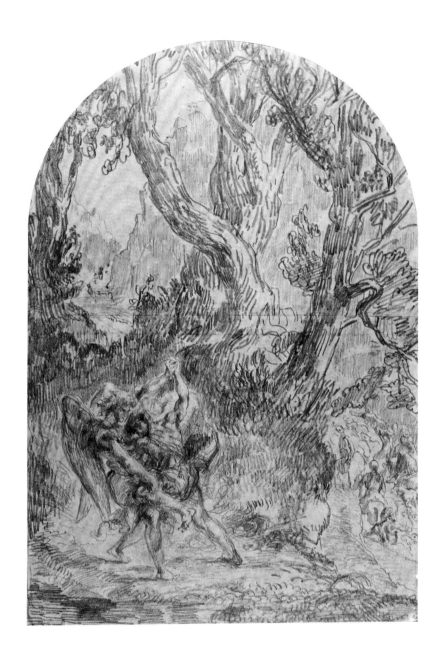

46. JACOB WRESTLING WITH THE ANGEL

Graphite, on tracing paper
14⁹⁄₁₆ x 21⁷⁄₈ in. (37 x 55.4 cm.)
Mark E.D (Lugt Supp. 838a)

BIBLIOGRAPHY: Johnson, V, p. 188.

The Pierpont Morgan Library, New York
Gift of Mrs. Landon K. Thorne, 1964
1964.2

Study with variations for the mural painting in the chapel of the Holy Angels, Saint-Sulpice, Paris. An oil sketch for this composition (no. 8) is based on this drawing.

45. THE TRIUMPH OF GENIUS OVER ENVY

Pen and brown ink, over graphite
10⅜ x 13¹³⁄₁₆ in. (26.4 x 35 cm.)
Inscribed in graphite at lower margin,
Serpent / plus grand le monstre.
Mark E.D (Lugt Supp. 838a)

BIBLIOGRAPHY: Robaut, no. 728; Sérullaz, 1963,
no. 294; Sérullaz, 1984, under nos. 506, 507.

The Metropolitan Museum of Art
Rogers Fund, 1961
61.160.1

In this allegorical composition, a hero is led toward the welcoming figure of Fame by
Heroic Virtue, who is identified by Hercules' club. The forces of Envy take form as savage
dogs, a clawing tailed monster, and flying armed figures. This grand composition was
never realized as a painting; it is perhaps a record of the projected *Génie arrivant à l'immortalité*
that Delacroix mentions in his *Journal* on October 17, 1849.

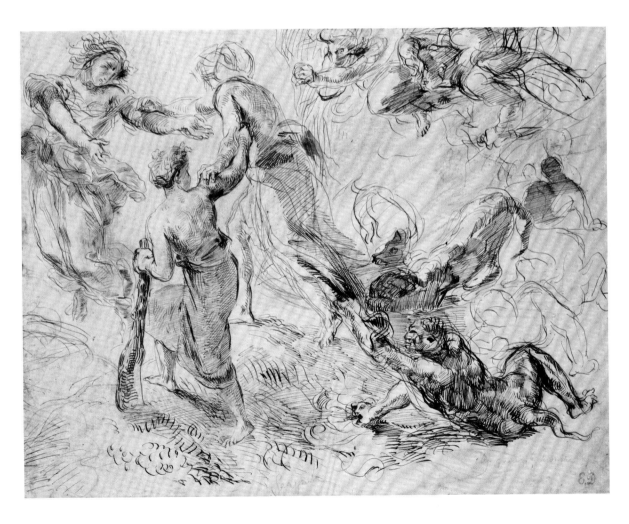

44. THE SULTAN OF MOROCCO AND HIS ENTOURAGE

Graphite, squared in white chalk. Horizontal strip
added at top and drawing continued in the artist's hand
23½ x 19⁹⁄₁₆ in. (59.8 x 49.7 cm.)
Mark E.D (Lugt Supp. 838a)

BIBLIOGRAPHY: Robaut, no. 1711; Sérullaz, 1963,
no. 349; Johnson, III, p. 183.

The Metropolitan Museum of Art
Rogers Fund, 1961
61.202

This large squared drawing corresponds quite closely to the painting of this subject, signed
and dated 1845, now in the Musée des Augustins, Toulouse (Johnson, no. 370). In the
painting, the composition extends a little farther to the right and includes a standing
figure of whom only part of the head is visible at the right margin of the drawing. The
painting records the audience with the Sultan of Morocco that Delacroix attended at
Meknes in March 1832, when the Sultan received the French ambassador, Count de
Mornay. Delacroix has taken some artistic license, both in detail and in general organiza-
tion of the spectacle that he had witnessed thirteen years before (see no. 29 for an earlier
representation of this event).

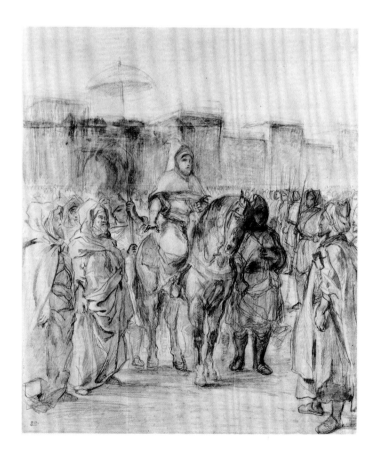

48. STUDIES OF A HORSE AND RIDER

Graphite, pen and brown ink
8⅝ x 12 in. (22 x 30.5 cm.)
Mark E.D (Lugt Supp. 838a)

BIBLIOGRAPHY: Johnson, V, p. 191.

Karen B. Cohen

Study for the mounted angel who drives Heliodorus from the Temple (from the second
book of the Maccabees) in Delacroix's representation of this subject in the chapel of the
Holy Angels, Saint-Sulpice, Paris (Johnson, no. 601).

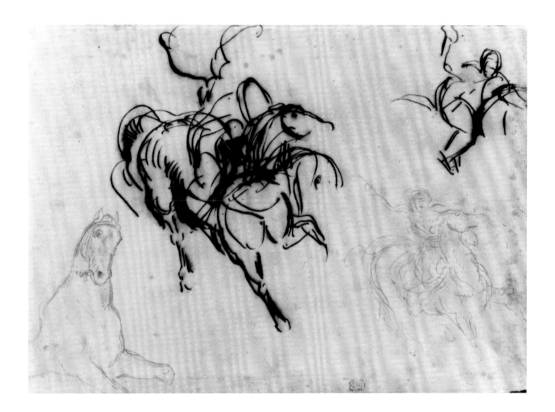

49. HELIODORUS DRIVEN FROM THE TEMPLE

Graphite
22⅞ x 15½ in. (58.2 x 39.5 cm.)
Inscribed in graphite at lower left,
Voir Jean Duvet pour les anges.
Mark E.D (Lugt Supp. 838a)

BIBLIOGRAPHY: Agnes Mongan and Paul J. Sachs, *Drawings in the Fogg Museum of Art,* Cambridge, Mass., 1940, I, no. 685, III, fig. 359, Sérullaz, 1963, no. 512; Johnson, V, pp. 159, 185, 191.

Fogg Art Museum, Harvard University, Cambridge, Mass.
Gift of Philip Hofer

A free composition study that is nonetheless quite close to the finished mural painting of the subject in the chapel of the Holy Angels, Saint-Sulpice.

Delacroix's note, *Voir Jean Duvet pour les anges,* indicates his interest in Duvet's twenty-four engravings illustrating the Apocalypse, published at Lyon in 1561.

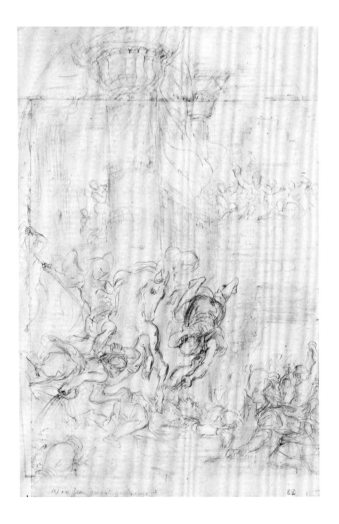

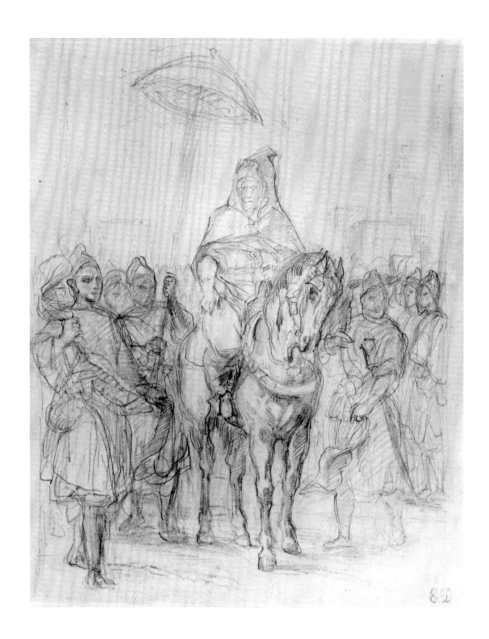

50. THE SULTAN OF MOROCCO
AND HIS ENTOURAGE

Graphite
8⅞ x 8¼ in. (22.5 x 21 cm.)
Mark E.D (Lugt Supp. 838a)

Karen B. Cohen

This is a preparatory study for a painting dated 1856 and now in the Norton Simon
Museum of Art, Pasadena (Johnson, no. 401). The picture is a small and considerably
simplified variant of the great painting of this subject exhibited in the Salon of 1845 (see
no. 44 above).

51. NOTES AND FIGURE STUDIES

Pen and brown ink
7¾ x 11¾ in. (19.7 x 29.8 cm.)
Inscribed in pen and brown ink, *Pourquoi ne pas copier la femme de 30 ans, par exemple, / comme la nature la fait; le col court le / petit double menton, la rondeur des cuisses / La nature fait une beauté pour / tous les âges; tous nos systemes tendent / à la borner . . / l'antique copie le beau de tous / les ages, mais / jamais / mesquinement / Goya sublime / dans ses femmes / pour cela / il n'aurait pas osé le faire dans sa jeunesse. / Ingres a entrevu une partie / de cela et y doit tout / son lustre. Son Homere / Son Oedipe / Ses femmes / C'est michel ange / qui a mis à la mode les muscles / ronflans / trouver aspasie / Etude de la tete d'Houël / Chercher un motif. / chercher un sujet dans l'arioste ou autre / de plusieurs femmes nues / Bains de femmes mores. Superbe motif / ou de Veronese / Dessiner d'après des tetes de Rubens / dans ses natures fortes dans le genre / du fou des noces de / Cana / tete du capitaine / du port à Tanger / Charlet. / Dans les medailles / Hommes gros et agés . . / Le Portrait du Titien gravure / de Schwiter / figure de femme d'une / nature grasse, très fidèle / d'imitation. (le ventre, la / gorge, les cuisses . . . / M. me disait: je definis / l'art, l'exageration à propos. / Comme les anciens l'ont bien senti! / Les masques, les portes voix, les / cothurnes / c'est le seul peuple artiste en tout.*

BIBLIOGRAPHY: Robaut, no. 949; Escholier, II,
repr. opposite p. 110.

Private collection

This crowded sheet of notes and sketches gives eloquent testimony to the vivacity of Delacroix's intelligence and the wide range of his intellectual interests. Pell-mell, he has jotted male heads and nude female figures onto the sheet, where they are closely interspersed with comments on subjects as various as the double chin of the woman of thirty years, the sublimity of Goya, the musculature of Michelangelo's figures, the head of the captain of the port at Tangier, an engraved portrait of Titian belonging to his friend Schwiter, and so on—with abbreviations that often defy exact interpretation.

119

52. STUDIES OF HORSES
VERSO. STUDIES OF GALLOPING HORSES
AND RIDERS

Graphite, brush and black wash (recto);
graphite (verso)
9¾ x 12 in. (24.8 x 30.5 cm.)
Mark E.D (Lugt Supp. 838a)

Karen B. Cohen

This fine double-faced sheet reflects Delacroix's abiding concern with the correct delinea-
tion of horses at rest or in movement. The two racing cavaliers at the top of the verso are in
Oriental costume, while the more sedate rider below wears a European uniform.

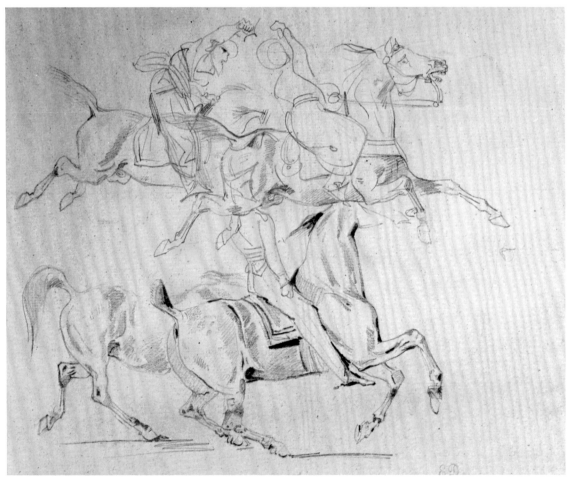

verso

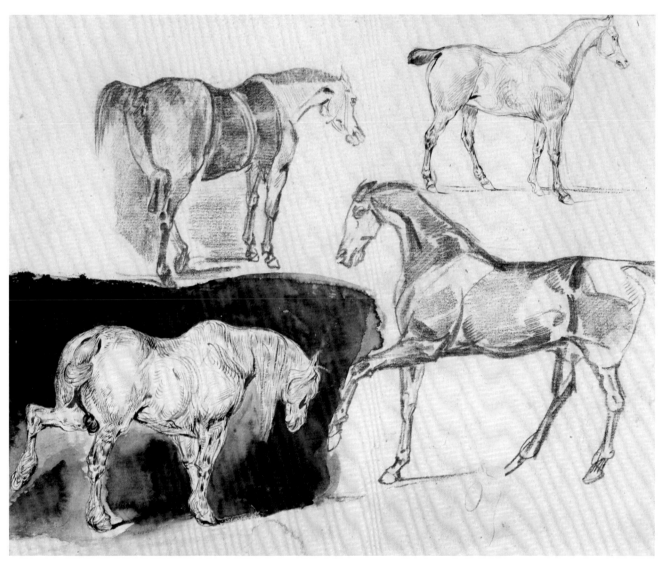

recto

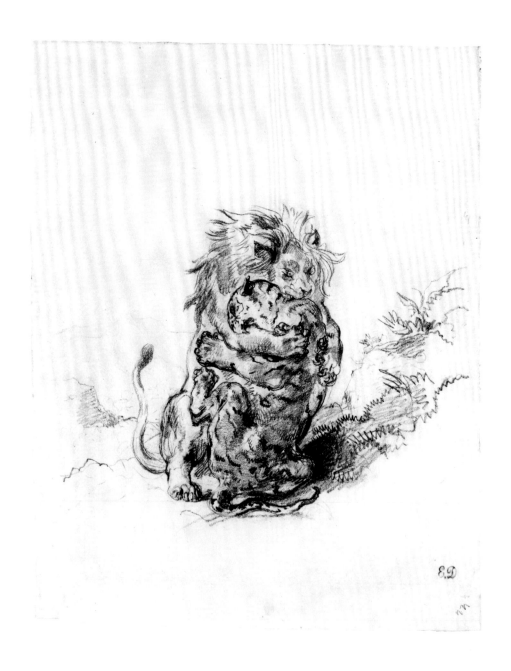

53. STRUGGLE BETWEEN A LION AND A TIGER

Graphite
12⁵⁄₁₆ x 9⁹⁄₁₆ in. (31.3 x 24.2 cm.)
Mark E.D (Lugt Supp. 838a)

BIBLIOGRAPHY: Escholier, II, repr. p. 324;
Paris, 1930, no. 615.

The Metropolitan Museum of Art
Bequest of Grégoire Tarnopol, 1979, and Gift of Alexander
Tarnopol, 1980
1980.21.13

54. ÉCORCHÉ: A MALE CADAVER

Graphite, pen and brown ink
10 x 14⅜ in. (25.3 x 36.5 cm.)
Inscribed in pen and brown ink
at lower right, *N.º 304.*
Marks E.D (Lugt Supp. 838a);
J. B. Carpeaux (Lugt 500)

Karen B. Cohen

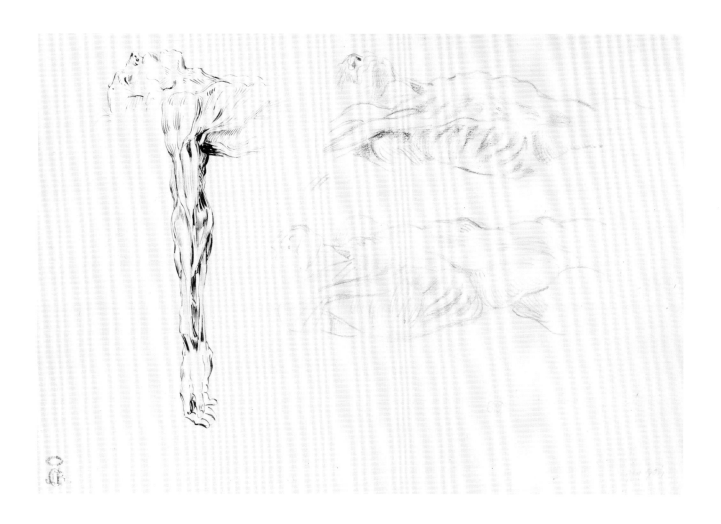

55. ÉCORCHÉ: STUDIES OF A SHOULDER

Black and red chalk
7⅜ x 9¾ in. (18.7 x 24.7 cm.)
Inscribed in pen and brown ink
at lower right, *N°. 319.*
Mark E.D (Lugt Supp. 838a)

Karen B. Cohen

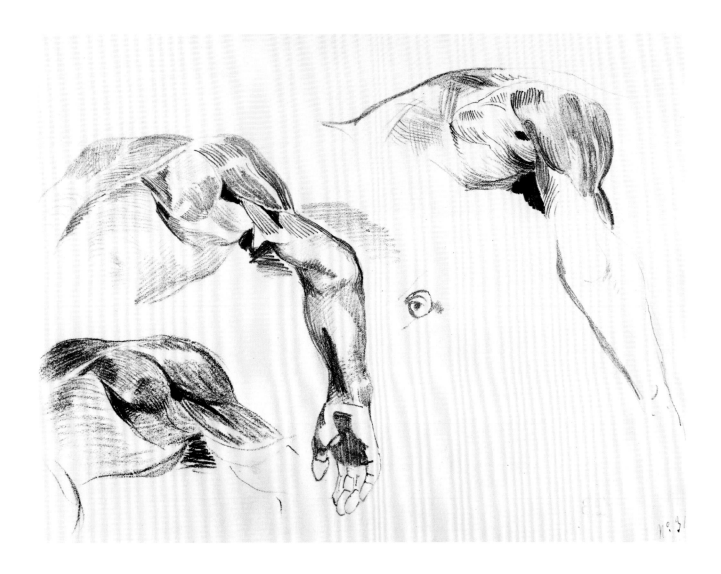

56. ÉCORCHÉ: ARMS AND SHOULDERS

Graphite
9½ x 14 in. (24.1 x 35.6 cm.)
Inscribed in pen and brown ink
at lower right, *N.º 204.*
Mark E.D (Lugt Supp. 838a)

Karen B. Cohen

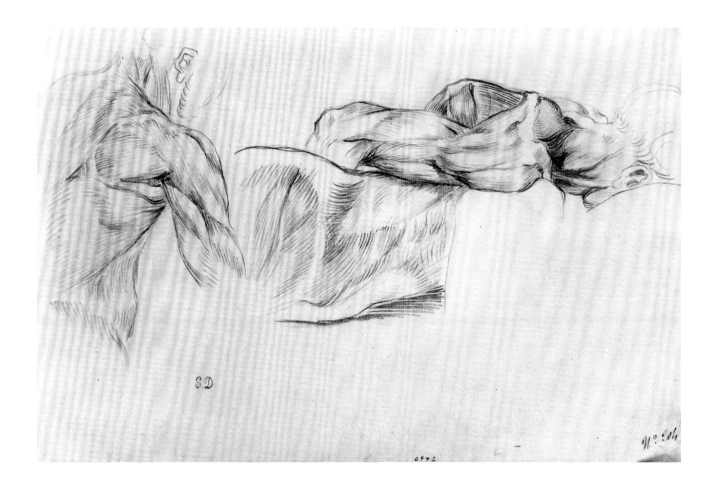

57. A COMBAT OF NUDE MEN, AFTER RAPHAEL

Pen and brown ink
12⅝ x 9⁷⁄₁₆ in. (32 x 24 cm.)
Mark E.D (Lugt Supp. 838a)

Karen B. Cohen

Delacroix has copied fairly exactly in pen and ink a red chalk drawing by Raphael now in
the Ashmolean Museum, Oxford. His model was not the original drawing, but an en-
graved facsimile by J. Vivares that appeared in William Young Ottley's *The Italian School of
Design* (London, 1823). Delacroix incorporates in his copy certain additions to the design
that appear in the facsimile but not in the original drawing.

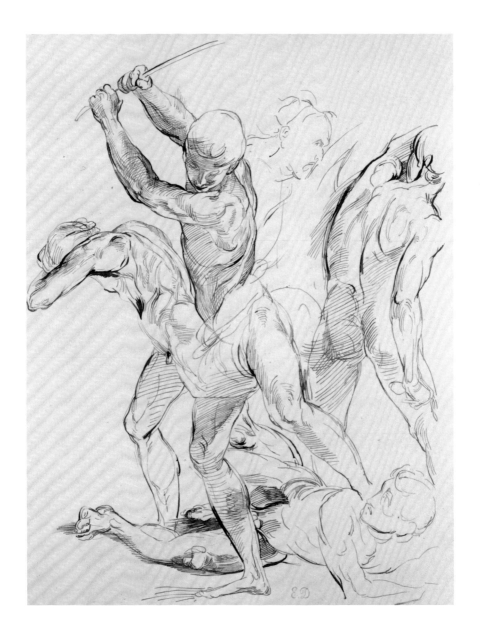

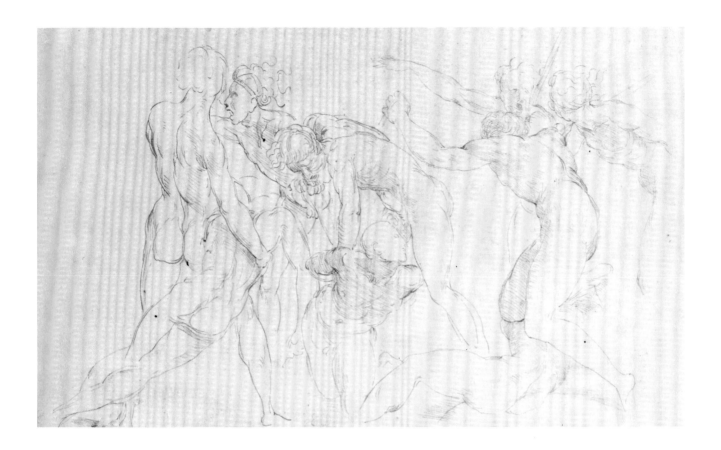

58. BATTLE SCENE WITH A PRISONER
 BEING BOUND, AFTER RAPHAEL

Graphite, on tracing paper
8 x 13¹¹⁄₁₆ in. (20.3 x 34.8 cm.)
Mark E.D (Lugt Supp. 838a)

Karen B. Cohen

This is a graphite copy by Delacroix after a drawing in pen and brown ink by Raphael that
is now in the Ashmolean Museum, Oxford. Raphael's drawing was etched by Count de
Caylus for Pierre Crozat's *Receuil d'estampes* (Paris, 1763). It is this facsimile, in which
Raphael's composition is reversed, that Delacroix has copied, reducing somewhat the size
of the etched figures.

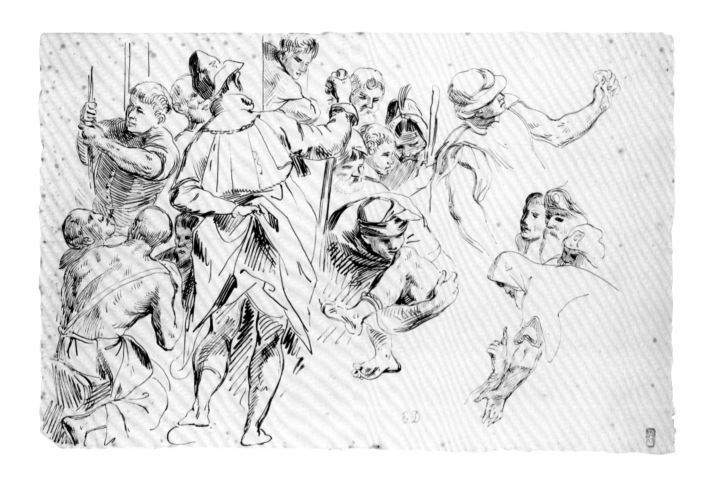

59. THE MARTYRDOM OF ST. SEBASTIAN,
AFTER PAOLO VERONESE

Pen and brown ink
9 x 14 in. (22.9 x 35.6 cm.)
Marks E.D (Lugt Supp. 838a);
P. Geismar (Lugt Supp. 2078b)

BIBLIOGRAPHY: Robaut, possibly part of no. 1935.

Karen B. Cohen

Delacroix has here copied certain details from Paolo Veronese's painting *The Martyrdom of
St. Sebastian* in the church of San Sebastiano, Venice. All the figures are in reverse from the
original. Delacroix, who never went to Italy, could not have seen the painting and took
these figures from a reversed reproductive print.

60. THE ADORATION OF THE MAGI,
 AFTER RUBENS

Graphite
10½ x 8¼ in. (26.6 x 20.9 cm.)
Mark E.D (Lugt Supp. 838a)

Karen B. Cohen

Delacroix has made a partial copy of the principal figures in *The Adoration of the Magi*, a painting by Rubens now at Kings College, Cambridge. The composition is in reverse from the original, and Delacroix no doubt based his copy on Jan Witdoeck's reversed reproductive engraving of the painting.

61. THE FALL OF THE REBEL ANGELS,
 AFTER RUBENS

Graphite
9½ x 12¼ in. (24.1 x 31.1 cm.)
Mark E.D (Lugt Supp. 838a)

Karen B. Cohen

These figures are taken from *The Fall of the Rebel Angels*, a painting by Rubens now in the
Alte Pinakothek, Munich, which Delacroix would have known through a reproductive
print.

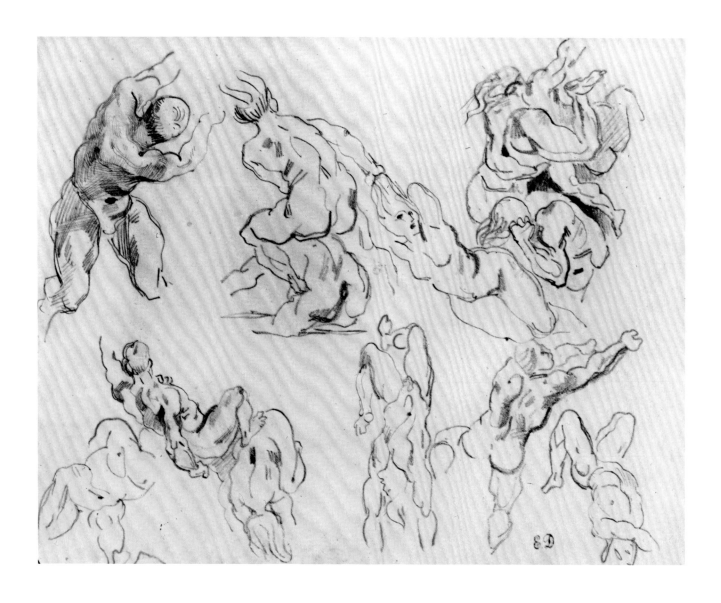

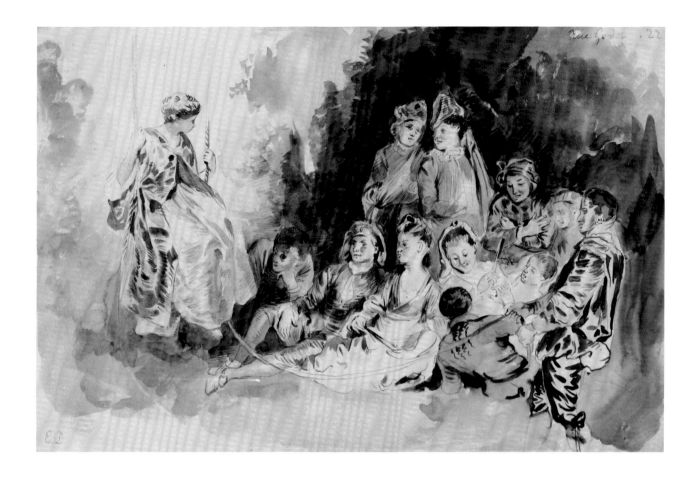

62. THE SWING, AFTER WATTEAU

Brush and brown wash, over graphite
8⁷⁄₁₆ x 13 in. (21.4 x 33 cm.)
Inscribed in graphite at upper right, *rue Godot .22.*
Mark ᴇ.ᴅ (Lugt Supp. 838a)

The Metropolitan Museum of Art
Gift of Jean Douglas Fowles, in memory of Ian Gavin
Douglas, 1977
1977.381

Delacroix has freely copied the central figures in *Les agréements de l'été*, a reproductive
engraving by François Joullain after a now-lost painting by Antoine Watteau.

63. FALLING NUDE FIGURES, AFTER
GERICAULT
VERSO. TWO STUDIES OF A MALE NUDE,
AFTER GERICAULT

Pen and brown ink (recto and verso)
9⅞ x 13 in. (25 x 33 cm.)
Mark E.D (Lugt Supp. 838a)

BIBLIOGRAPHY: Lorenz Eitner, "Dessins de Géricault d'après
Rubens: la genèse du 'Radeau de la Méduse,' " *Revue de l'Art,*
XIV, 1971, pp. 51–56, figs. 9 (verso), 10 (recto).

Karen B. Cohen

Lorenz Eitner has pointed out that the falling figures on the recto of this sheet, although
ultimately derived from Rubens's *Fall of the Damned,* were probably copied by Delacroix
from sketches by Théodore Gericault. The male nude on the reverse was copied from a
drawing by Gericault that is now in a Canadian private collection.

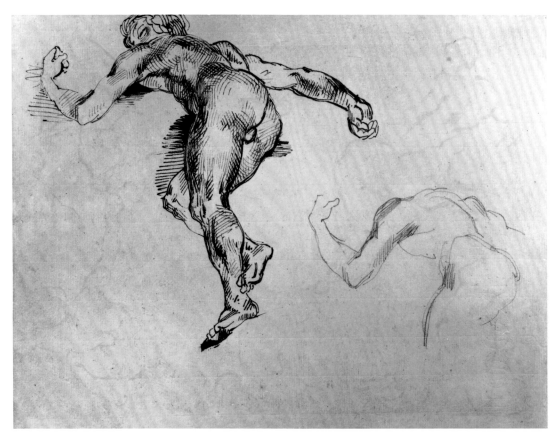

verso

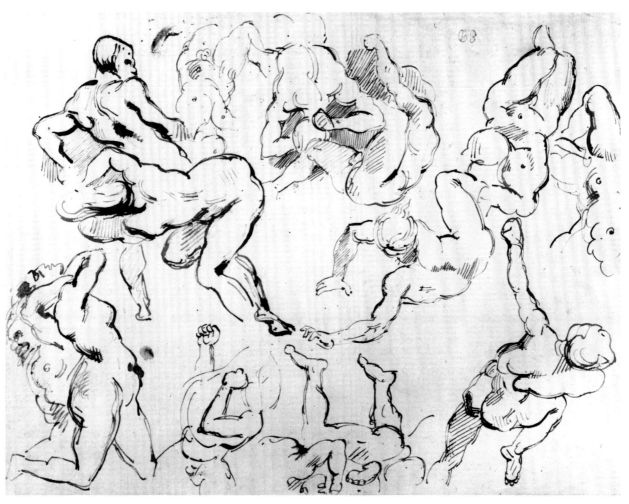

recto

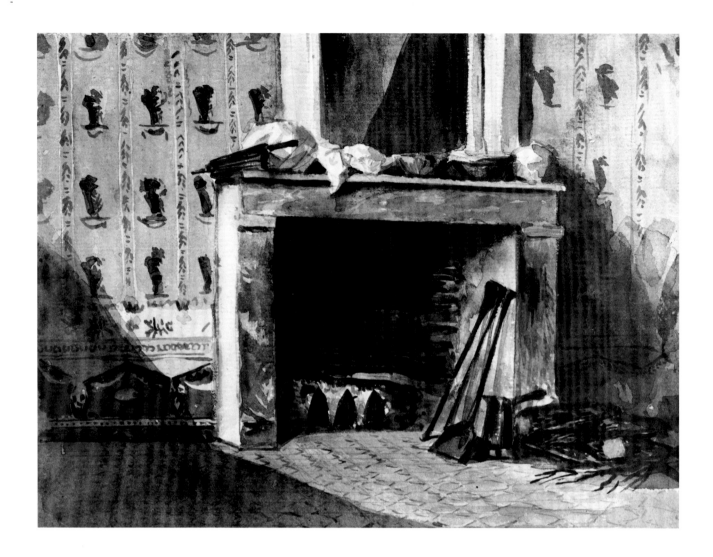

64. THE FIREPLACE

Watercolor, over graphite
7¼ x 9¾ in. (18.4 x 24.8 cm.)
Mark E.D (Lugt Supp. 838a, hidden by mount)

BIBLIOGRAPHY: Robaut, no. 90; Escholier, I, repr.
opposite p. 80.

Philadelphia Museum of Art
The Henry P. McIlhenny Collection in memory of
Frances P. McIlhenny

This view of a fireplace in a modest interior was dated to 1824 by Alfred Robaut.

65. A STAIRCASE IN SEVILLE

Watercolor and graphite
8⁷⁄₁₆ x 12³⁄₈ in. (21.5 x 31.5 cm.)
Inscribed in graphite, *le sac devant / noir et
jaune / vert / rubans de couleurs / Mules de la /
voiture le jour du Couvent / de St. Gérôme.*
Mark E.D (Lugt Supp. 838a)

Karen B. Cohen

This sketch must have been made during Delacroix's short stay in Seville at the end of May
1832, on a visit to Spain from Morocco.

66. A STAIRCASE

Graphite
19½ x 12½ in. (49.5 x 31.7 cm.)
Inscribed in graphite at lower left, *bois.*

Karen B. Cohen

This wooden staircase with vase-shaped balusters is a provincial derivation from grander
French models, usually executed in stone.

67. AN OAK TREE

Graphite
7 x 5 in. (17.8 x 12.7 cm.)
Inscribed in graphite at lower right, *10 mai / 53.*
Mark E.D (Lugt Supp. 838a)

Karen B. Cohen

Delacroix made a number of drawings of oak trees in the forest of Sénart, near his country house in Champrosay, south of Paris. This study is dated May 10, 1853, and in his *Journal* entry of that day the artist mentions having made such a sketch of the patterns formed by the branches of an oak.

137

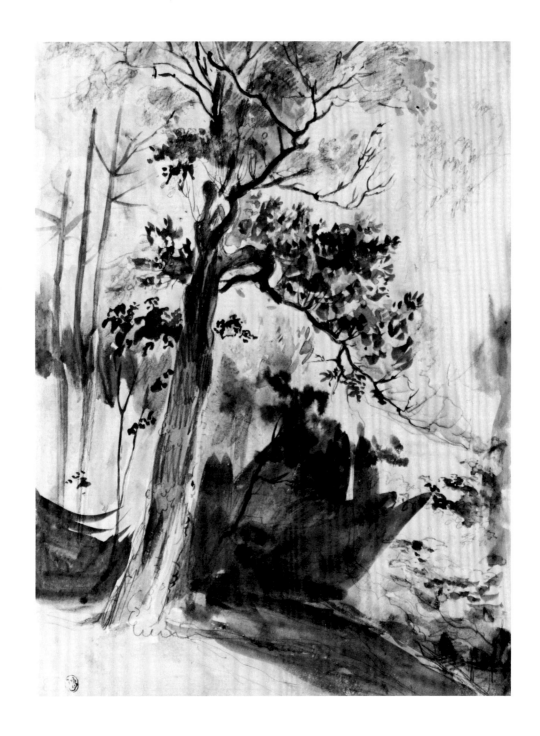

68. FOREST VIEW WITH AN OAK TREE

Watercolor
12¼ x 8⅞ in. (31 x 22.5 cm.)
Marks E.D (Lugt Supp. 838a);
A. Beurdeley (Lugt 421)

Mr. and Mrs. Eugene Victor Thaw

69. THE SEA OFF THE COAST OF NORMANDY

Watercolor
11 x 17¹⁵⁄₁₆ in. (28 x 45.6 cm.)
Inscribed in graphite at right, *presque toujours*
brume grisatre violete / à l'horizon entre le ton de la
mer / et le bleu du ciel / par le beau temps / les
montagnes / violatres / le ton de la mer / paraissant
d'un vert / charmant, mais / melé de vert [the last two
words crossed out] *d'arc en ciel / où le vert domine.*
Mark E.D (Lugt Supp. 838a)

BIBLIOGRAPHY: Robaut, probably part of no. 1775.

Karen B. Cohen

The notes at the right evidence Delacroix's keen, almost scientific, interest in the colors of natural phenomena—here the blue, gray, and violet tones that appear on the moving surface of waves. This study may have been executed at Dieppe in August 1854; in his *Journal* for the twenty-fifth of that month Delacroix makes similar observations on the colors of the sea.

70. BOATS AT THE MOUTH OF A RIVER
 AT LOW TIDE

Watercolor, over graphite
4¹¹⁄₁₆ x 7¹¹⁄₁₆ in. (11.8 x 19.6 cm.)
Inscribed in graphite in the artist's hand, *galet* /
sable / *talus* / *sable* / *lac* / *jaune g. de Suede* / *6 7ᵇ lundi.*

BIBLIOGRAPHY: Escholier, III, p. 143.

The Pierpont Morgan Library, New York
Bequest of John S. Thacher
1985.35

This watercolor was probably executed on Monday, September 6, 1852, when the artist
was staying in Dieppe, and the river represented may be the Arques.

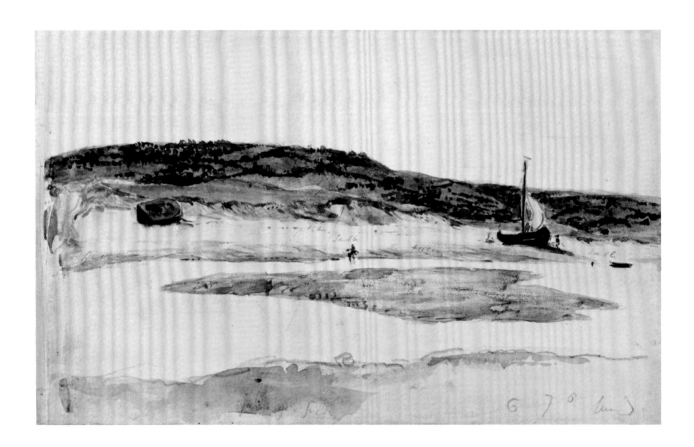

140

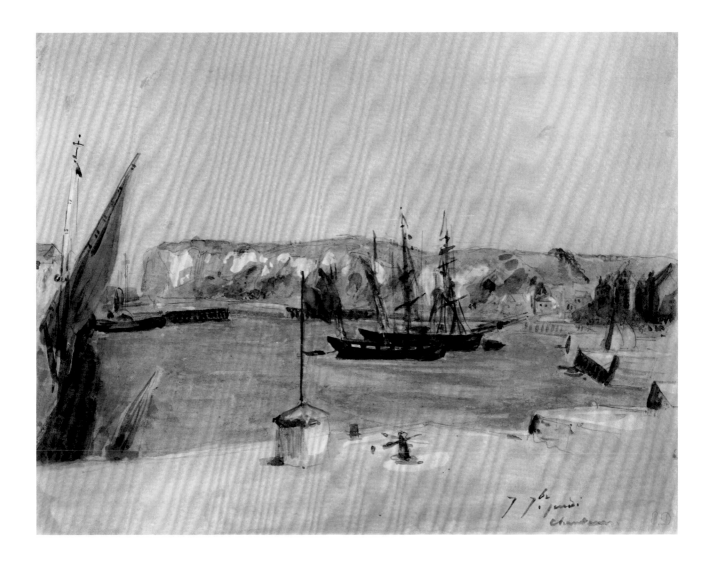

71. VIEW OF THE HARBOR AT DIEPPE

Watercolor and gouache, over graphite
9⁵⁄₁₆ x 12⁵⁄₁₆ in. (23.7 x 31.3 cm.)
Inscribed in brush and brown wash in the
artist's hand, 7 7ᵇʳ Jeudi / chanteurs.
Mark E.D on recto (Lugt Supp. 838a)

The Pierpont Morgan Library, New York
Bequest of John S. Thacher
1985.44

This view made from Delacroix's lodgings at number 6 quai Dusquesne in Dieppe on
Thursday, September 7, 1854, is described in his *Journal*. In the port, black American
clippers are silhouetted against the chalk cliffs north of the city. The note, *chanteurs,* on the
sheet refers to singers from the Pyrenees whose expressive voices had touched Delacroix at
Mass that morning in the nearby church of Saint-Jacques.

72. SKETCHBOOK WITH DRAWINGS EXECUTED IN TOURS AND ITS ENVIRONS

The sketchbook, bound in black and green paper, measures 5⁵/₁₆ x 8¹/₁₆ in. (13.5 x 20.5 cm.). On the inside back cover there is a printed sticker that reads, *Se vend à Paris, / chez Chavant, rue / de Cléry, n. 19.*

On the inner covers there are notes in Delacroix's hand in graphite and in brown ink: *Librairie de Pichonet Didier / quai des Augustins n⁰ 47 / Oeuvres posthumes et inédites de Mᶜ. Guizot / Conseils de morale ou essai sur l'homme, / les moeurs, les caractères, les femmes, l'éducation / Pompe funèbre du duc Charles III / de Lorraine par DelaRuelle / Entrée du duc Henry 2 à Nancy / par le même. / le Vade mecum . . livre de médecine / chez le docteur d [crossed out] Chez Persan libr. rue du coq n⁰ 11. / Charon: de la sagesse, liv. I. Chap. XLII. Sur le mariage. / Pompe funèbre du duc Charles de Lorraine et / autres gravures de Laruelle, graveur Lorrain / Mᶜ Toly rue neuve Sᵗ. Eustache n⁰ 36. / pour Charles le Téméraire / Le livre des échecs amoureux. dedié à Louis . . .*

The sketchbook contains thirty-six folios numbered from *1* to *36* in graphite on the verso. There are drawings on the obverse on all of these folios and on the reverse of twelve of the folios. Thus there are forty-eight drawings in all. The sheets, which measure 4¹⁵/₁₆ x 7¹¹/₁₆ in. (12.5 x 19.5 cm.), are of white wove paper, which has become so brittle that the folios were removed from the binding and mounted separately in 1970.

With one exception, these drawings were executed by the artist during a stay in Tours with his elder brother, General Charles Delacroix, in 1828. The dates noted in the sketchbook range from November 1 to November 19. At that time, Charles Delacroix occupied an apartment in the so-called Maison Papion in Tours. Eugène Delacroix's drawings in the sketchbook were made in the course of his walks through Tours and his excursions in the valley of the river Cher south of the city. Almost all of the sites recorded in this hitherto-unpublished sketchbook were identified by Jacques Olivier Bouffier on a trip to Tours in June 1990. In Tours he was offered much courteous assistance by Mme Sophie Join-Lambert, Dr. Jean-Luc Stephant, Prof. Pierre Leveel, and in Saint-Avertin, Mme Annie-France Saint-Poulof.

The sketches on the recto of the first folio are difficult to date. *Jeudi 12 fevrier* occurred in 1824 and again in 1829. It may seem logical to assume that this first drawing was executed in 1824 and the sketchbook not used again until 1828. However, the pressure applied by Delacroix with his pencil in delineating the lion's head has offset some of the graphite from the recto of folio 2, a view of Tours, onto the verso of folio 1. Thus the drawing on the first folio is likely to date from February 1829, when Delacroix was back in Paris after his stay in Tours.

The Metropolitan Museum of Art
Gift of Alexander and Grégoire Tarnopol, 1969
69.165.2

Fol. 1 recto.	HEAD OF A LION IN PROFILE TO RIGHT, HEAD OF A LIONESS LOOKING LEFT, AND STUDY OF AN EYE Graphite. 4^{15}/$_{16}$ x 7^{11}/$_{16}$ in. (12.5 x 19.5 cm.) Inscribed in graphite at lower left, *jeudi 12 fevrier* [1829?].
Fol. 1 verso.	Blank page.
Fol. 2 recto.	TOURS: ROOFTOPS AND THE TOUR CHARLEMAGNE SEEN FROM THE TOUR DE L'HORLOGE Watercolor, over graphite. 4^{15}/$_{16}$ x 7^{11}/$_{16}$ in. (12.5 x 19.5 cm.)
Fol. 2 verso.	Blank page.
Fol. 3 recto.	LEVEE AND WINDMILL ON THE RIVER CHER, SOUTH OF TOURS Watercolor, over graphite. 4^{15}/$_{16}$ x 7^{11}/$_{16}$ in. (12.5 x 19.5 cm.)
Fol. 3 verso.	Blank page.
Fol. 4 recto.	EMBANKMENT BY THE RIVER CHER, SOUTH OF TOURS Watercolor, over graphite. 4^{15}/$_{16}$ x 7^{11}/$_{16}$ in. (12.5 x 19.5 cm.) Faint inscriptions in graphite, *ciel / jaune / Prussian green*; the other inscription erased and illegible.
Fol. 4 verso.	Blank page.
Fol. 5 recto.	LEVEE ON THE RIVER CHER, SOUTH OF TOURS Graphite. 4^{15}/$_{16}$ x 7^{11}/$_{16}$ in. (12.5 x 19.5 cm.) Delacroix stood at a point farther down the levee represented on fol. 3 recto.
Fol. 5 verso.	Blank page.
Fol. 6 recto.	SMALL MANOR HOUSE IN AN ENCLOSURE, VINEYARDS IN THE FOREGROUND Graphite. 4^{15}/$_{16}$ x 7^{11}/$_{16}$ in. (12.5 x 19.5 cm.) Inscribed in graphite at upper right, *1.er novembre* [1828].
Fol. 6 verso.	OUTLINE SKETCH OF THE BUILDINGS REPRESENTED ON FOL. 7 RECTO Graphite.
Fol. 7 recto.	FORTIFIED FARM ON A HILL WITH VINEYARDS IN THE FOREGROUND Graphite. 4^{15}/$_{16}$ x 7^{11}/$_{16}$ in. (12.5 x 19.5 cm.) Inscribed in graphite at upper margin, *1.er novembre* [1828].
Fol. 7 verso.	Blank page.

Fol. 8 recto. VALLEY OF THE RIVER CHER SEEN FROM THE CHÂTEAU DE PARADIS

Graphite. $4^{15}/_{16}$ x $7^{11}/_{16}$ in. (12.5 x 19.5 cm.)

In the middle ground is the village of Saint-Avertin with its steepled church. In the distance, the city of Tours with the Tour Charlemagne and the Tour de l'Horloge at the center, and the cathedral, Saint-Gatien, at the right.

Fol. 8 verso. Blank page.

Fol. 9 recto. VINEYARDS ON A HILLSIDE

Graphite. $4^{15}/_{16}$ x $7^{11}/_{16}$ in. (12.5 x 19.5 cm.)
Inscribed in graphite, *gris plus foncé et chaud / bleu azur / blanc ocre / azur très clair / gris chaud ocre / jaune / g . . . / vignes rouge plus jau . . . / terre d' / Vert emeraude vert / olive gris / terre d'ombre clair / terre d'ombre plus clair et vignes rouges brun.*

Fol. 9 verso. Blank page.

Fol. 10 recto. A RAVINE WITH SMALL SHRUBS

Graphite. $4^{15}/_{16}$ x $7^{11}/_{16}$ in. (12.5 x 19.5 cm.)

Such ravines occur along the left bank of the river Cher.

Fol. 10 verso. HEAD OF A YOUNG WOMAN IN PROFILE TO LEFT
Graphite.

The sketch has the air of a copy after an unidentified painting rather than a study from life.

Fol. 11 recto. DOORWAY WITH ARCHITECTURAL ORNAMENTATION

Graphite. $7^{11}/_{16}$ x $4^{15}/_{16}$ in. (19.5 x 12.5 cm.)

The doorway, probably dating from the fifteenth century, is surmounted by an *arc en accolade*. There are many such door frames in Tours, often leading to towers with staircases.

Fol. 11 verso. Blank page.

Fol. 12 recto. A RAVINE WITH VINEYARDS AND A FARMHOUSE ON A HILL

Graphite. $4^{15}/_{16}$ x $7^{11}/_{16}$ in. (12.5 x 19.5 cm.)
Inscribed in graphite, *J. r / x / x / vignx / v / j et v. / v. / j. / b / v / v / v / b. / v / v.*

Delacroix used exactly the same view in a watercolor now in a European private collection (*French Drawings. Masterpieces from Five Centuries. A Loan Exhibition Organized by L'Association Française d'Action Artistique and Circulated by the Smithsonian Institution,* 1952–1953, no. 130, not repr.).

Fol. 12 verso. Blank page.

Fol. 13 recto.	DOORWAY OF A RUINOUS BUILDING
	Graphite. 4^{15}/$_{16}$ x 7^{11}/$_{16}$ in. (12.5 x 19.5 cm.)
Fol. 13 verso.	FOLIAGE ON A BANK
	Graphite.
Fol. 14 recto.	BANK SURMOUNTED BY SHRUBBERY
	Watercolor, over graphite. 4^{15}/$_{16}$ x 7^{11}/$_{16}$ in. (12.5 x 19.5 cm.)
	Inscribed in graphite, *j. ʃ r / g / j / j / j / mousse / devient brunatre / terr d'on / d'Eg … / terre d'ombr. j. cla … / blanc / terre d'o … cl. et Herbe.*
Fol. 14 verso.	Blank page.
Fol. 15 recto.	TREES ON A BANK
	Graphite. 4^{15}/$_{16}$ x 7^{11}/$_{16}$ in. (12.5 x 19.5 cm.)
	Inscribed in graphite, *v / v / j. / v / br. / b. / b. / vert et br. … / bl. g / herb / gris / v …*
Fol. 15 verso.	Blank page.
Fol. 16 recto.	RENAISSANCE PILASTERS AND CAPITALS
	Graphite. 4^{15}/$_{16}$ x 7^{11}/$_{16}$ in. (12.5 x 19.5 cm.)
	It is very probable that these sketches record architectural features of the west wing of the early sixteenth-century Hôtel de Beaune-Semblançay in Tours. This wing was unfortunately destroyed in World War II.
Fol. 16 verso.	DOORWAY SURMOUNTED BY A POINTED ARCH
	Graphite.
	Inscribed in graphite, *Dimanche 9. 9bre* [1828].
Fol. 17 recto.	PORTRAIT OF LOUIS XI AND STUDIES OF WINDOWS
	Graphite. 4^{15}/$_{16}$ x 7^{11}/$_{16}$ in. (12.5 x 19.5 cm.)
	Delacroix would have seen this portrait in the Musée de Tours, which reopened in new quarters in 1828. The painting is now in the Château du Plessis-lez-Tours.
Fol. 17 verso.	Blank page.
Fol. 18 recto.	WINDOW AND DOORWAY OF A HOUSE IN TOURS
	Graphite. 4^{15}/$_{16}$ x 7^{11}/$_{16}$ in. (12.5 x 19.5 cm.)
	The house is the so-called Maison de Tristan l'Hermite, rue Briçonnet, Tours. Its richly ornamented facade and doorway date from the late fifteenth century.
Fol. 18 verso.	Blank page.

Fol. 19 recto. A RAVINE

Graphite. $4^{15}/_{16}$ x $7^{11}/_{16}$ in. (12.5 x 19.5 cm.)

Fol. 19 verso. BLUFFS ALONG THE NORTH BANK OF THE LOIRE, NEAR TOURS

Graphite.
Inscribed in graphite, *bande roug.*

Fol. 20 recto. BLUFFS ALONG THE NORTH BANK OF THE LOIRE, NEAR TOURS

Graphite. Creases at center. $4^{15}/_{16}$ x $7^{11}/_{16}$ in. (12.5 x 19.5 cm.)
Inscribed in graphite, *3 9bre* [1828] */ sable / sable / bleu.*

Fol. 20 verso. Blank page.

Fol. 21 recto. THE TOWERS OF SAINT-GATIEN, TOURS

Graphite. $4^{15}/_{16}$ x $7^{11}/_{16}$ in. (12.5 x 19.5 cm.)

This view of the cathedral of Tours is taken from the quai d'Orléans on the south bank of the Loire. The steeply pitched roof in the middle ground, partially concealing the tower on the left, is that of the left transept of Saint-Gatien. The crossing of the nave and transepts is surmounted by a small bell tower.

Fol. 21 verso. Blank page.

Fol. 22 recto. BLUFFS ALONG THE NORTH BANK OF THE LOIRE, NEAR TOURS

Graphite. $4^{15}/_{16}$ x $7^{11}/_{16}$ in. (12.5 x 19.5 cm.)
Inscribed in graphite, *gris rougeatre / bleu / gris jaune rouge / cob. f. / roug. / mardi 11* [1828].

Fol. 22 verso. BLUFFS ALONG THE NORTH BANK OF THE LOIRE, NEAR TOURS

Graphite.
Inscribed in graphite, *gris / bleu / Cui… / jaune rouge / cuivre / gris / gris Cobalt n …/ Plus clair et rougeatre / Violet / violet rouge laque g … g.*

Fol. 23 recto. BROAD PERSPECTIVE OF THE LOIRE VALLEY, NEAR TOURS

Graphite. $4^{15}/_{16}$ x $7^{11}/_{16}$ in. (12.5 x 19.5 cm.)
Inscribed in graphite, *bleu / bla … / cobalt noir / bleu gris / gris lumineux / v. / br. / vert / gris.*

Fol. 23 verso. BROAD PERSPECTIVE OF THE LOIRE VALLEY, NEAR TOURS
Graphite.

Fol. 24 recto. FARM BUILDINGS, TREES, AND A BRIDGE

Graphite. 4^{15}/$_{16}$ x 7^{11}/$_{16}$ in. (12.5 x 19.5 cm.)
Inscribed in graphite, *mercredi 12* [1828].

Fol. 24 verso. Blank page.

Fol. 25 recto. TREES AND BUILDINGS AT WATER'S EDGE, HILLS IN THE
DISTANCE

Graphite. 4^{15}/$_{16}$ x 7^{11}/$_{16}$ in. (12.5 x 19.5 cm.)
Inscribed in graphite, *mercredi 12 9bre* [1828].

Delacroix recorded the same site in a pen-and-wash drawing now in
the collection of Jan Krugier, Geneva (repr. *Victor Hugo and the Romantic Vision. Drawings and Watercolors,* exhibition catalogue, New
York, 1990, no. 66, as "Paysage à Eaubonne").

Fol. 25 verso. Blank page.

Fol. 26 recto. HOUSES ALONG A ROAD AT DUSK

Graphite. 4^{15}/$_{16}$ x 7^{11}/$_{16}$ in. (12.5 x 19.5 cm.)

Fol. 26 verso. HOUSE AT DUSK

Graphite.

A good deal of graphite has rubbed off from fol. 27 recto.

Fol. 27 recto. STEEP HILLSIDE AT SUNSET

Graphite. 4^{15}/$_{16}$ x 7^{11}/$_{16}$ in. (12.5 x 19.5 cm.)
Inscribed in graphite, *cuivre . . . / bleu / gris / gris rouge / olive gri . . / vendredi
soir 14* [1828].

Fol. 27 verso. FAINT OUTLINE OF A BUILDING (not reproduced)

Graphite.

Fol. 28 recto. ROOFTOPS IN TOURS WITH THE OCTAGONAL TOWER OF
THE HÔTEL DE LA CROIX-BLANCHE

Gray wash, over graphite. 4^{15}/$_{16}$ x 7^{11}/$_{16}$ in. (12.5 x 19.5 cm.)
Inscribed in graphite, *ard.*[oise] / *ard*[oise].

Fol. 28 verso. Blank page.

Fol. 29 recto. SAILBOATS ON THE LOIRE

Graphite, some gray wash. 4^{15}/$_{16}$ x 7^{11}/$_{16}$ in. (12.5 x 19.5 cm.)
Inscribed in graphite, *jaune / gris jaune violet / bleu clair doré / violatre.*

Fol. 29 verso. Blank page.

Fol. 30 recto. ROOFTOPS IN TOURAINE

Graphite, stumped. 4¹⁵⁄₁₆ x 7¹¹⁄₁₆ in. (12.5 x 19.5 cm.)
Inscribed in graphite, *blanc et ardoise.*

Fol. 30 verso. MANOR HOUSE AT PLESSIS-LEZ-TOURS

Graphite.
Inscribed in graphite, *maison de Tristan Prevot de Louis .. XI.*

Delacroix has drawn the western facade of a sixteenth-century house called La Rabaterie. He notes that it was said to be the house of Tristan l'Hermite, a minister of Louis XI. According to another tradition, the house was the residence of Olivier le Dain, barber and confidant of the same king.

Fol. 31 recto. ROOFTOPS IN TOURAINE

Graphite. 4¹⁵⁄₁₆ x 7¹¹⁄₁₆ in. (12.5 x 19.5 cm.)

Fol. 31 verso. PLESSIS-LEZ-TOURS

Graphite.

See fol. 32 recto for a similar view.

Fol. 32 recto. PLESSIS-LEZ-TOURS

Graphite. 4¹⁵⁄₁₆ x 7¹¹⁄₁₆ in. (12.5 x 19.5 cm.)
Inscribed in graphite, *Plessis les Tours / vert.*

On the left appears the tower of the old château.

Fol. 32 verso. FAINT OUTLINE OF A ROOF (not reproduced)
Graphite. The drawing continues on fol. 33 recto.

Fol. 33 recto. PLESSIS-LEZ-TOURS

Graphite. 4¹⁵⁄₁₆ x 7¹¹⁄₁₆ in. (12.5 x 19.5 cm.)
Inscribed in graphite, *Plessis les Tours..*

At the left a farm, at the right the eastern facade of the château.

Fol. 33 verso. VILLAGE AT THE FOOT OF A RANGE OF HILLS
Graphite.

Fol. 34 recto. TWO VIEWS OF A CASTLE ON THE LOIRE
Graphite. 4¹⁵⁄₁₆ x 7¹¹⁄₁₆ in. (12.5 x 19.5 cm.)

Fol. 34 verso. Blank page.

Fol. 35 recto. AN OUTDOOR TRIBUNE, TOURS

Graphite. 4^{15}/$_{16}$ x 7^{11}/$_{16}$ in. (12.5 x 19.5 cm.)

This tribune, added in the sixteenth century to the exterior facade of an earlier building on the place Grégoire-de-Tours, is said to have been used for the proclamations of the ecclesiastical tribunal.

Fol. 35 verso. A DORMER WINDOW AND AN OUTDOOR TRIBUNE, TOURS

Graphite.

Both the dormer window and the tribune still look onto the place Grégoire-de-Tours.

Fol. 36 recto. AN OUTDOOR TRIBUNE, TOURS

Graphite. 4^{15}/$_{16}$ x 7^{11}/$_{16}$ in. (12.5 x 19.5 cm.)
Inscribed in graphite, *19 9bre au soir.*

Two studies of the same tribune that Delacroix sketched on fol. 35 recto and verso.

Fol. 36 verso. Blank page.

Fol. 1 recto.

Fol. 2 recto.

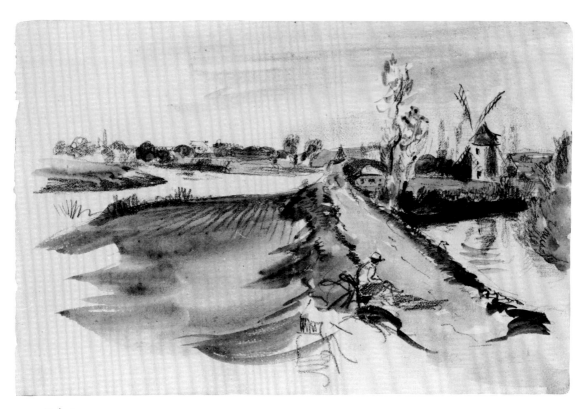

Fol. 3 recto.

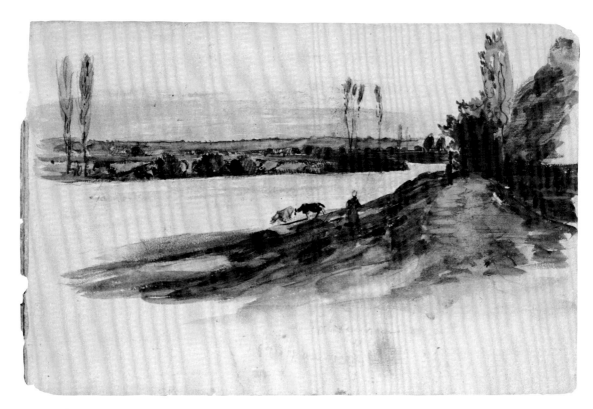

Fol. 4 recto.

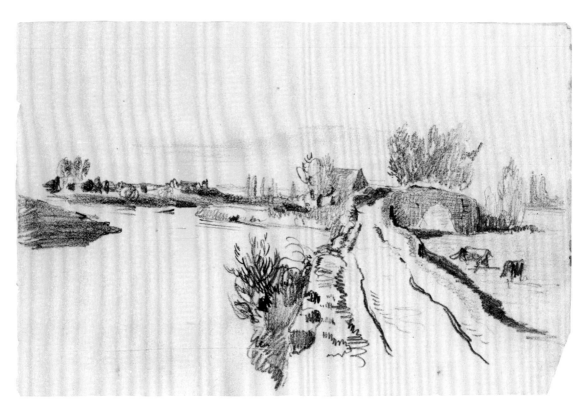

Fol. 5 recto.

Fol. 6 recto.

Fol. 6 verso.

Fol. 7 recto.

Fol. 8 recto.

Fol. 9 recto.

155

Fol. 10 recto.

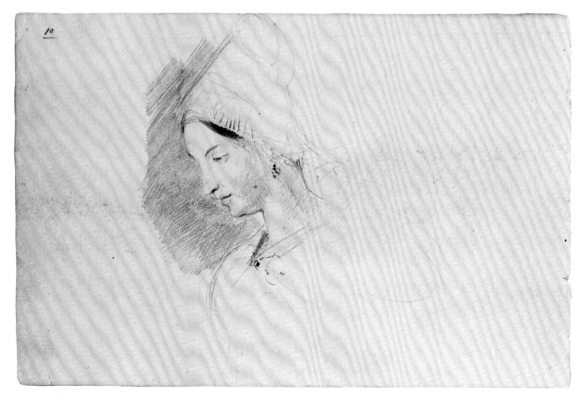

Fol. 10 verso.

Fol. 11 recto.

Fol. 12 recto.

Fol. 13 recto.

Fol. 13 verso.

Fol. 14 recto.

Fol. 15 recto.

160

Fol. 16 recto.

Fol. 16 verso.

Fol. 17 recto.

Fol. 18 recto.

Fol. 19 recto.

Fol. 19 verso.

163

Fol. 20 recto.

Fol. 21 recto.

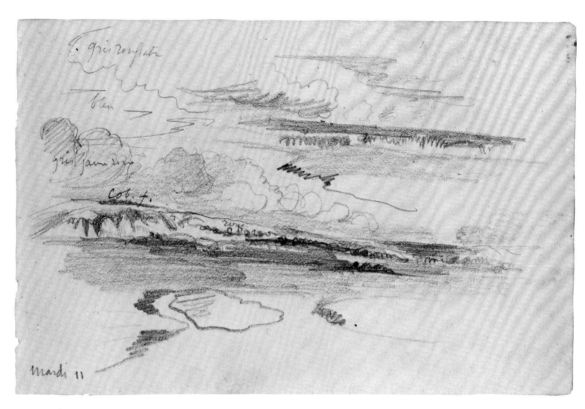

Fol. 22 recto.

Fol. 22 verso.

Fol. 23 recto.

Fol. 23 verso.

Fol. 24 recto.

Fol. 25 recto.

Fol. 26 recto.

Fol. 26 verso.

Fol. 27 recto.

Fol. 28 recto.

Fol. 29 recto.

Fol. 30 recto.

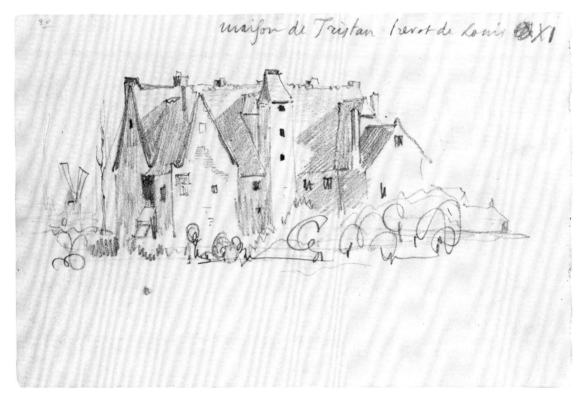

Fol. 30 verso.

Fol. 31 recto.

Fol. 31 verso.

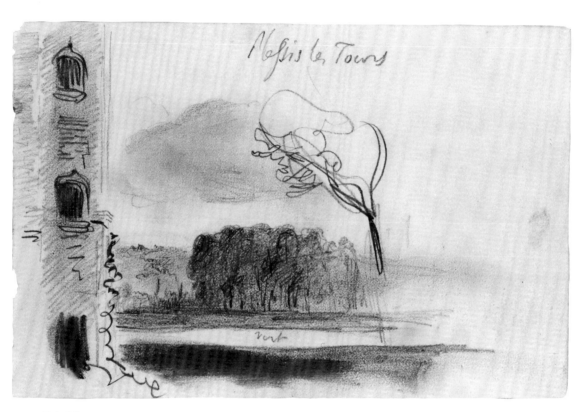

Fol. 32 recto.

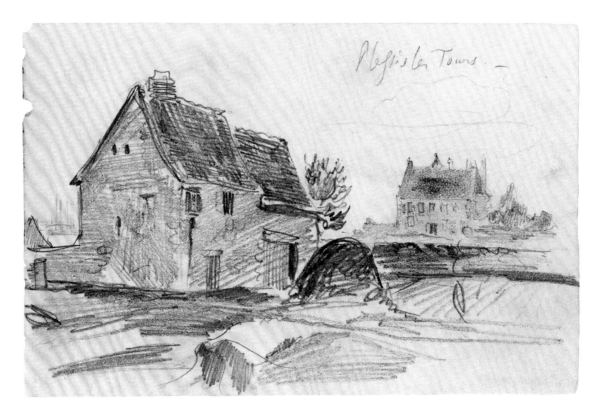

Fol. 33 recto.

Fol. 33 verso.

Fol. 34 recto.

Fol. 35 recto.

Fol. 35 verso.

Fol. 36 recto.

PRINTS AND RELATED DRAWINGS

73. WOUNDED TURKISH SOLDIER IN A MILITARY HOSPITAL

Aquatint
8¾ x 10¼ in. (22.2 x 26 cm.)
Marks of P. Burty (Lugt 413);
A. Beurdeley (Lugt 421)

BIBLIOGRAPHY: Delteil, no. 8, only state.

The Metropolitan Museum of Art
Rogers Fund, 1922
22.63.13

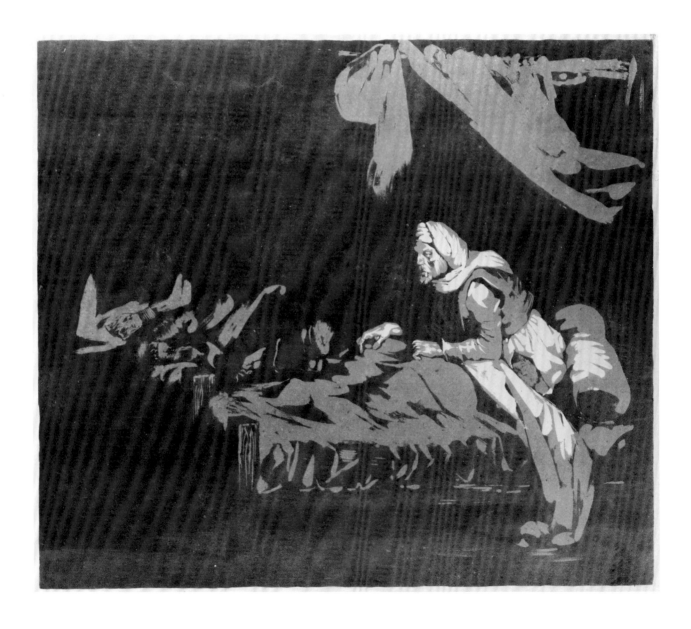

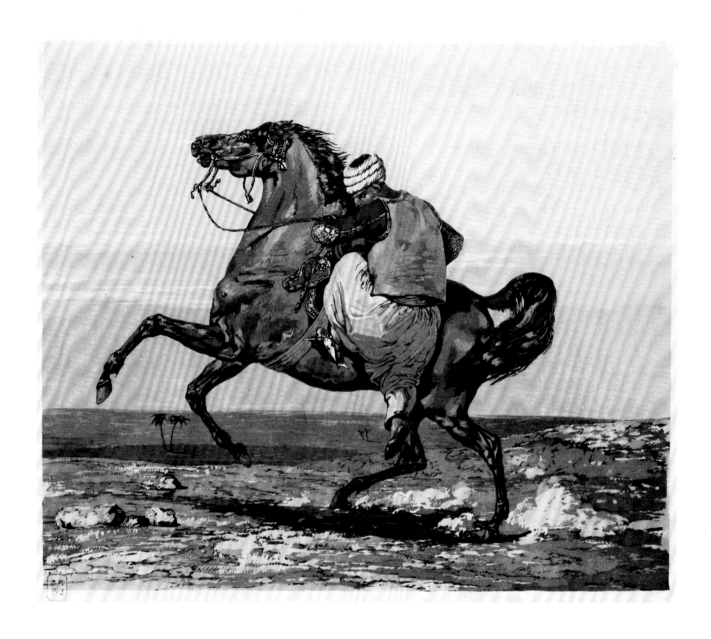

74. TURK MOUNTING A HORSE

Aquatint
8½ x 10⅜ in. (21.6 x 26.4 cm.)
Mark of A. Moreau (Lugt 1900)

BIBLIOGRAPHY: Delteil, no. 11, probably first state of two.

The Metropolitan Museum of Art
Purchase, The Elisha Whittelsey Collection,
The Elisha Whittelsey Fund and
Arthur Ross Foundation Gift, 1990
1990.1113

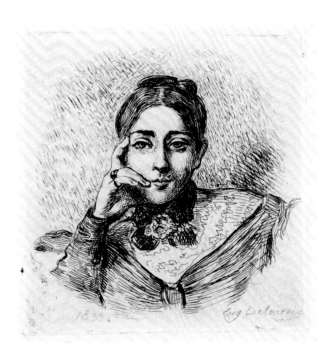

75. MADAME FRÉDÉRIC VILLOT

Etching
3⅜ x 3¼ in. (8.6 x 8.3 cm.)
Signed and dated in the plate, *Eug. Delacroix 1833.*

BIBLIOGRAPHY: Delteil, no. 13, second and final state.

The Metropolitan Museum of Art
The Elisha Whittelsey Collection,
The Elisha Whittelsey Fund, 1957
57.583

Mme Villot, née Pauline Barbier, was the wife of Delacroix's great friend Frédéric Villot.
For his portrait, see no. 36 above.

76. ALGERIAN JEWESS WITH HER SERVANT

Etching
8⅜ x 6⅞ in. (21.3 x 17.5 cm.)
Signed and dated in the plate, *Eug. Delacroix / 1833.*
Marks of P. Burty (Lugt 413); A. Beurdeley (Lugt 421)

BIBLIOGRAPHY: Delteil, no. 18, first state of four.

The Metropolitan Museum of Art
Purchase, Jacob H. Schiff Bequest, 1922
22.60.14

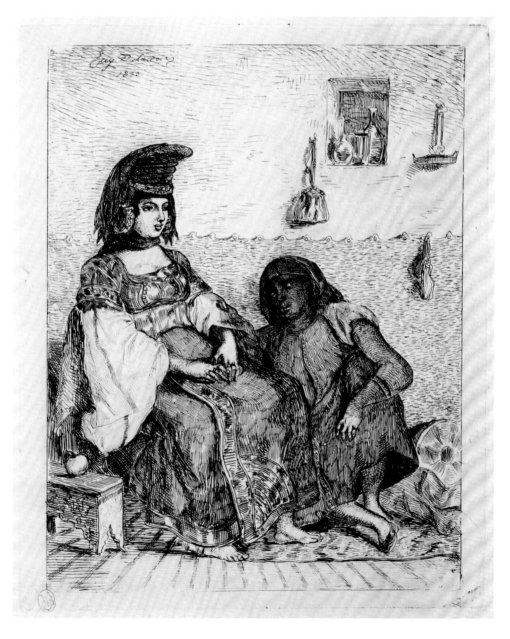

77. COLLISION OF MOORISH HORSEMEN

Etching
7¼ x 9⅞ in. (18.4 x 25.1 cm.)
Inscribed and dated in the plate,
Eug. Delacroix / f. 1834.
Mark of A. Moreau (Lugt 1900)

BIBLIOGRAPHY: Delteil, no. 23, only state.

The Metropolitan Museum of Art
Harris Brisbane Dick Fund, 1936
36.7.1

The print reproduces in reverse the central figures in a painting by Delacroix of 1833–1834
now in a private collection, Paris (Johnson, no. 355). Although Delteil attributed this
etching to Delacroix himself, it now appears that it was executed by Célestin Nanteuil after
a drawing supplied by the painter.

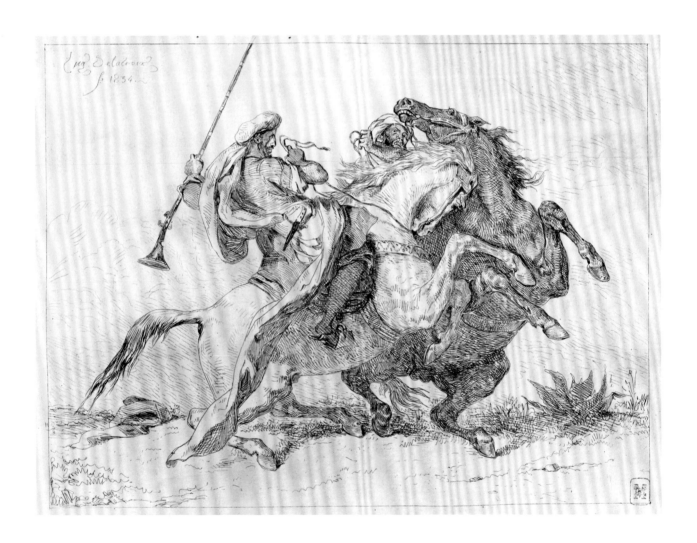

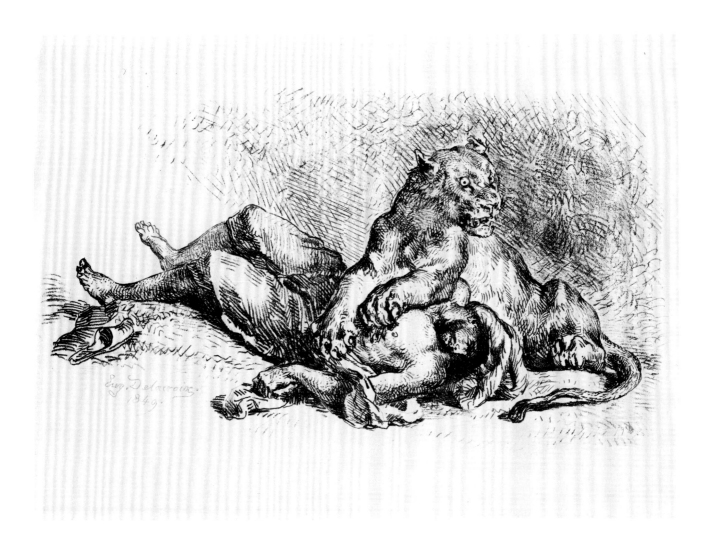

78. A LIONESS MAULING A DEAD ARAB

Soft ground etching and roulette
8⅜ x 11 in. (21.3 x 27.9 cm.)
Signed and dated in the plate, *Eug. Delacroix / 1849.*
Mark of L. Le Rey (Lugt 1757)

BIBLIOGRAPHY: Delteil, no. 25, first state of three.

The Metropolitan Museum of Art
Rogers Fund, 1922
22.63.18

The lioness and the corpse appear in a landscape setting in a now-lost painting that may
be dated around 1848/1849 (Johnson, III, pp. 269–270).

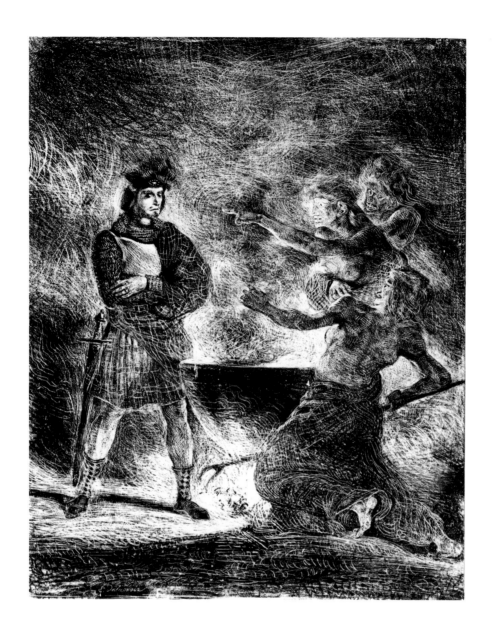

79. MACBETH AND THE WITCHES

Lithograph
12⅝ x 9⅞ in. (32.1 x 25.1 cm.)
Signed in the stone, *E. Delacroix.*

BIBLIOGRAPHY: Delteil, no. 40, third state of five.

The Metropolitan Museum of Art
Rogers Fund, 1922
22.63.19

The scene is taken from act 4, scene 1, of *Macbeth*. Datable to 1825, this lithograph is one of Delacroix's first works inspired by Shakespeare.

80. FOUR GREEK COINS

Lithograph
6¾ x 7⅝ in. (17.1 x 19.4 cm.)
Signed and dated in the stone, *E. Delacroix / 1825*.
Mark of A. Moreau (Lugt 1900)

BIBLIOGRAPHY: Delteil, no. 43, fourth and final state.

The Metropolitan Museum of Art
Harris Brisbane Dick Fund, 1931
31.77.28

81. SEVEN GREEK COINS

Lithograph
11¼ x 9⅛ in. (28.6 x 23.2 cm.)
Signed and dated in the stone, *E. Delacroix / 1825.*
Mark of A. Moreau (Lugt 1900)

BIBLIOGRAPHY: Delteil, no. 45, first state of five.

The Metropolitan Museum of Art
Harris Brisbane Dick Fund, 1931
31.77.27

82. TWELVE GREEK AND ROMAN COINS

Lithograph
9¼ x 12 in. (23.5 x 30.5 cm.)
Signed and dated in the stone, *E. Delacroix / 1825.*
Mark of A. Moreau (Lugt 1900)

BIBLIOGRAPHY: Delteil, no. 47, second state of four.

The Metropolitan Museum of Art
Harris Brisbane Dick Fund, 1931
31.77.24

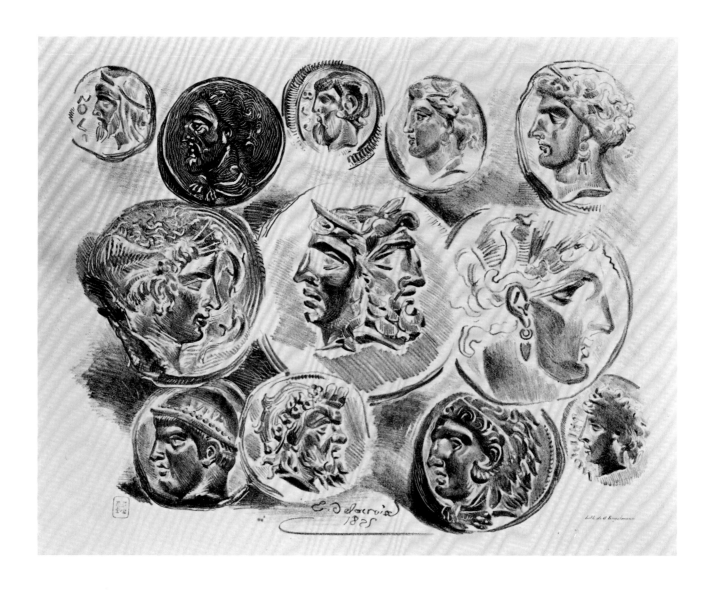

83. YOUNG MAN ATTACKING A CENTAUR

Lithograph
5⅛ x 7⅛ in. (13 x 18.1 cm.)
Mark of A. Moreau (Lugt 1900)

BIBLIOGRAPHY: Delteil, no. 48, only state.

The Metropolitan Museum of Art
Harris Brisbane Dick Fund, 1931
31.77.19

The figures occur in a metope from the south side of the Parthenon frieze that is now in the British Museum. The lithograph reproduces in reverse a drawing that Delacroix would have made during his stay in London in 1825.

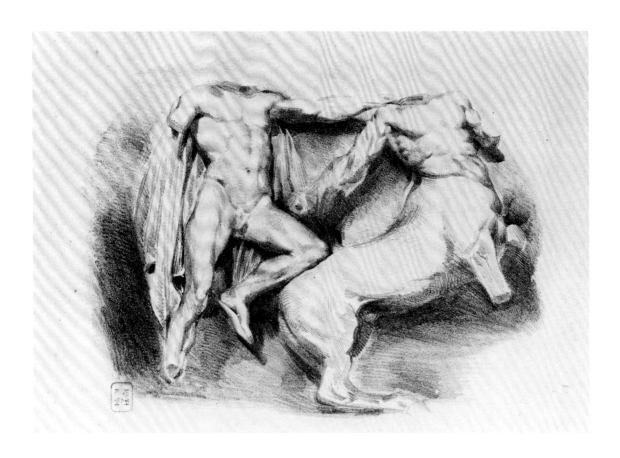

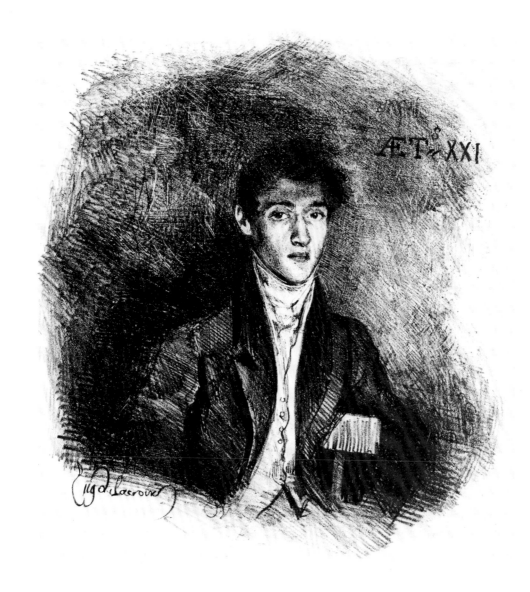

84. LOUIS-AUGUSTE SCHWITER

Lithograph
8⅝ x 7⅞ in. (21.9 x 20 cm.)
Signed in the stone, *Eug delacroix*.

BIBLIOGRAPHY: Delteil, no. 51, only state.

The Metropolitan Museum of Art
Purchase, Derald H. and Janet Ruttenberg Gift
and The Elisha Whittelsey Collection,
The Elisha Whittelsey Fund, 1983
1983.1170

Louis-Auguste Schwiter (1805–1889) was a painter and a friend of Delacroix, who painted
a full-length portrait of him that is now in the National Gallery, London (Johnson, no. 82).

De temps en temps j'aime à voir le vieux Père,
Et je me garde bien de lui rompre en Visière.

85. MEPHISTOPHELES IN FLIGHT

Lithograph
10⅝ x 9⅜ in. (27 x 23.8 cm.)

BIBLIOGRAPHY: Delteil, no. 58, second state of five.

The Metropolitan Museum of Art
Rogers Fund, 1917
17.12

This is the first of a series of seventeen illustrations supplied by Delacroix for a French translation by Albert Stapfer of part one of Goethe's *Faust,* published in Paris in 1828. In this scene from the Prologue in Heaven, Mephistopheles, flying above the nocturnal city skyline, comments of his recent interview with the Lord, "I like to see the Old Man now and then, / and take good care to keep on speaking terms."

86. FAUST COURTING MARGARETE

Lithograph
10⅜ x 8⅜ in. (26.4 x 21.3 cm.)

BIBLIOGRAPHY: Delteil, no. 65, second state of six.

The Metropolitan Museum of Art
Gift of David J. Impastato, 1962
62.617.2

Faust, encountering Margarete in the street, addresses her, "My lovely young lady, may I perhaps venture to give you my arm and be your escort?" His advances are unsuccessful, she frees her arm and leaves him.

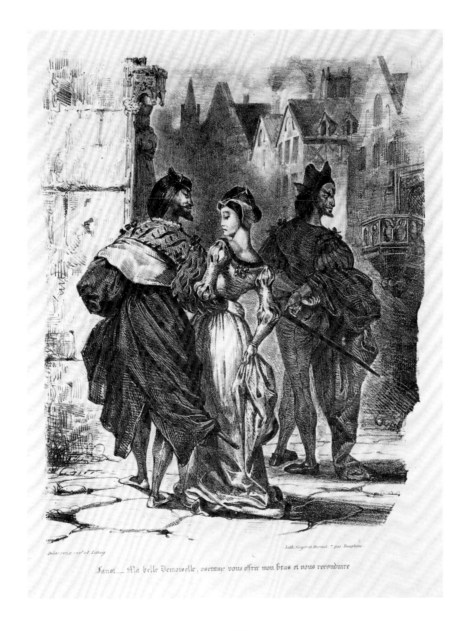

87. FAUST AND MEPHISTOPHELES IN THE
 MOUNTAINS

Lithograph
9¾ x 8⅜ in. (24.8 x 21.3 cm.)

BIBLIOGRAPHY: Delteil, no. 71, seventh and final state.

The Metropolitan Museum of Art
Gift of David J. Impastato, 1962
62.617.1

Faust and Mephistopheles climb up the Hartz Mountains, where they will witness Wal-
purgis Night.

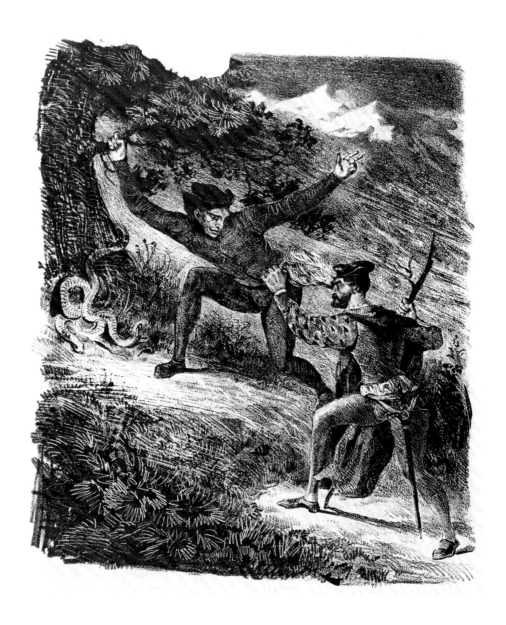

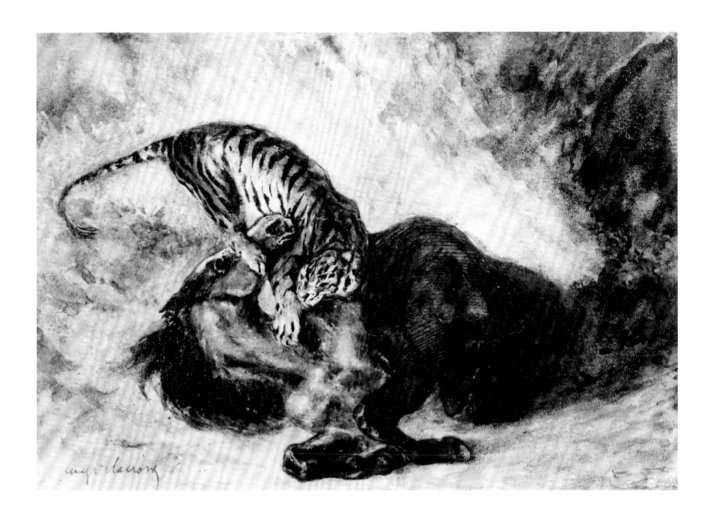

88. WILD HORSE FELLED BY A TIGER

Watercolor, gouache, and gum arabic
5⁵⁄₁₆ x 7¹⁵⁄₁₆ in. (13.5 x 20.2 cm.)
Signed in pen and brown ink, *Eug delacroix.*

Karen B. Cohen

The composition was utilized in reverse in a lithograph dated by Delteil to 1828 (no. 89 below).

89. WILD HORSE FELLED BY A TIGER

Lithograph
8⅝ x 11⅛ in. (21.9 x 28.3 cm.)

BIBLIOGRAPHY: Delteil, no. 77, first state of four.

The Metropolitan Museum of Art
Rogers Fund, 1922
22.63.43

The lithograph repeats in reverse the composition of a watercolor and gouache drawing in this exhibition (no. 88 above).

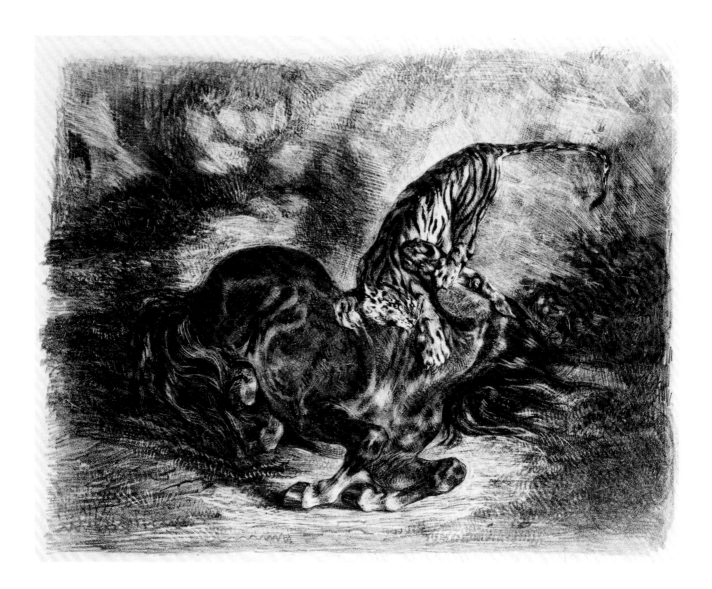

90. WILD HORSE

Lithograph
9 x 9¼ in. (22.9 x 23.5 cm.)
Signed and dated in the stone,
Eug Delacroix / X^{re} 1828.
Mark of A. Moreau (Lugt 1900)

BIBLIOGRAPHY: Delteil, no. 78, first state of two.

The Metropolitan Museum of Art
Harris Brisbane Dick Fund, 1931
31.77.20

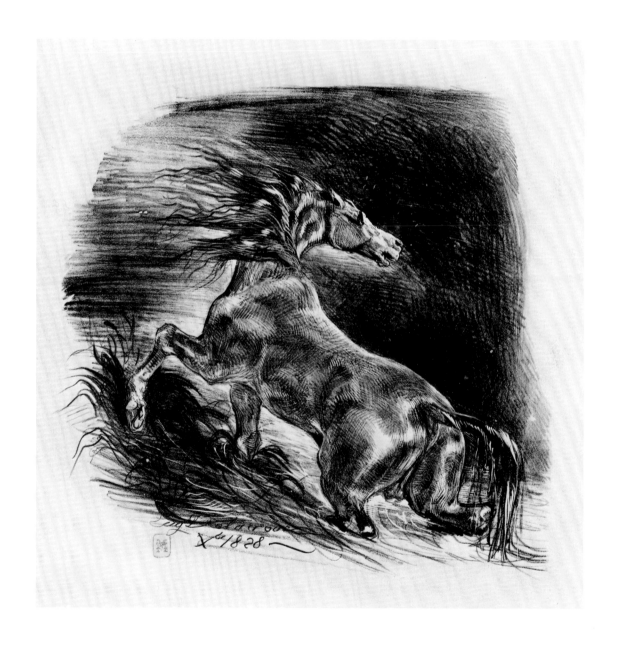

91. LION OF THE ATLAS MOUNTAINS

Lithograph
13 x 18⅜ in. (33 x 46.7 cm.)

BIBLIOGRAPHY: Delteil, no. 79, probably
second state of four.

The Metropolitan Museum of Art
Bequest of Susan Dwight Bliss, 1966
67.630.13

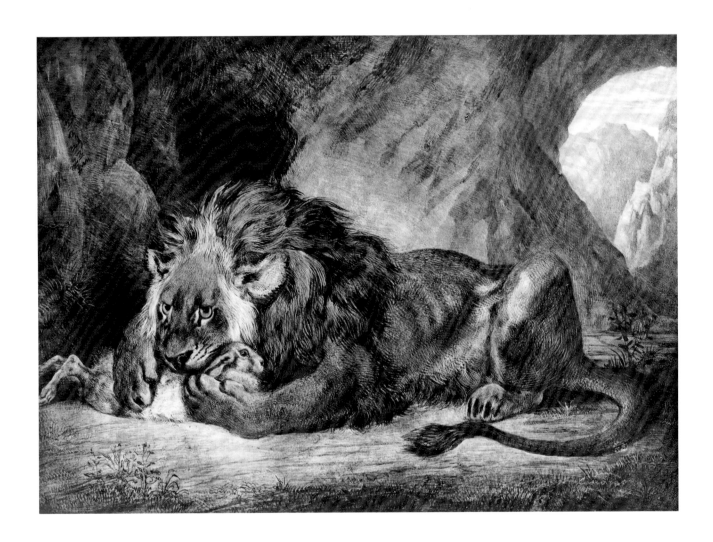

95. HAMLET REPROACHES HIS MOTHER

Graphite
9⁷⁄₁₆ x 7⅛ in. (24 x 18 cm.)
Mark E.D (Lugt Supp. 838a)

BIBLIOGRAPHY: Robaut, no. 573.

Karen B. Cohen

Preparatory study in reverse for the lithograph illustrating act 3, scene 4, of *Hamlet* (no. 96 below). Holding a portrait miniature of his dead father, Hamlet reproaches his mother for her affection for his uncle Claudius.

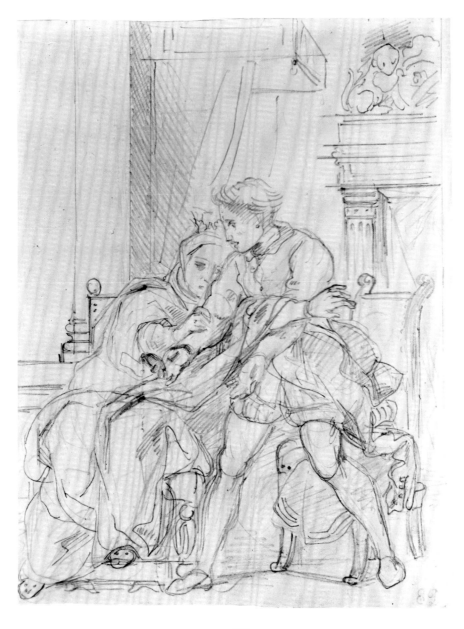

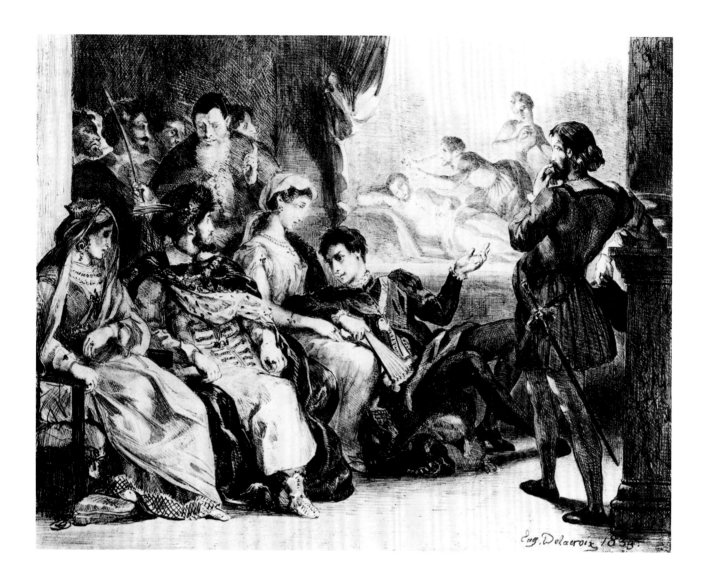

94. *HAMLET:* THE PLAY-WITHIN-A-PLAY

Lithograph
9¾ x 12¾ in. (24.8 x 32.4 cm.)
Signed and dated in the stone, *Eug. Delacroix 1835.*

BIBLIOGRAPHY: Delteil, no. 109, second state of three.

The Metropolitan Museum of Art
Rogers Fund, 1922
22.56.10

Delacroix produced sixteen lithographs illustrating Shakespeare's *Hamlet* over a period
extending from 1834 to 1843. This print illustrates act 3, scene 2, the play-within-a-play.
Hamlet has welcomed a troupe of visiting players and arranged a performance of a
play about fratricide, in which an actor appears to murder his uncle by pouring poison
into his ear.

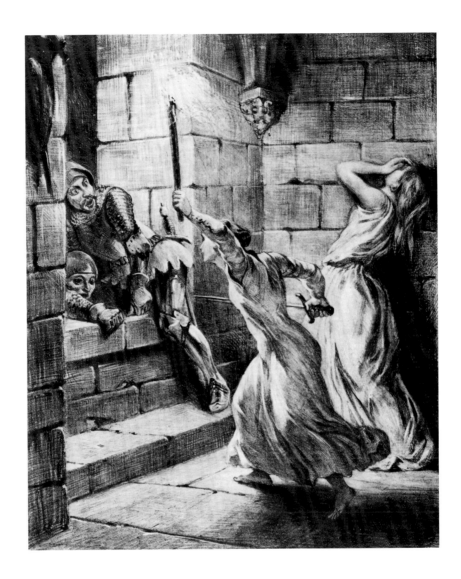

93. THE SISTER OF DUGUESCLIN

Lithograph
9⅞ x 7⅞ in. (25.1 x 20 cm.)
Mark of A. Beurdeley (Lugt 421)

BIBLIOGRAPHY: Delteil, no. 81, first state of four.

The Metropolitan Museum of Art
Harris Brisbane Dick Fund, 1923
23.21.31

This is one of two illustrations that Delacroix supplied for *Chroniques de France,* tales of chivalry by Mme Amable Tastu (Paris, 1829). Julienne, a sister of the noble warrior Bertrand Duguesclin, is responsible for the castle of Pontorson during her brother's absence. Sword and torch in hand, she attacks two English soldiers who have treacherously entered the castle through the complicity of the maid, Alix, who swoons at the right.

92. ROYAL TIGER

Lithograph
12⅞ x 18½ in. (32.7 x 47 cm.)

BIBLIOGRAPHY: Delteil, no. 80, probably
second state of four.

The Metropolitan Museum of Art
Bequest of Susan Dwight Bliss, 1966
67.630.7

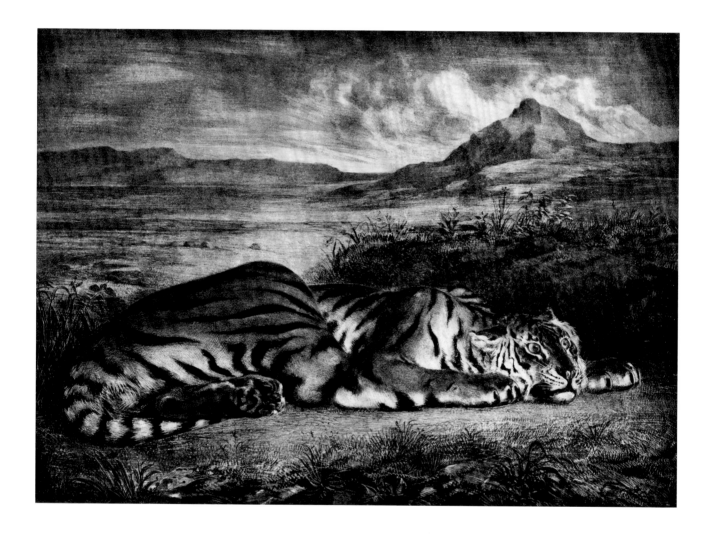

96. HAMLET REPROACHES HIS MOTHER

Lithograph
10⅛ x 7 in. (25.7 x 17.8 cm.)
Signed and dated in the stone, *Eug. Delacroix / 1834.*

BIBLIOGRAPHY: Delteil, no. 112, third state of four.

The Metropolitan Museum of Art
Rogers Fund, 1922
22.56.13

For a preparatory drawing, see no. 95 above.

97. *HAMLET:* THE DEATH OF OPHELIA

Lithograph
7⅜ x 10⅛ in. (18.7 x 25.7 cm.)
Initialed and dated in the stone, *E.D. 1843.*

BIBLIOGRAPHY: Delteil, no. 115, first state of three.

The Metropolitan Museum of Art
Harris Brisbane Dick Fund, 1928
28.92.8

In act 4, scene 7, of *Hamlet,* the death of Ophelia is described. Hamlet has rejected her and, already mad with grief over her father's death, she drowns herself.

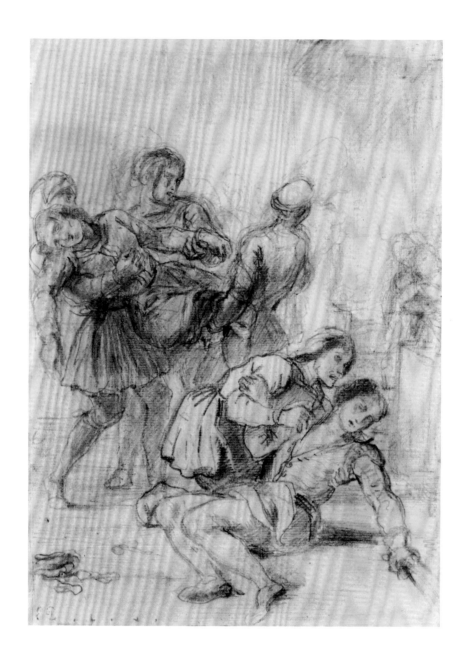

98. THE DEATH OF HAMLET

Graphite
11½ x 8¼ in. (29.2 x 21 cm.)
Mark E.D (Lugt Supp. 838a)

Roberta Olson and Alexander Johnson

Free preparatory study in reverse for the lithograph illustrating act 5, scene 2, of *Hamlet* (no. 100 below). Hamlet, supported by his friend Horatio, is dying in the foreground. The body of Laertes is lifted before Claudius, who looks on in horror as the Queen drinks from the poison cup.

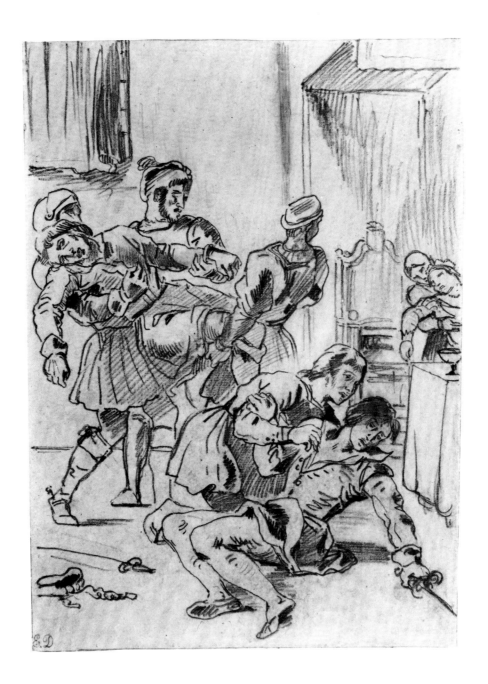

99. THE DEATH OF HAMLET

Graphite, on tracing paper
11⁷⁄₁₆ x 8⅜ in. (29 x 21.3 cm.)
Mark E.D (Lugt Supp. 838a)

BIBLIOGRAPHY: Robaut, no. 756.

Karen B. Cohen

Another preparatory study in reverse for the lithograph (no. 100 below).

100. THE DEATH OF HAMLET

Lithograph
11⅜ x 8 in. (28.9 x 20.3 cm.)
Signed and dated in the stone,
Eug Delacroix / 1843.

BIBLIOGRAPHY: Delteil, no. 118, second state of three.

The Metropolitan Museum of Art
Rogers Fund, 1922
22.56.17

Except for "Ah! Je meurs Horatie!," the French translation of the dying Hamlet's last words does not correspond to Shakespeare's original, and the second line is actually spoken by Fortinbras.

For preparatory drawings, see nos. 98 and 99 above.

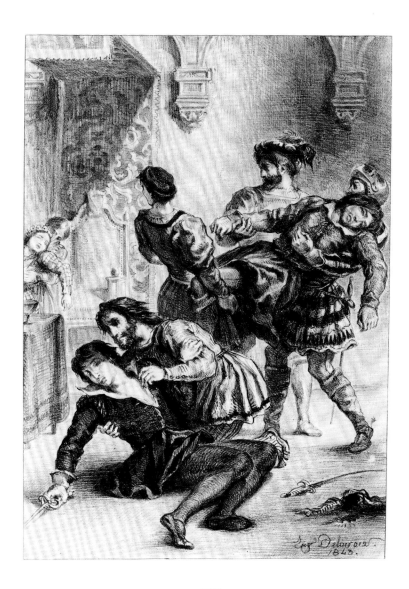

101. GOETZ VON BERLICHINGEN WRITING
THE STORY OF HIS LIFE

Graphite, on beige paper
Pen and brown ink sketch of a horse on verso
10 x 7½ in. (25.4 x 19 cm.)

The Metropolitan Museum of Art
Robert Lehman Collection, 1975
1975.1.614

Preparatory study in reverse for a lithograph illustrating act 4, scene 5, of Goethe's prose
play *Goetz von Berlichingen* (no. 102).

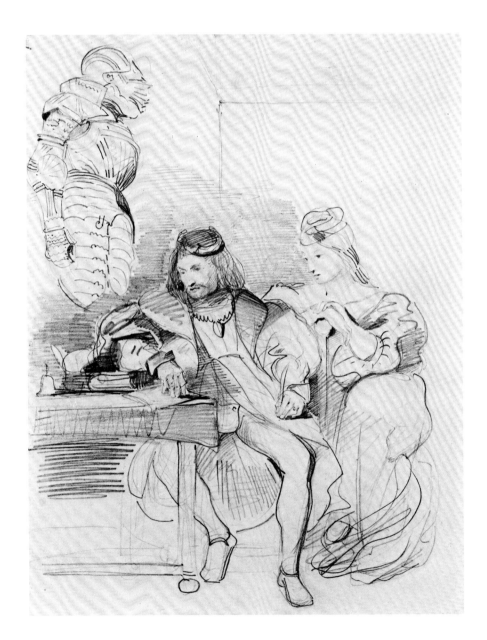

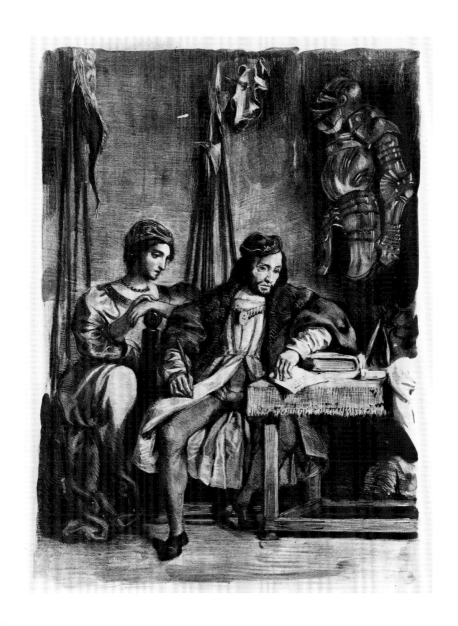

102. GOETZ VON BERLICHINGEN WRITING
 THE STORY OF HIS LIFE

Lithograph
10⅜ x 7⅜ in. (27 x 18.7 cm.)

BIBLIOGRAPHY: Delteil, no. 122, second state of four.

The Metropolitan Museum of Art
Harris Brisbane Dick Fund, 1931
31.31.43

This lithograph is the fourth in a series of seven illustrations to Goethe's play *Goetz von Berlichingen*, executed by Delacroix between 1836 and 1843. For a preparatory drawing, see no. 101 above.

103. THE WOUNDED GOETZ TAKES
REFUGE IN A GYPSY CAMP

Graphite, blue and brown wash
10¾ x 9 in. (27.3 x 22.9 cm.)
Mark E.D (Lugt Supp. 838a)

BIBLIOGRAPHY: Paris, 1930, no. 377D.

Karen B. Cohen

Preparatory drawing in reverse for the lithograph illustrating act 5, scene 6, of *Goetz von
Berlichingen* (see no. 105 below).

104. FRONTAL VIEW OF A HORSE

Pen and brown ink
7⅞ x 5½ in. (20 x 14 cm.)
Mark E.D (Lugt Supp. 838a)

BIBLIOGRAPHY: Paris, 1930, no. 377E.

Karen B. Cohen

Study in reverse for the exhausted horse that bears the wounded Goetz to safety in the Gypsy camp (see no. 105 below).

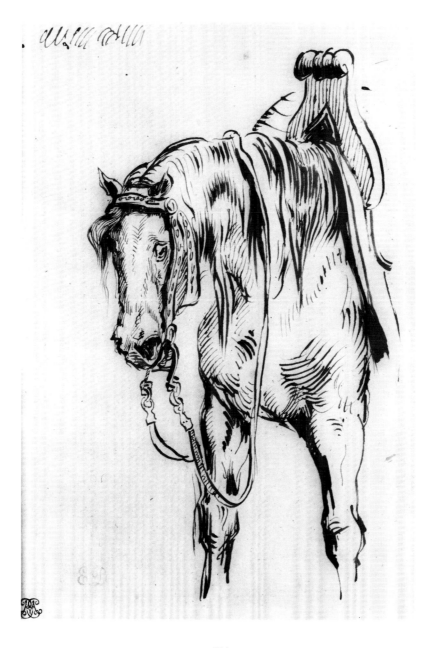

105. THE WOUNDED GOETZ TAKES
REFUGE IN A GYPSY CAMP

Lithograph
12 x 9 in. (30.5 x 22.9 cm.)

BIBLIOGRAPHY: Delteil, no. 123, second and final state.

The Metropolitan Museum of Art
Gift of Mrs. Gula V. Hirschland, 1948
48.126.9

For preparatory drawings, see nos. 103 and 104 above.

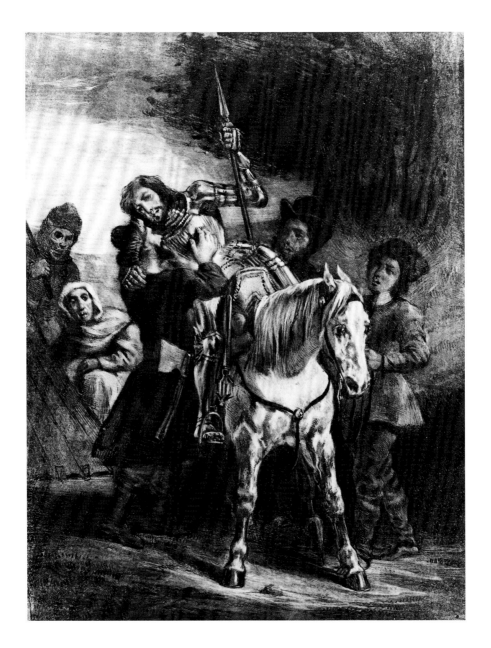

Photograph Acknowledgments

Photographs have been supplied by the lenders and by The Photograph Studio, The Metropolitan Museum of Art. Following are additional acknowledgments:

Archives Photographiques, Paris, pp. 17, 19
Patricia Layman Bazelon, Brooklyn, pp. 48, 53
Caisse Nationale des Monuments Historiques et des Sites, Paris, p. 29
Giraudon, Paris, pp. 13, 15, 23, 24, 40
Réunion des Musées Nationaux, Paris, pp. 14, 21, 32
Malcolm Varon, New York, pp. 54, 59